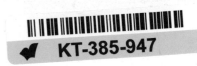

Constable's
ENGLISH LANDSCAPE SCENERY

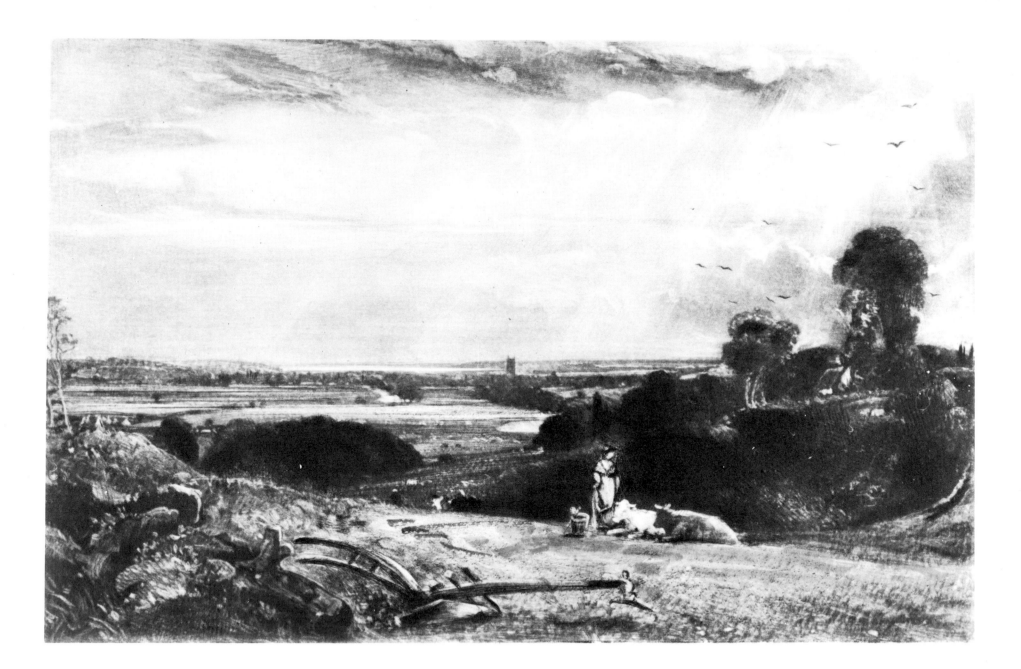

Constable's
ENGLISH LANDSCAPE SCENERY

David Hill

JOHN MURRAY

For John and Catherine

Designed and produced by
Breslich & Foss
Golden House
28-31 Great Pulteney Street
London W1R 3DD

First published in 1985 by
John Murray (Publishers) Ltd
50 Albemarle Street
London W1X 4BD

ISBN 0 7195 4236 7

Editor: Nicholas Robinson
Designer: Roger Daniels
Maps: Olivia Hill
Typeset by Lineage, Watford
Printed in Great Britain by
Cambus Litho, East Kilbride

FRONTISPIECE
Summer Morning – The Vale of Dedham, mezzotint by
David Lucas after Constable.

CONTENTS

ACKNOWLEDGEMENTS

Breslich & Foss would like to thank all the museums, art galleries, photographic agencies, photographers and collectors for permission to reproduce works of art and for providing photographs. They are particularly grateful to Gillian Saunders at the Victoria & Albert Museum, Evelyn Joll and Sue Valentine at Thos. Agnew & Sons, Charles Leggatt at Leggatt Brothers, Leslie Parris at the Tate Gallery, Sotheby's and Christie's for their assistance.

Individual acknowledgements and present whereabouts are as follows:

FRONTISPIECE
 Victoria & Albert Museum
FIG. 1 National Portrait Gallery
FIG. 2 Victoria & Albert Museum
FIG. 3 The Royal Academy of Arts, London
FIG. 4 (*Left*) Victoria & Albert Museum
 (*Centre*) Victoria & Albert Museum
 (*Right*) Whitworth Art Gallery, Manchester
FIG. 5 Victoria & Albert Museum
FIG. 6 C. Attfield Brooks
FIG. 7 Statens Museum for Kunst, Copenhagen
FIG. 8 Victoria & Albert Museum
ILL. 1 Ipswich Museums & Galleries
ILL. 2 Victoria & Albert Museum
ILL. 3 Private Collection
ILL. 4 Mr. and Mrs. W. W. Kimball Collection, The Art Institute of Chicago
ILL. 5 Victoria & Albert Museum
ILL. 6 Private Collection, on loan to the Fitzwilliam Museum, Cambridge
ILL. 7 Victoria & Albert Museum
ILL. 8 Leeds City Art Gallery
ILL. 9 Private collection, on loan to the Birmingham Museum and Art Gallery

ILL. 10 Victoria & Albert Museum
ILL. 11 Victoria & Albert Museum
ILL. 12 Private collection
ILL. 13 National Gallery, London
ILL. 14 Tate Gallery, London
ILL. 15 Paul Mellon Collection, Upperville, Virginia
ILL. 16 Private collection, on loan to the Corcoran Gallery of Art, Washington D.C.
ILL. 17 Tate Gallery
ILL. 18 Tate Gallery
ILL. 19 Glasgow Art Gallery & Museum
ILL. 20 Fitzwilliam Museum, Cambridge
ILL. 21 Victoria & Albert Museum
ILL. 22 City of Manchester Art Galleries
ILL. 23 John G. Johnston Collection, Philadelphia
ILL. 24 Louvre
ILL. 25 Tate Gallery
ILL. 26 The Royal Academy of Arts, London
PL. 1 Tate Gallery
PL. 2 Victoria & Albert Museum
PL. 3 Victoria & Albert Museum
PL. 4 National Gallery of Victoria, Melbourne
PL. 5 Private collection, on loan to the Laing Art Gallery, Newcastle
PL. 6 Victoria & Albert Museum
PL. 7 Victoria & Albert Museum
PL. 8 Louvre
PL. 9 Victoria & Albert Museum
PL. 10 Detroit Institute of Arts
PL. 11 Victoria & Albert Museum
PL. 12 Ipswich Borough Council
PL. 13 National Trust, Fairhaven Collection, Anglesey Abbey, Cambs.
PL. 14 Victoria & Albert Museum
PL. 15 Private collection

PL. 16 Royal Holloway College, University of London
PL. 17 Photograph courtesy Sotheby's, present whereabouts of painting unknown
PL. 18 Louvre
PL. 19 Tate Gallery
PL. 20 Tate Gallery
PL. 21 Yale Center for British Art, New Haven, USA
PL. 22 Victoria & Albert Museum
PL. 23 Private collection
PL. 24 Tate Gallery
PL. 25 Victoria & Albert Museum
PL. 26 Victoria & Albert Museum
PL. 27 Tate Gallery
PL. 28 Private collection, on loan to the Whitworth Art Gallery, Manchester
PL. 29 Paul Mellon Collection, Upperville, Virginia
PL. 30 Victoria & Albert Museum
PL. 31 Toledo Museum of Art, Ohio
PL. 32 Victoria & Albert Museum
PL. 33 Victoria & Albert Museum
PL. 34 Frick Collection, New York
PL. 35 Private collection
PL. 36 Yale Center for British Art, New Haven, USA
PL. 37 Oskar Reinhart Collection 'Am Römerholz', Winterthur, Switzerland
PL. 38 National Gallery, London
PL. 39 Walter Morrison Collection, Sudeley Castle, Glos.
PL. 40 Private collection, on loan to the National Gallery, London
PL. 41 Private collection
PL. 42 National Gallery of Scotland, Edinburgh

JOHN CONSTABLE

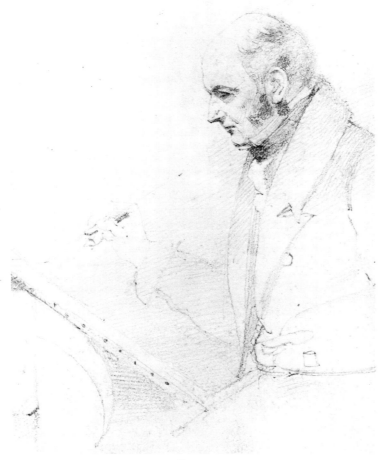

Fig. 1
John Constable painting, *c.*1831, pencil sketch by Daniel Maclise.

JOHN CONSTABLE'S career as an artist led to neither fame nor fortune. By 1816 he had sold only two landscapes to customers who were not relatives, friends or neighbours. His income from painting was so low 'as not to allow him to make a return as would appear to the Commissioners of the Property Tax to constitute a sufficient means of living'. In 1819, however, the *Literary Chronicle* in its review of the Royal Academy exhibition predicted that the young author of *The White Horse* (Pl. 34) would soon become the leading landscape painter. The 'young' author was nearly forty-three years old and his election as Associate of the Royal Academy on 1 November that year must at that age have seemed as much a snub as an accolade. In 1824 at the peak of his success

he sold pictures to French dealers at an average price of about twenty pounds. In the same year he won the gold medal of Charles X at the Paris salon but the honour was of little worth to an artist still virtually unrecognised in his own country and not to be elected full Royal Academician for another five years. The highest price he received for a picture was £300 for *The Valley Farm* (Ill. 14) in 1835 when he was fifty-nine. (Turner, who was one year older, had been able to command such prices thirty years before.) He also had a consumptive wife, seven children to support, and not surprisingly was often at his wit's end for money.

His troubles were mostly self-inflicted. Constable had a secure, even luxurious future mapped out for him even before he was born.

His father was a prosperous Suffolk corn merchant who owned land, two watermills, a windmill, barges, shipping and navigation rights, and earned a substantial enough fortune to build the third largest house in East Bergholt (Fig. 2). When plans were drawn up to sell it in 1816, Constable's brother Abram prepared the following advertisement: 'To be sold in the delightful pleasant village of East Bergholt, a Capital Brick Mansion Freehold, with about 37 acres of land, pasture and arable, in excellent condition, communicating with excellent roads. The Mansion consists of 4 very good rooms & spacious entrance hall on the ground

FIG. 2
Mr Golding Constable's House at East Bergholt. The Birthplace of the Painter.

floor, 4 excellent sleeping rooms, with light closets & spacious landing on the second floor, 4 exceeding good attics, most capital cellars & offices, brick stables & coach house, & every convenience that can be thought of, &c.'

The Constables' first son was born in 1774, and if naming him Golding after his father indicated the hopes of the parents they were to be disappointed. He turned out to be epileptic and mentally unsound, and their hopes transferred to their second son born 11 June 1776, christened John after his paternal grandfather, the farmer and landowner John Constable of Bures. While the parents still had expectations of Golding, John Constable was trained up for the clergy. He attended Lavenham boarding school and Dedham Grammar School where his headmaster, Dr. Grimwood, discovered 'that he was not remarkable for his proficiency in his studies, the only thing he excelled in being penmanship'. By the time Golding was eighteen in 1792 it must have been obvious that he would be unfit to inherit the family business. John, aged sixteen and finishing his studies at Dedham, became the obvious successor.

'For about a year,' his first biographer, C. R. Leslie, tells us, 'Constable was employed in his father's mills, where he performed the duties required of him carefully and well. He was remarkable among the young men of the village for muscular strength, and being tall and well formed, with good features, a fresh complexion, and fine dark eyes, his white hat and coat were not unbecoming to him, and he was called in the neighbourhood the "handsome miller".' He had, however, evidently become used to study and contemplation. A windmill carved on one of the timbers of his father's windmill, which stood on the common at East Bergholt, bears the legend 'J. Constable 1792', and testifies to the young miller's preference as to occupation.

Constable pursued his interest by going out sketching with the local plumber and glazier John Dunthorne. In 1796 while visiting London to further his knowledge of the corn trade he made the acquaintance of John Thomas Smith, a drawing master of Edmonton. At some stage during the next three years he managed to convince his father that he should be allowed to attempt a career in the arts and in 1799 he went up to London armed with a letter of introduction to Joseph Farington RA. An account of the twenty-three-year-old Constable was given by a local girl, Ann Taylor: 'It was in December 1799 that I was first introduced to his family, and I may venture *now* to say, that so finished a model of what is reckoned manly beauty I never met with as the young painter; while the report in the neighbourhood of his taste and excellence of character rendered him interesting in no small degree. There were, too, rumours afloat which conferred upon him something of the character of a hero in distress, for it was understood that his father greatly objected to his prosecution of painting as a profession, and wished to confine him to the drudgery of his own business – that of a miller. To us this seemed unspeakably barbarous, though in Essex and Suffolk a miller was commonly a man of considerable property, and lived as Mr. Constable did, in genteel style. I have the pleasure of finding that the opinion formed at that time of John Constable by a jury of girls between the ages of fifteen and twenty-one, is attested to be true by his life, now published. He lived and died, it seems, the same man of taste, feeling, and truly domestic excellence that he appeared to us.' He was clearly the object of these young ladies' admiration and one morning they walked over to Bergholt to pay court; 'we found his mother, Mrs Constable, a shrewd-looking, sensible woman, at home. There we were, five girls, all "come to see Mr John Constable's paintings", and as we were about to be shown up into his studio, she turned and said dryly, "Well, young ladies, would you like to go up all together to my son, or one at a time?" I was simpleton enough to pause for a moment, in doubt, but we happily decided upon going *en masse*.'

What sort of life Constable imagined himself leading as an artist we can only guess. His knowledge of the world of art was limited to John Dunthorne, John Thomas Smith, and a painter from Ipswich named George Frost. There was, however, one man from the region who provided a ready model of success. Thomas Gainsborough had been born in Sudbury about ten miles west of East Bergholt, started his career in Ipswich, and had risen to the summit of fashionable society with his portraits of the wealthy. Constable made sketching expeditions to sites associated with him and it seems possible that he was hoping to follow in the celebrated artist's footsteps. Golding Constable, meanwhile, no doubt expected that his soon-to-be-disillusioned prodigal would quickly return to the fold.

By 1802 Golding was a little happier with his son's 'career'. In September John became the owner of a small cottage just over the road from the family home, and since the artist had little money of his own he was presumably grateful to his father for this indulgence. Six years later in 1808, still responsible for his thirty-two-year-old son, Golding was beginning to shown signs of exasperation. Some time in June, Constable had written to his mother for financial assistance. His eldest sister Ann wrote with good news on the 19th: 'Since you wrote to my Mother she has been unceasing to my Father to obtain what I know you want and which I could not have got myself alone, tho' I assisted my Mother. You know money comes loath from our Father, & that he thinks any sum a great one, that goes away in a lump as it were, without value *apparent*. He has now sent what I think will clear you of all, and I do hope, that you may not again be in want of aid, other than your own.'

Having left East Bergholt in 1799 to become an artist Constable promptly turned back to it for his subject-matter. From 1802 he returned most summers to sketch in the fields and work in the studio and, between times, his mother kept him in touch with the news. On 7 July 1808, for example, she reported: 'your Father's health is better, but his cough is very troublesome indeed, he is now gone to Flatford & I fear will be vex'd, as upon spending yesterday at the new floodgates there appears to be some unlucky leakage, but I trust it can be rectify'd without taking up the new work or drawing off the water & detaining Barges, Gangs &c. which has been the case this last fortnight — &

must have been longer but for the luck of fine weather. This morning began to mow the Town meadow, & Harvest will then have to be thought of — Man was not intended for idleness — or at least incur'd the punishment of Labour for disobedience. God bless you.'

The following March she was losing patience, and wrote to warn him that money might not be as forthcoming in future: '[Your father] soon hopes to visit the Mills &c. He has in contemplation, a great repair & alteration at Dedham Mill — which as it must be for the benefit of *succeeders*, cannot be disapproved, tho' the expense *there* must cause privations elsewhere — dear John how much do I wish your profession proved much more lucrative, when will the time come that you realize!!! [I much] fear — not before my glass is run out.' Her entreaties were persistent. On 16 March 1811 she hoped that he would 'meet with many respectable friends — both for your pleasure and advantage'. On 28 April 1811 that he would 'with diligence & attention, be the performer of a Picture worth £3000' like Benjamin West, or on 9 February 1813, that he would fulfil his father's 'earnest wish, [that] is to have you what he terms, *earn money*'. Though he had a considerable talent for portraiture he was not inclined to pursue it to any great extent. With greetings for his thirty-seventh birthday his mother wrote on 10 June 1813: 'I most earnestly wish that you may experience many returning Birthdays, with happiness and comfort. Much, very much of this depends upon your own mind & exertions, for you cannot have lived thirty seven years without knowing that; — & I do hope the sight

you have so lately seen in the Exhibition of Sir Joshua Reynolds' performances [at the British Institution that year] will stimulate your exertions to promote your own emolument, and your Parents' & Friends' hopes and wishes. See what has been done by one bright genius & one pair of hands, — who can then be satisfied with one landscape, a few sketches & some unfinished portraits, for an annual employment?' Nothing changed in the next year except that Constable decided to take on John Dunthorne's son as an assistant. His mother despaired: 'he will prove like his patron; & never again regard his home & parental ties, as he did before; nor ever again be in possession of that "bashful forehead" (as Shakespeare terms it), that he brings with him — and besides all this, double your expenditure; which alas! now so far exceeds your income, for not a shilling do I hear of encreasing stocks — & how this can end, God knows — for I am sure I do not. You seem really anxious to avoid any, or every opportunity of earning almost your daily bread.' His mother accurately predicted the outcome in 1809. Her son was still not independent by the time of her death in 1815, nor indeed until the death of his father the following year. It was then that he decided to get married.

It was Golding Constable's third son, Abram, who took on the responsibility for the business. He was named after his father's uncle, old Abram Constable who had left Golding his stock in trade in shipping, more than £3,000 in cash and securities, furniture, pictures and property in East Bergholt, including Flatford Mill. The younger Abram was

born in 1783 and was thus thirty-three when his father died. With two older brothers and three sisters, all with a claim on the estate, the continuity of the business was a complicated affair. In order to settle matters the house that Golding had built had to be sold and Abram moved back down the hill to Flatford. Perhaps matters might have been different had John followed the career his father had wanted.

Constable had determined on a life of observation. Leisure and pleasure became one of the central themes of his art, and there was evidently an element of self-indulgence in his decision to become an artist in the first place. In 1826 he wrote: 'Depend on [it], the love of nature is strongly implanted in man, at least the pursuit of it, is almost a certain road to happiness.' The themes of leisure and work in his paintings have provided material for much discussion recently. The rural poor were exploited, underpaid, disenfranchised and in many cases starving during a period of acute agricultural distress. None of this appears in Constable's idyllic vision of rural England. It has been suggested that this amounts to an unconscious conspiracy by the artist and patrons inclined to gloss over responsibility for the economic system that produced the wealth which supported their class. This 'conspiracy' theory depends upon the assumption that the artist deliberately falsified the record. Constable himself, however, said that the object of his paintings was not to deceive but to remind and when we consider them carefully we find that this is the way they work. They reminded him of the landscapes of childhood in the selective, nostalgic manner in which all of us recollect our early years. His figures are pushed into the landscape, rather than brought to the foreground, not because he wanted to disguise their poverty, but because he wanted to show their unity with the landscape. The frequently high viewpoint is not simply 'proprietorial' because it does not share the relationship that the workers have with the land. It is unnaturally detached — not so much the view from a carriage or the back of a horse, but a view from ten, sometimes twenty feet above the ground. In *Flatford Mill* (Pl. 27), for example, we look *down* on a boy mounted on a horse. This is a view possible only in the imagination and in this Constable provides us with a sign of his own dislocation.

The pursuit of happiness in relationship with nature was one of the driving forces in Constable's painting. He sought it in his sketches — the direct product and record of his observations — or in his studio work — the considered reflection upon them. He was occasionally so enraptured that he could do nothing. On 3 November 1821 he wrote from Hampstead that: 'The last day of Octr was indeed lovely so much that I could not paint for looking — my wife was walking with me all the middle of the day on the beautifull heath', but when he could paint his sketches are alive with his pleasure and excitement. His subjects were the places that meant most to him, those places that he was a part and product of, East Bergholt, the Stour valley, and later, Hampstead, Salisbury and Brighton. His brushstrokes and pencil marks recorded not only the facts of those places, the particular trees, fields and buildings, but also his feelings in relation to them. They are sometimes precise, controlled, and descriptive, as often they are wild, excited and inspired — descriptive more of the person making them than the objects they are meant to represent. Each sketch is the document of an intense encounter between the artist and his world; each is intended to record the effect on him of the landscape. Constable's paintings present us with an encyclopaedia of sensations — the wind beating in our face on a beach, the heat and light of midday in midsummer; the freshness of a passing squall or shower; the sounds of dogs barking, rooks cawing or children shouting; the smell of the sea or hay meadows, or dung ripe for the fields in *Stour Valley and Dedham Village* (Ill. 8). or pitch boiling in a cauldron in *Boat Building* (Ill. 11); the taste of cool water being enjoyed by the boy in *The Cornfield* (Pl. 38); the effort of poling barges, opening sluice gates, guiding ploughs or swinging a scythe. Constable had rejected the physical world for the sake of art, but his paintings record his attempt to regain it. Each sketch is such a record. To appreciate the importance of *physical contact* with nature, Constable had to move away from it to London. There, his painting reflected a discovery which the newly urbanised society was making. As he put it himself in 1821: 'I hear of so many clever pictures for the exhibition especially by Ex[hibitor] members [i.e. ARAs], that it must be a capital show. They are chiefly in the historical & fancy way — I hear little of Landscape — and why? The Londoners with all their ingenuity as artists know nothing of the feeling of a country life (the essence of Landscape) — any more than a

hackney coach horse knows of pasture.' The word 'feeling' was particularly well chosen.

Constable summarised his own feeling for country life in a famous letter of the same year: 'How much I can Imagine myself with you on your fishing excursion in the new forest, what River can it be. But the sound of water escaping from Mill dams, so do Willows, Old rotten Banks, slimy posts, & brickwork. I love such things — Shakespeare could make anything poetical — he mentions "poor Tom's" haunts among *Sheep cots* — & *Mills* — the Water ... & the Hedge pig. As long as I do paint I shall never cease to paint such Places. They have always been my delight — & I should indeed have delighted in seeing what you describe in your company "in the company of a man to whom nature does not spread her volume or utter her voice in vain". But I should paint my own places best — Painting is but another word for feeling. I associate my "careless boyhood" to all that lies on the banks of the *Stour*. They made me a painter (& I am gratefull) that is I had often thought of pictures of them before I had ever touched a pencil, and your picture [*The White Horse* (Pl. 34)] is one of the strongest instances I can recollect of it. But I will say no more — for I am fond of being an Egotist, in whatever relates to painting.' The man to whom he wrote, John Fisher, was Constable's most important confidant and the volume of their correspondence offers many insights into Constable's views and ambitions. As Constable hinted above, it was mostly about the artist, and so it remained. On 27 September 1826 Fisher wrote to Constable to stress the importance of setting his life and opinions down for posterity:

You are in possession of some very valuable and original matter on the subject of painting, particularly on the *Poetry* of the Art. As I should be very sad to see this seed sown on some unvisited feild where it would blossom in forgetfulness: while some theiving author, like a sparrow, would fly off with a sample & take the credit from you. Throw your thoughts together, as they arise (in a book that they be not lost), when I come to see you we will look them over put them into shape & do something with them. Perhaps we could illuminate the world thro' *the Quarterly*. Pray do not forget to put together the history of your life & opinions with as many of your remarks on men & manners as occur to you. Set about it *immediately*. Life slips. It will perhaps bring your children in £100 in a day of short-commons, if it does nothing else. Besides *I* have been all along desirous of writing your life & rise in the art.'

The full range of Constable's opinions and the full interest of the life can only be seen by reading his correspondence in seven volumes in full. It is one of the most remarkable pieces of self-documentation ever undertaken by any artist and reinforces the view that recognition of the autobiographical nature of Constable's art is essential to a proper understanding of it. One purchaser of his pictures, Francis Darby of Coalbrookdale, received a frank invitation to take a more personal interest in the artist when he bought two paintings of Hampstead in 1825: 'I ought not to trouble you, Sir, with myself, but the truth is, could I divest myself of anxiety of mind I should never ail anything. My life is a struggle between my "social affections" and my "love of art". I dayly feel the remark of Lord Bacon's that "single men are the best servants of the publick". I have a wife (daughter of Mr. Charles Bicknell of the Admiralty) in delicate health, and five infant children. I am not happy apart from them even for a few days, or hours, and the summer months separate us too much, and disturb my quiet habits at my easil.' Constable continued in much the same confessional vein for another three paragraphs before apologising for 'this most unconscionable letter which I have now written to you'. In his correspondence Constable set down the material with which we might, as with Wordsworth's *Prelude*, trace 'the growth of a poet's mind'. It was vital for Constable to have '*real patrons*, elegant and superior men who were his friends and who thought themselves the gainers when they allowed his judgement to exceed theirs in that study in which he had been all his life successfully engaged'. Men who, like Fisher, were as much concerned with the artist as with his work.

Constable's paintings record his relationship with the world. If his sketches show his immediate responses, the works he made in the London studio record his response to his memories. Most of the Stour valley subjects painted before his father died in 1816 were painted while he still had contact with the landscape itself. Many were painted in the studio at East Bergholt, some, such as *Boat Building* (Ill. 11) and the *Kitchen* and *Flower* (Ill. 1)

Gardens, were painted directly from the motif. After this date, however, his Stour valley subjects were painted in his London studio. One of the last to be painted at East Bergholt was *Flatford Mill* (Pl. 27). Constable appears to have been working on it in September 1816. His father had died in May and he was intending to get married in October. The picture was especially important to him, therefore, since it was the last he painted as a free agent, and that summer was the last that he would be able to consider East Bergholt as home. Determined to make this last tribute to his origins, he even went so far as to suggest that the wedding be postponed so that he could complete it.

The painting shows the view from the end of Flatford Bridge looking downstream to the lock and mill. A family legend tells us that Constable's father inherited the mill as a result of an altercation that took place on the bridge: 'Uncle Abram had at one time intended leaving his fortune to another nephew, an elder brother of Golding. His property included a mill on the Stour; and the story goes that the hitherto favoured brother fell into an argument with his uncle while lounging on the footbridge nearby. This ended in his throwing the old man's crutch into the river, whereupon old Abram exclaimed, "There goes crutch, mill, and all".' The mill was left to Golding. The painting is an exquisitely careful record of the site. The paintwork is meticulously descriptive, distinguishing the particular trees, shrubs and flowers, each exactly appropriate to the time of year at which it was painted. We know that Constable arrived in Suffolk on 16 July 1816 and on 9 July Abram had written: 'the weather

has been uncommonly bad for hay, & is now very uncertain altho' just at this moment, fine.' Constable himself recorded on 16 August: 'The weather is very unfortunate. We cannot get up our hay which is at least a month later than usual, and the corn backward in proportion.' The hay would normally have been in before Constable's arrival, but in the field on the right of the painting we see it in the process of being cut, remarkable testimony to the exact date at which the painting was made.

Elsewhere in the painting there is evidence of Constable's knowledge of and affection for the life on the canal. In the foreground a boy sits on a tow horse while another hauls in the tow rope which has been untied so that the two barges can be poled under the bridge on their way upstream to Dedham. They are full and heavy, for they are low in the water (compare the unladen barge by the mill to the left) and they are proving difficult to manage. The current is driving the leading barge backwards causing the boats to jack-knife. The bargemen, however, sit unconcernedly smoking their pipes, happy to let the boys do the work. It seems likely that it was in precisely this sort of work that the village boys earned their pocket money, John Constable among them. One wonders how we are meant to know all this. We can see that the barges are being poled and that the tow rope has been untied, but we cannot see why. The bridge, apart from a couple of timbers in the bottom left-hand corner of the painting, is not included. In order to complete the understanding of the picture one has to know that the bridge is there. In other words, the spectator has to know as much

about the place as the artist did and view the scene with his mind as well as through his eyes.

After *Flatford Mill* Constable's Stour subjects became acts of memory rather than observation. The first three were painted entirely at his house in Keppel Street. Since the pictures were no longer begun from the motif or painted close by, it became necessary for Constable to work out his image in a large-scale rough sketch. In these he could push the paint about freely without the need to describe accurately. He began his sketches by blocking in the main areas in tone. Into this he would work indications of details, presumably as he remembered them. Gradually suggestions emerged as he explored and re-explored his memory. Finally the light was added: the clouds, the lights on the water, sunshine gleaming through leaves, sparkling from brickwork, old posts, tiles, boats or meadows. The study enabled his memory to develop gradually, one element signposting another until everything he could remember about the scene was satisfactorily suggested. At this point he could begin the finished painting. Each of his large canvases starting with *The White Horse* in 1819 (Pl. 34) and continuing through *Stratford Mill* in 1820 (Pl. 41), *The Hay Wain*, 1821 (Ill. 13), *View on the Stour near Dedham*, 1822 (Pl. 16), *The Lock*, 1824 (Pl. 39), *The Leaping Horse*, 1825 (Fig. 3), and *The Cornfield*, 1826 (Pl. 38) was begun in this way. In each the composition, the paintwork, the chiaroscuro and the content represent the statement of what his memories meant to him at that time.

Each new picture, each fresh monument

of memory, seemed his best. In 1821 he told Fisher: 'I do not consider myself at work without I am before a six-foot canvas.' Four years later painting had an even greater importance: 'I find it a cure for all ills besides its being the source "of all my joy and all my woe".' In 1829 after the death of his wife he was in need of its curative powers: 'I have been ill, but have endeavoured to get to work again — and could I get afloat on a canvas of six feet, I might have a chance of being carried away from myself.' Constable could lose himself in his painting. In his London studio, surrounded by his sketches and memories, he could remake the world of his past to his satisfaction. After 1816, however, this world was becoming increasingly remote, and the world of the present increasingly fraught with problems. His wife's illness was a constant source of anxiety and his search for fame an increasingly embittered one. A comparison of *The Hay Wain* with *The Leaping Horse* documents a considerable shift in sensibility in the four years that separates them.

The Hay Wain shows the view from the forecourt of Flatford Mill, looking across the tail race of the mill to Willy Lott's cottage. It glows from the walls of the National Gallery with a cool, fresh light which will surprise anyone used to it only in reproduction. It is calming and delightful, and the artist's pleasure in describing each remembered detail is evident. At the extreme right we can just see the end of a brick wall. It serves no pictorial function as such, nor does it add anything to the composition, yet it tells us a great deal about the way Constable's mind worked. As with *Flatford Mill*, what is *not* shown is almost as important

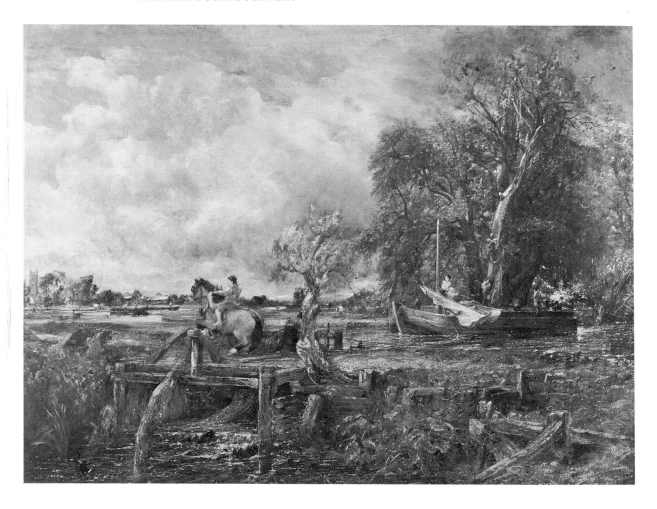

FIG. 3
The Leaping Horse, 1825.

as what is. A visit to the site will show that the wall belongs to Flatford Mill itself which from this viewpoint is to the right and behind us. The same wall can be seen in the earlier painting of *The Mill Stream* (Pl. 12) with a boy fishing from it. Constable was relating this view to his others of Flatford. The boy reappears here in a slightly different position, still with his fishing-rod. In *The Mill Stream* we see a small ferry-boat which plied through the cut, seen above the cart in *The Hay Wain*, across to the far bank of the Stour. The same boat reappears here, tied up on the bank to the right.

In *The Leaping Horse* (Fig. 3) such precision of place and memory has disappeared. To the extreme right we can see the tower of Dedham Church but the actual site of the painting cannot be identified. A towhorse is leaping over a barrier in the towpath, having been untied from the barge it has been towing upstream. Compared with the meticulous precision of *The Hay Wain* the paintwork is loose and undefined as if the memory has not quite crystallised, not quite struggled free of the paint in which it was being created. For the first time this is not a picture of a particular place. It is a 'Stour' scene and full of the incidents which Constable associated with the river: 'a canal and full of the bustle incident to such a scene where four or five boats are passing with dogs, horses, boys & men & women & children, and best of all old timber-props, water plants, willow stumps, sedges, old nets, &c &c &c', but as Michael Rosenthal has recently pointed out: 'topography is irrelevant. Constable used either *Flatford Mill* or his drawing of the elms as a basis for those behind the sluice, but without worrying about transferring their surrounds as well. Dedham Church, a landmark, achieved definition, probably to close off the right with a vertical, but possibly because it had previously appeared in both *A View on the Stour* [Pl. 16] and *The Lock* [Pl. 39], and was integral to the conception.' For the first time Constable was creating a pastiche of elements which had previously appeared in other paintings. The artist's memory is now of his art rather than of reality, and we find him adrift, driving the paint around in pursuit more of style and effect than of his past.

By 1825 Constable's life had taken him well away from the landscape of his youth. Since 1819 he had been spending his summers at Hampstead, Salisbury, or latterly, Brighton. These were the landscapes to which he now belonged and he spent every opportunity sketching on Hampstead Heath, on the shore at Brighton, or around the close and meadows at Salisbury. These new experiences became increasingly the subject of his interest and he exhibited nine or ten Hampstead subjects at the Academy between 1821 and 1825, a large painting of Salisbury in 1823, views of Gillingham Mill in 1826 and 1827 and *The Chain Pier, Brighton* (Ill. 25) in 1827. Increasingly the new subjects included the feeling for place which the Stour subjects had lost by the time of *The Leaping Horse*.

In 1827 Constable decided to renew his contact with the Stour valley and take his children down to enjoy those things which had made him a painter. Visiting Suffolk, however, was no longer the simple, go-as-he-pleased operation that he was accustomed to, and Abram wrote from Flatford to discourage him on two grounds, firstly, that there was insufficient room, and secondly that 'a more dangerous place for children could not be found on earth. It would be impossible to enjoy your company, as your mind would be absorb'd & engross'd with the children & their safety.' A compromise was reached and Constable went down with only his two eldest, John and Minna, probably on 2 October. They had a pleasant journey down apart from Minna being sick on the coach. 'The children,' Constable reported with pleasure, 'are overcome with

delight at all they see — Minna thinks Suffolk very like Hampstead. When we arrived at Stratford Bridge I told her we were in Suffolk — she, O no, this is only fields.' Constable was so struck by Minna's reaction that he repeated the story in his next letter a few days later. All Minna knew of Suffolk was derived from her father's paintings, and all she knew of nature was derived from Hampstead. The reality of the Stour valley, 'only fields', must indeed have been below her expectations. Where was the marvellous colour of art, where the towering painted cumulus, where the thick drips of light sparkling like mortar on every wooden post? The blackberries, she had to admit, however, were much finer than those at home.

The stay was a delight for the children and the father. He took John and Minna fishing and the fish obligingly jumped out of the water for the children. They went for a ride on a barge, John had two rides on horseback, Minna did some drawings and after all this the father was pleased to report, the children 'have never waked once yet during the night any one night, & I manage to lay them very nicely in their places when they get out of them.' Minna slept particularly well 'though [at home] she wakes so much she never woke till six.' The father seems to have been mostly occupied supervising the children, but in between times he managed to do some sketching. One of these shows John and Minna fishing from a barge moored by the sluice to the boat dock at Flatford, looking towards the lock. Constable revisited a number of his familiar motifs around Flatford, including *Flatford Old Bridge and Cottage*, returning to the exact site of a sketch made in

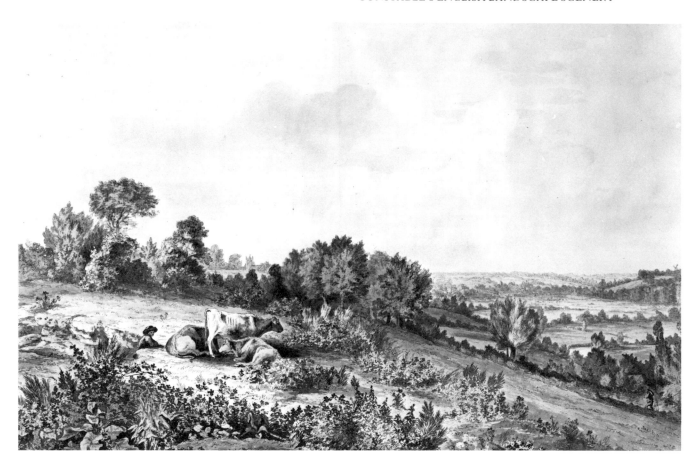
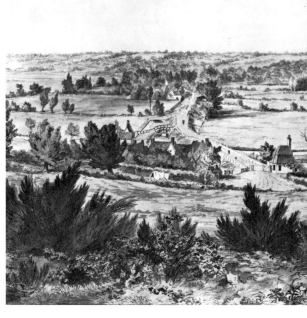

FIG. 4
Constable's panorama of the Stour valley, painted in
watercolour in 1800. It shows Langham Church (on the
hill) and Higham (below the windmill on the right) in the
left-hand picture, Stratford Bridge and Stratford St. Mary
Church (in the distance on the right) in the centre picture,
and Dedham Church and Harwich Water (East Bergholt
would be on the hillside to the left) in the right-hand
picture.

1813. Nothing much had changed in the inter-
vening fourteen years, apart from a few trees
grown up on the far bank, as indeed nothing
much has changed in the century and a half
since, apart from rebuilding of the bridge in
1930. Far greater changes had been wrought on
the artist and on his relationship to the subject.
When he made his first sketch his mother and
father were still alive, he was thirty-seven,
single, the landscape was his home, and more

or less anything seemed possible. By the time
he made the second he was fifty-one, married,
the father of six children with another well on
the way, and a tourist up from London. As if
reminded that Suffolk was no longer his home
he wrote to Maria with a comforting observa-
tion: 'Our nice house in the Well Walk far ex-
ceeds any of the houses inhabited by any of my
family here, for comfort & convenience.' Later
in the same letter he was confronted by an

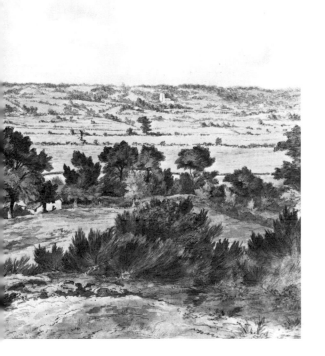

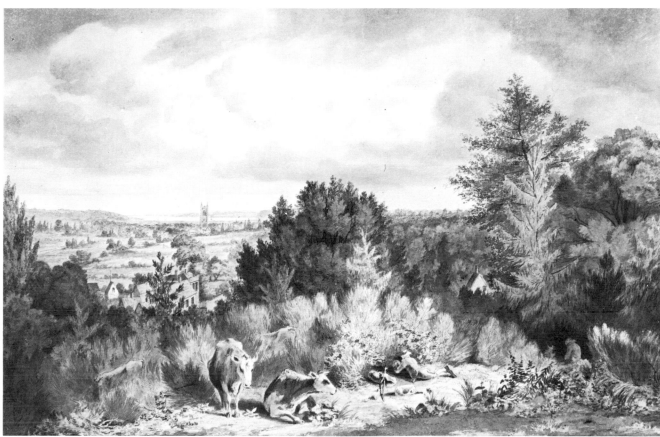

event which brought home to him how much of a stranger to the valley he had become: 'Yesterday a wedding at Dedham, a Miss Bell & a Mr Spink a horse surgeon — God knows who they are — but the bells rang all day.' The landscape, at least, was familiar, and his sketch at Flatford Bridge seems to have delighted him. It was the same, favourite place it had always been, and as if to make the point, he included a dog sitting at the very spot from which he had painted *Flatford Mill* in 1816, looking, we might note, in exactly the same direction. Four years earlier Constable had said: 'In a sketch there is nothing but the one state of mind — that which you were in at the time.' From these sketches we might deduce that in 1813 Constable was eager to be somewhere else from its brevity. In 1827 he seems to have been happy to stay there all day. Every timber is recorded with care, the complex shadows and their reflections under the bridge, the sedges, clouds and newly grown willows. He was also in high spirits to judge from the vertical emphasis and the animation of the marks recording the foliage at the left and the movement of the clouds across the sky. Constable's feeling for the landscape seems to have been revitalised. They enjoyed 'a week or more most delightfull weather' and the children were well behaved throughout. On his return to

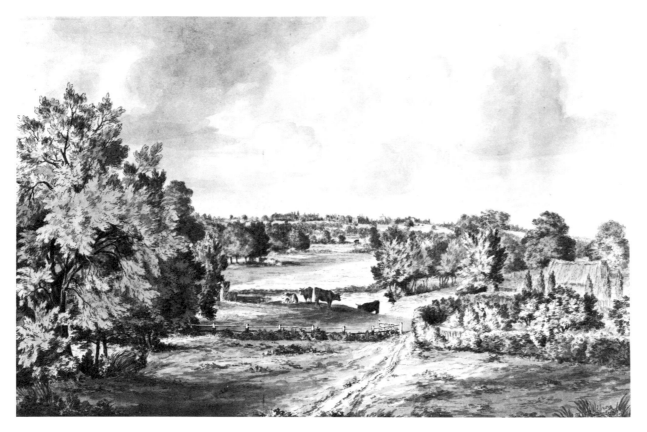

FIG. 5
Made, with the panorama of the Stow Valley, as a
wedding present for the daughter of the curate of
Langham in 1800, this watercolour shows the view from
Dedham to East Bergholt. East Bergholt Church is
visible on the hilltop and the viewpoint is located in the
right-hand picture of the panorama illustrated as Fig 4.

and Stratford St. Mary, to East Bergholt,
Dedham, Flatford and Harwich Water in the
east, with Manningtree and Mistley in the dis-
tance (Fig. 4). This was the most complete
record of the layout of the landscape that he
ever made, three watercolours forming a con-
tinuous panorama, with a fourth showing the
view up to East Bergholt from Dedham
(Fig. 5), made as a wedding present for Lucy
Hurlock, the daughter of the curate of Lang-
ham. Later in his career Constable would have
been reluctant to part with such a record with-
out having a version which he could keep, but
at the age of twenty-four perhaps memory did
not yet have quite the same importance as it
acquired in later life. Nevertheless, he returned
two years later to a similar viewpoint to record
the view to Dedham in oils, and returned again
a few years later to make his most detailed
record of the scene, including Stratford Bridge
in the foreground (Ill. 5), and by 1814 his
studio contained no fewer than twelve records
of the same view from Gun Hill, or from
nearby Langham Church, in both oil and in
pencil.

In planning his new picture in 1828, Con-
stable no doubt consulted every one of these
records and probably arranged them around
his studio for reference. It is interesting that out
of this material he chose to construct his new
picture from the two earliest works he had to
hand, *Dedham from Langham*, painted in Sep-
tember 1802, and *The Valley of the Stour* (Ill. 5),
painted about 1805. In a letter of 29 May 1802
he had written: 'Nature is the fountain's head,
the source from whence all originally must
spring — and should an artist continue his

London Constable capitalised upon his re-
kindled feelings for Suffolk by beginning
another large Stour valley subject for the
Academy.

He chose the view from Gun Hill, near
Langham, looking east towards East Bergholt,
with Dedham and Harwich Water in the dis-
tance. In 1800 he had used a similar vantage
point to survey the complete panorama of the
Stour valley from Langham Church in the west,
swinging north past Higham, Stratford Bridge

practice without referring to nature he must soon form a *manner* For these two years past I have been running after pictures and seeking the truth at second hand ... I am come to a determination to make ... some laborious studies from nature — and I shall endeavour to get a pure and unaffected representation of the scenes that may employ me ...' The paintings of 1802 and 1805 were the direct result of this determination. By 1828, however, Constable was seeking out pictures, albeit his own, in precisely the way that he had rejected earlier. His 1802 painting had the manner of Claude, particularly in the composition and the paintwork of the trees, but elsewhere, particularly in the distances, it was inventive and original. The 1805 was one of the purest unaffected representations that he produced. The *Dedham Vale* (Pl. 42) of 1828 has topographical accuracy, as the helicopter photograph (Fig. 6) plainly demonstrates, although this is only to be expected since it is based on such careful studies. The rest, however, is all manner. The paintwork is highly wrought, scumbled, brushed, dragged, glazed, rubbed, smeared, smoothed, mixed and moulded. It is expressive of pleasure in painting, pleasure in manipulating the medium, and above all of the energy, feeling and concentration that the artist could muster in front of his canvas. But if the painting gained in expressive power, it lost something in its relationship to the subject. There is a restless quality about the workmanship; a lack of descriptive precision and a pervading feeling of unease and overwork. The trees at the right writhe and twist, and the eye shifts restlessly over the surface of the paint, search-

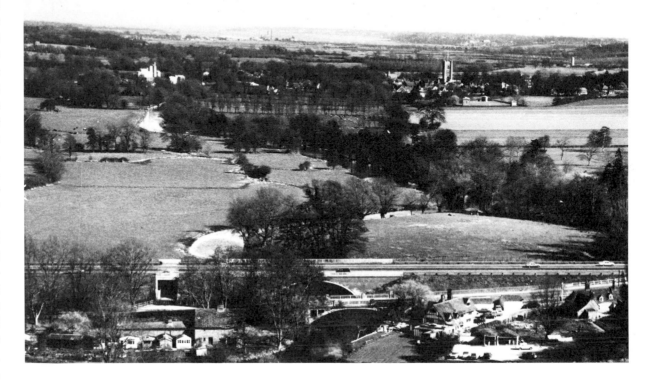

ing (mostly in vain) for some quiet haven of representational simplicity. Constable, however, was no longer interested in clarity of recognition. He had chosen pictures as his starting point for this painting and not nature. His painting had finally engulfed him.

On the basis of this picture he was elected full Royal Academician the following February. This was an honour which had eluded him while he had pursued his naturalistic ideals. Even before his election an alarm bell

FIG. 6
Aerial photograph of the Stour valley, with Dedham Church top right, Dedham Mill top left, and Harwich Water visible in the distance.

had been ringing: on 21 January 1829 he wrote, 'I have little heart to face an ordeal (or rather should I not say, "run a gauntlet") in which "kicks" are kind treatment to those "insults to the mind", which "we candidates, *wretches of necessity*" are exposed to, annually, from some "highminded" members who stickle for the "elevated & noble" walks of art — i.e. preferring the *shaggy posteriors of a Satyr* to the *moral feeling of landscape*.' As early as 1822 he had recognised the dangers of becoming more involved with art than with reality, and when plans were drawn up to found the National Gallery, Constable was uneasy: 'The art will go out — there will be no genuine painting in England in 30 years. This is owing to "pictures" — driven into the empty heads of the junior artists by their *owners* — the Governors of the Institution &c &c. In the early ages of all the arts, the productions were more affecting & sublime — owing to the artists being without human exemplars — they were forced to have recourse to nature.' He repeated his doubts on 6 December 1822: 'Should there be a national gallery (as it is talked) there will be an end to the Art in poor old England, & she will become the same non entity as any other country which has one. The reason is both plain & certain. The manufacturers of pictures are then made the criterion of perfection & not nature.' The essential feature of art was its relationship to reality. In 1829, when Constable was elected to the Academy, his own painting had lost that conviction.

In 1830 Constable began to suspect that perhaps he had made a mistake: 'I have filled my head with certain notions of *freshness — sparkle*

— brightness — till it has influenced my practice in no small degree, & is in fact taking the place of truth so invidious is manner, in all things — it is a species of self worship — which should always be combated — & we have nature (another word for moral feeling) always in our reach to do it with — if we will have the resolution to look at her.' Constable, unfortunately, no longer seems to have had that resolution, for after his visit to Salisbury in 1829 he hardly painted a single oil sketch from nature during the rest of his life. As we shall see, much of his time was devoted to the problems of publishing his 'English Landscape' series and, between times, he often struggled to find pleasure even in painting in the studio. In 1833 he wrote to Leslie: 'I am determined not to harrass *my mind* and HEALTH by scrambling over my canvas — as I hitherto have too often done. Why should I — I have little to lose and *nothing* to gain. I ought to respect myself — for my friends' sake, who love me — and my children. It is time at "56" to begin at least to *know "one's self"* . . .' At the age of fifty-six two of the people who had loved him most, his wife and John Fisher, were already dead. Nevertheless he nurtured the hope that his spirits would revive and he continued in the same letter, 'your regard for me has at least awakened me to believe in the possibility that I may yet make some impression with my "light" — my "dews" my "breezes" — my *bloom* and my *freshness* — no one of which qualities has yet been perfected on the canvas of any painter in this world.'

In 1834 he began another attempt to find these things in his last painting of Willy Lott's

cottage, *The Valley Farm* (Ill. 14). On 8 September he told Leslie that he had 'almost determined to attack another canal for my large frame'. He had completed and probably exhibited a version of exactly the same view twenty years earlier in 1814, when he had written: 'I am anxious about the large picture of Willy Lott's house, which Mr Nursey says promises uncommonly well in masses &c., and tones — but I am determined to detail but not retail it out.' The view is taken from the south bank of the Stour, looking in almost exactly the opposite direction to *The Hay Wain* (Ill. 13), through the ferry cut. The ferry is seen in both versions of the present composition, about to pass through the cut, moored in *The Hay Wain*, and approaching the shore near Willy Lott's in *The Mill Stream* (Pl. 12). In 1814 Constable was concerned that the manner and handling an exhibited picture required should not overwhelm his particular knowledge of the place: '. . . I am determined to detail but not retail it out . . .' In comparison *The Valley Farm* of twenty years later looks overworked. In March 1835, two months before it went to the Academy, he described the picture as 'a rich plumb pudding', and the same month the collector Robert Vernon bought it from Constable's easel for £300. However he did not receive it until December. As Graham Reynolds observes, 'Constable's correspondence shows how persistently he continued to work on the picture, without much regard either to the views or impatience of the owner.' In October he told J. J. Chalon, 'I have been very busy with Mr. Vernon's picture. Oiling out, making out, polishing, scraping, &c seem to have

agreed with it exceedingly. The "sleet" and "snow" have disappeared, leaving in their places, silver, ivory, and a little gold.' Constable's obsessive reworking this time got the better of him. As Leslie Parris has argued: 'Willy Lott's cottage may well have become for Constable a nostalgic symbol of a "natural" way of life which was no longer his own [the same author points out that Willy Lott was living there when Constable was born, and was still living there when Constable died]. The tortured surface … suggests an almost desperate attempt to recreate the past.' But Constable's paintings were usually more than an attempt to simply recreate the past, they were his method of analysing, and expressing, his relationship to it in the present. Only as things emerged under his hand, became visible, could he consider what they might mean. In *The Valley Farm* gone are the dews, the breezes, the light, the bloom and the freshness, which were his constant reminders of a healthy relationship with nature. They are replaced by blackened trees, a sky more grey and brown than blue, and while a breeze seems to shake the tops of the trees, below the air is still and heavy, to judge from the reflections of the cows, swallows still skim over the water, but its surface is oily, and the ferry seems stuck in gelatine rather than fresh water. The Stour has become the Styx, and the girl in the boat is being taken to a rambling house where a dark figure waits at the gate. If Constable discovered anything about his relationship with the past in painting this picture, it must have been that it was long dead. Not much more than a year after Vernon took possession of the picture, following its appearance at the British Institution in 1836, Constable himself was dead.

On 2 March 1833 he had written: 'Good God — what a sad thing it is that this lovely art — is so wrested to its own destruction — only used to blind our eyes and senses from seeing the sun shine, the feilds bloom, the trees blossom, & to hear the foliage rustle — and old black rubbed-out dirty bits of canvas, to take the place of God's own works.' No clearer illustration of the truth of this for Constable at the end of his career can be found than *The Valley Farm*. It is not for this, however, that Constable should be remembered. We should turn instead to the vast majority of his paintings which have that vital quality of direct contact with nature. His sketches are alive with the marks made in response to that contact, and his finished pictures are filled with reminders of it: the breeze blowing, the sun sparkling, the air turning chill or warm; and full of people enjoying health and vitality. The act of painting served to intensify his relationship with the world. His pictures show what may be achieved in a life attuned to these pleasures, and record how fugitive this achievement can be. In concluding his final lecture on landscape at the Literary and Scientific Society at Hampstead on 25 July 1836, eight months before his death on 31 March 1837, he directed us to himself at his best: '[As] Paley observed of himself … "the happiest hours of a sufficiently happy life were passed by the side of a stream"; and I am greatly mistaken if every landscape painter will not acknowledge that his most serene hours have been spent in the open air, with his palette on his hand. "It is a great Happiness", says Bacon, "when men's professions and their inclinations accord." '

CONSTABLE'S 'ENGLISH LANDSCAPE'

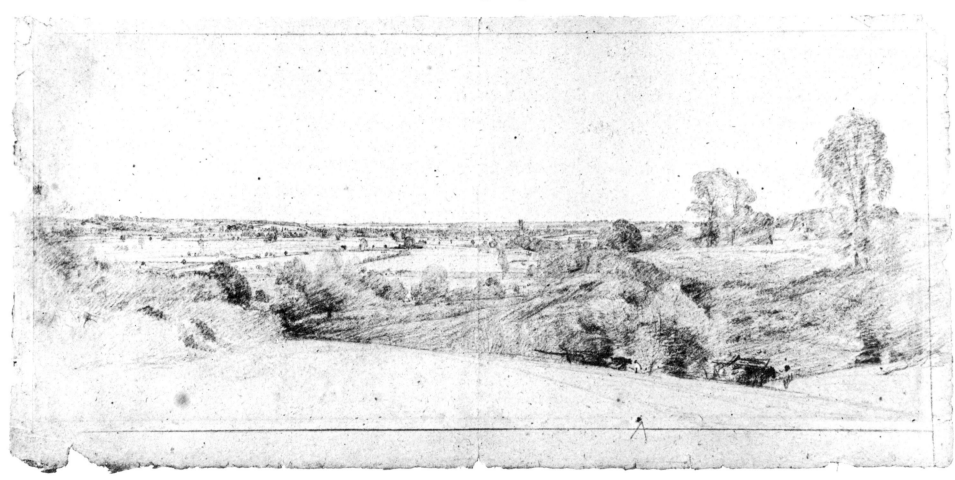

Fig. 7
Dedham from Langham, pencil sketch, *c.* 1812

WHEN CONSTABLE exhibited *Hadleigh Castle: The Mouth of the Thames — morning after a stormy night* (Pl. 21) at the Royal Academy in 1829 he had been a widower for six months and a Royal Academician for two months. The passage he quoted from James Thomson's *The Seasons* in the catalogue probably reflected his state of mind:

> The desert joys
> Wildly, through all his melancholy bounds
> Rude ruins glitter; and the briny deep,
> Seen from some pointed promontory's top,
> Far to the dim horizon's utmost verge
> Restless, reflects a floating gleam.

In fact, Constable misquoted the original. The alteration was slight and confined to the second line, but the comma inserted after 'Wildly' and the full stop removed from the end of the line altered the sense. For Constable, the ruins were specifically located in his 'melancholy bounds'; Thomson does not tell us where they are. The desert in either case could refer to his misery at the death of his wife, and the stormy night in the title of the exhibited picture may stand for the months of attendant grief. Constable's 'desert' was full of glittering ruins, and he changed the sense to include them. A visit to his studio would have immediately shown why he did this: the paintings standing around his studio, each one the relic of part of his past life, each one the subject of his ambitions for his art. The promontory at Hadleigh was to provide a good vantage point from which to survey the ruin-strewn bounds of his past.

About this time Constable decided to publish a series of his own works in mezzotint.

The idea had been germinating for some time. On 17 December 1824 he had written to tell John Fisher that the French dealer John Arrowsmith had engaged him 'to make twelve drawings (to be engraved here, and published in Paris) ... [from a sketchbook used in Brighton in 1824], size of the plates the same as the drawing, about 10 or 12 inches. I work at these in the evening. This book is larger than my others — and does not contain odds, and ends (I wish it did), but all complete compositions — all of boats, or beach scenes — and there may be about 30 of them ... [S.W.] *Reynolds* (the engraver) who saw ... [*The Hay Wain* and *View on the Stour*] in the Louvre says he was astonished at their power and the art & nature which appeared in them. He is going over in June to engrave them. He has sent two assistants to Paris to prepare the plates — they will be in mezzotint. He is now about my Lock [Pl. 39]. I sent it to him last week and he is to engrave the 12 drawings. All this is very desirable to me, as I am at no expence about them, and it cannot fail of advancing my reputation.' After 1824, however, public taste was more inclined to the fine line and greater economy of steel engraving, and Constable, though well-known in Paris after the sensational impact of his pictures at the Salon of 1824, was still hardly known at home. The project came to nought. Nonetheless, mezzotint held a specific attraction for Constable. It is rich in tone and shows its *facture* clearly. The technique involves pitting the whole surface of the plate so that it prints entirely one deep, velvety black, and then by a process of smoothing and burnishing, the highlights and detail gradually

emerge from the shadow. Unlike line engraving, which always tends a little to the grey, mezzotint can exploit the full range of tones and half-tones, from the deepest black that the ink can produce to the pure white of the paper. Into this range of tone, further detail can be added with the burin. This made it ideal for translating Constable's work into print. When Constable misquoted Thomson in the RA catalogue for 1829, he may also have hoped that we would consider the rest of the passage from which it was taken:

> The very dead creation from thy touch
> Assumes a mimic life. By thee refined,
> In brighter mazes the reluent stream
> Plays o'er the mead. The precipice abrupt,
> Projecting horror on the blackened flood,
> Softens at thy return. The desert joys
> Wildly through all his melancholy bounds.
> Rude ruins glitter ...

The first five lines tell us that it is the process of making 'mimic life' out of 'dead creation' which brings joy to the 'melancholy bounds'. The possible analogy with painting was clearly not lost on Constable, particularly as the second sentence described his favourite subject over the past thirty years: 'By thee refined, In brighter mazes the reluent stream Plays o'er the mead.' Over the following years Thomson's description must have seemed even more apt as Constable supervised the emergence of his own life from the ink of the 'English Landscape' mezzotints.

By 1829 Constable had formed a close association with one of S. W. Reynold's assistants, David Lucas. Lucas was born at

Brigstock in Northamptonshire in 1802, the year in which Constable exhibited his first painting at the Royal Academy. He was the son of a farmer-grazier and his youth was spent working on his father's farm. By chance, when Reynolds was touring Northamptonshire in 1820, he happened to call in at the farm for a drink and noticed the eighteen-year-old's drawings. Reynolds was so impressed that he took on young Lucas as an apprentice for seven years, reducing the normal fee of £300 to a mere ten shillings. Lucas moved in straight away to Reynolds's workshop in Bayswater. We are told that the new apprentice had an unruly shock of hair and a boisterous temperament which was not out of place among the other wild apprentices, and it seems possible that Constable recognised something of himself in the young provincial recently translated from his father's farm to the London art scene.

It was against John Fisher's advice that Constable chose mezzotint as the best medium in which to reproduce his work. As early as 1 October 1822 Fisher had suggested lithography: 'Your pencil-sketches always take people, both learned and unlearned. Get one done on stone as an experiment, unless it is derogatory from the station you hold in the art ...' On 1 January 1825 Fisher replied to Constable's news that Reynolds was to engrave the Paris pictures and Brighton sketches: 'I am pleased to find they are engraving your pictures, because it will tend to spread your fame, but I am almost timid about the result. There is in your pictures too much evanescent effect & general tone to be expressed by black & white. Your charm is colour & the cool tint

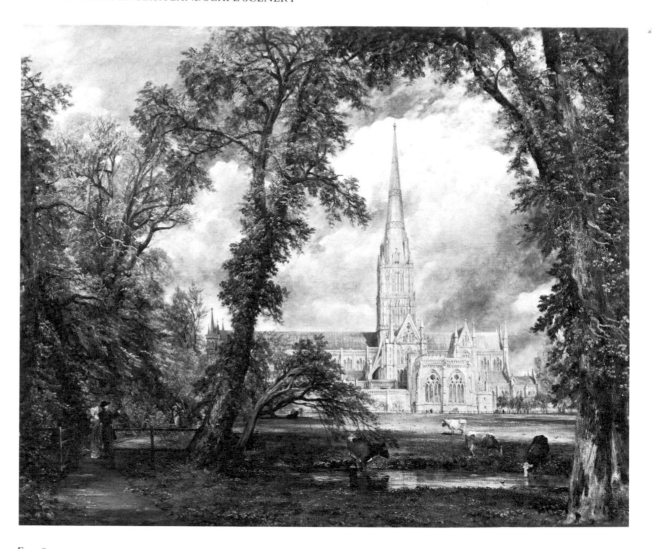

FIG. 8
Salisbury Cathedral, from the Bishop's Grounds, exhibited RA 1823, showing Dr John Fisher, Bishop of Salisbury. Dr Fisher was formerly curate of Langham in the Stour valley and was the uncle of Archdeacon John Fisher, who was one of Constable's greatest friends and patrons. Archdeacon Fisher acquired this painting after his uncle's death in 1825 but sold it back to the artist in 1829 as a result of financial difficulties.

of English daylight. The burr of mezzotint will not touch that. Your sketch books would I guess engrave well.' Constable was not deterred from his choice of medium, but he was influenced in his choice of subjects. The first works that he sent to Lucas were all rough sketches, some even seem to have been made especially for the purpose.

Lucas started work for Constable engraving two watercolours, *The Approaching Storm* and *The Departing Storm*. Both were published by S. Hollyer of Everett Street in 1829 although from the scarcity of the prints we may deduce that this was not the publishing event of the year. Perhaps Constable intended them only as test pieces for Lucas, but in any case he learned enough of the young engraver's potential to persuade him to embark on a more ambitious project. Constable had three weeks' holiday in July with Fisher at Salisbury, and it was probably soon after his return to London that he set Lucas to work on the first plates of 'English Landscape'.

Leslie recorded in his *Life of John Constable* that the first plate was that of *Dedham Mill* (Pl. 17), but Lucas noted in his own copy of Leslie: 'No. this is a mistake the first engraving was the small Hampstead Heath called the Vignette [Mezzotint No. 22]. The figure on the brow of the bank was Collins the painter who happened to be sketching on the heat at the time.' It seems appropriate that Constable should have turned first to an image of an artist sketching in the open air. It seems also to indicate the aspect of his work that he most wished to promote, that of sketching direct from the motif. The first two pictures to be engraved were both themselves the product of

this activity. The project seems to have been well underway by 28 August 1829 when Constable sent a note to Lucas with material being sent round to the engraver. From a note dated 15 September we learn a good deal more about the subjects being considered: 'A total *change* has again taken place. Leslie dined with me yesterday — we have agreed on a long landscape (Evening with a flight of rookes) [Pl. 3], as a companion to the "Spring" [Pl. 2], and the "Whitehall Stairs" [Pl. 36], in place of the Castle [i.e. *Hadleigh Castle*, Pl. 21]. Prithee come and see me at six, this evening — & take the things away, lest I *change* again. ... A pity the "Evening" [Pl. 7] prints so very bad.' At this stage all the subjects being considered were sketches, apart from the *Whitehall Stairs*, which was a study, and the *Summer Evening* (Pl. 7) which was exhibited at the Academy in 1812, but apparently painted direct from the motif. We also learn something of Constable's indecision, which was to set a pattern for his future dealings with Lucas.

A month later a finished proof of *Old Sarum* (Pl. 14), also from a sketch, was ready and Constable sent it to the President of the Royal Academy, Sir Thomas Lawrence, as a gift. Lawrence wrote to Constable on 27 October to offer his thanks and to say that it was 'exceedingly well executed'. From a letter dated 26 December 1829 we learn that *Helmingham Dell* (Pl. 8), was also underway, again from a study, together with *Stoke-by-Nayland* (Pl. 11) from another sketch, and *A Summerland* (Pl. 15), another exhibited picture but again painted largely from nature. From a note made at the end of the year we learn that the cost of engrav-

ing was fifteen guineas per plate, and on 19 January 1830 Constable sent Lucas thirty sovereigns. He was buoyant with optimism: 'I think we must succeed as every body likes them.'

A letter to Lucas dated 26 January 1830 gives the first good picture of what Constable was intending at this stage, and of some of the problems he was encountering. It seems that he was intending at this stage to publish eight plates only:

Charlotte St.
Feby. 26, 1830.

Dear Lucas—

I am anxious to have a further talk with you about the plates.

First—I want to know how forward the "Evening" is & the retouched Stoke, for I am desirous of "eight" being all you are engaged on for me—if it does not delay the work too long a time.

I have not the wish to become the owner of the large plate of the Castle, but I am anxious that it should be fine, & will take all pains with it. It will not fail of being so, if I may now judge.

I have taken much pains, with the last proof of the "Summerland", but I fear I shall be obliged to reject it—it has never recovered from its first trip up, and the sky with the new ground is and ever will be as rotten as cow dung.

I like your first plates, for they are by far (very far) the best, but I allow much for

your distractions since, with these devils the printers—and your finances, and other matters, not in unison with that patient toil, which ought always to govern the habits of us both—but more perhaps yours.

I want proofs of the Water Mill printed as I have not seen it in its present state. I may be as disappointed with *it* as with the Summerland.

Do not neglect the Wood, as I am almost in want of the picture.

Bring me another large Castle or two or three, for it is mighty fine—though it looks as if all the chimney sweepers in Christendom had been at work on it, & thrown their soot bags up in the air. Yet every body likes it—but I should recollect that none but the elect see my things—I have no doubt the world despises them.

Come early tomorrow evening, and bring what you can—& an account of the state of the next—I am nervous, & anxious about them.

I have made the upright windmill quite perfect.

I should like the book to consist of eight. Pray tell the "writer" not to compleat his sketch of the title—I have made another.

Yours truly
John Constable

From the correspondence and from dated proofs we discover that ten plates had been started by this time, the *Windmill near Brighton* (Pl. 33), *Helmingham Dell* (Pl. 8), *Dedham Mill* (Pl. 17), *A Summerland* (Pl. 15), *Summer Evening*

(Pl. 7), *Stoke-by-Nayland* (Pl. 11), *Autumnal Sunset* (Pl. 3), *Old Sarum* (Pl. 14), *Vignette: Hampstead Heath* (Mezzotint No. 22), and *Spring: East Bergholt Common* (Pl. 2). He was unhappy with *Summer Evening* on 15 September 1829, as we have seen, and discounted *A Summerland* in the letter quoted. Although he had enough plates to happily supply the intended eight, he was still dissatisfied and set Lucas to work engraving *Weymouth Bay* (Pl. 18) for inclusion in Part 1, no doubt so that he would have a marine subject for variety. This must have been a rushed job, for on 7 April he told William Carpenter that 'the first number of my work is almost ready, and it would afford me great pleasure to present you with it, and the following numbers as they are due.' It seems from this that Constable already intended going beyond the eight, since he talked of following *numbers*, but three weeks later, on 30 April, he suffered one of his first bouts of despondency about the project: 'I am now fairly sick of the concerne and, as they have been the first, I devoutly hope they will be the last, plates I shall ever see done from my own works under my own eye.' On 24 May, however, he was on the threshold of publication and wrote to tell Fisher: 'My little book — entitled, "Various subjects of Landscape, characteristic of English Scenery" — is forth coming in Numbers — No. 1, next week — it will consist of 4 prints in each, & promises well. Should it pay I shall continue it.' As it turned out he continued regardless.

He was no doubt encouraged to do so by the kind review published in *The Athenaeum* on 26 June 1830:

Various Subjects of Landscape, characteristic of English Scenery. From pictures painted by John Constable, R.A. Engraved by David Lucas. Colnaghi.

This little work will be published in about a week or ten days, and we have been gratified with the sight of the four plates of which the first number will consist. The subjects are more varied than we could have expected to find in a work taken wholly from the productions of Mr. Constable; who appears to have fed his genius, like a tethered horse within a small circle in the homestead. The village river with its lock—the water-mill, with its rude deep shades and solitary wheel— the old decaying trees, and country lanes stealing down by the upland corn:—these have been within eye and heart-reach of Mr. Constable's home; and these were to him 'riches fineless'.

The four plates are, 'A Dell, in Helmingham Park, Suffolk', 'Weymouth Bay, Dorsetshire', 'A Mill' and 'Spring'. The painter's object, which has evidently been to give the varied effects of *chiaroscuro*, has been well seconded by the engraver. 'The Dell' is one of those deep nooks, in which sadness communes with shadows, and which seems made for the painter. The shades are solemn as night; and between the tortuous sombre trees, you get at the garish light of day. 'The Mill' is a natural piece of Suffolk flat, made beautiful by the just management of light

and shade. And 'Spring' is an open living landscape, with corn-mill turning its dark sails against the light, flurried, cloudy sky, with birds winging about over the head of the plough-man, and everything speaking of country life 'preparing to start'. To the admirer—but that is a cold word—to the lover of nature, these, which are faithful miniatures of his mistress, will be treasures indeed . . .

Constable seems to have been emboldened enough to increase his original printing order for Part 1 from 224 prints from each plate, 12 each unlettered on French and India paper, plus 100 lettered on each, to 374, taking an additional 100 lettered impressions on French paper, plus 50 'prints' on ordinary English paper. His first prospectus set the prices at 2 guineas for a set of four India proofs, 1½ guineas for a set of French proofs, and 1 guinea for a set of ordinary prints. With 100 sets of the first, 200 of the second and 50 of the last, he stood to make 550 guineas if he sold them all. Since he had sunk about £250 into the project already, unless the project was an immediate success it would be some time before he showed a profit. Constable was not very successful at marketing his work at the best of times. In this case, we hear of no subscribers at all, and in the event, most of the sets he parted with were given away.

After publication of Part 1, Constable had seven plates left from which to select four for Part 2. This was not enough and *A Sea Beach* (Pl. 10) was added, again to provide a marine subject, and *West End Fields, Hampstead: Noon*

(Pl. 4), no doubt to provide some relief from Suffolk subjects, three of which had already appeared in Part 1. On 4 October 1830, even though Part 2 had not yet appeared, Constable told Leslie that he was making arrangements for a third number, and by November the project had expanded to six numbers each with four prints 'which with a title and vignette will make 26 *prints*'. The concept had not only grown in terms of size, but also in terms of its subjects. Whereas many of the paintings selected so far had been sketches or studies, and mostly small in size, a number of large exhibited pictures were now proposed. In an undated letter of about this time we find *View on the Stour* (Pl. 16) proposed for Part 3, together with *Yarmouth Jetty* (Pl. 5), *The Glebe Farm* (Pl. 20), *Flatford Mill* (Pl. 27), *Hampstead Heath* (Pl. 9), *The White Horse* (Pl. 34), and *Hadleigh Castle* (Pl. 21) which last had been considered from the start. The late autumn of 1830 seems to have been the most crucial period in the development of the series as a whole. During it, Constable looked for a successful permutation of subject types: historical, marine, Stour valley, pastoral, grand, lyrical and sketches. He tried combination after combination over the following two years to find some way of adequately representing his full range and achievement. His ambitions were running high, but Part 2 was still at the printers. The first copy was sent out on 29 December, and on 5 January 1831, sending a free copy to Carpenter, he began to wonder about promotion: 'I send you another number — the second — which I hope you will like! Perhaps it will soon be time that I should advertize my work which

has not yet been done, and we have another number in some forwardness.'

The *Spectator* review of 26 February 1831 did not help:

FINE ARTS
Mr. Constable's Landscapes.

'John, bring me my umbrella—I'm going to see Mr. Constable's picture', said old Fuseli to his servant; and the sarcasm was complimentary; for, if Mr. Constable delights to paint Nature in her moist aspects, he always represents her truly, and looking beautiful through her tears. But it is the extreme freshness of his colouring that gives that cool and moist tone to his landscapes; and although we protest against his handling, as we do against Mr. Turner's 'yellow fever' we nevertheless admire his vivid force and truth, as we do the poetry of the latter, in spite of these idiosyncracies of manner, which detract from the reputation of the artists, as well as from the value of their pictures.

We have before us the two first numbers of a series of mezzotint engravings by David Lucas, from pictures by Mr. Constable, of landscape characteristic of English scenery. They have two great and prevailing faults—extreme blackness and coarseness: their rough execution we do not so much object to, as it appears to imitate the style of painting in the originals; but the shadows are sooty. These hasty mezzotinto scrapings, however, display great feeling, and a knowledge of Mr. Constable's peculiar effects; and contain some strikingly natural and

simple compositions—genuine bits of nature, rendered more beautiful by art. We fear, however, that the manner of their execution will prevent their due appreciation by the multitude.

Though the reviewer himself seems to have quite liked Constable's work, and to have admired aspects of the mezzotints, his phrase 'hasty mezzotinto scrapings' is horribly memorable. Constable, from the apparent lack of interest in his first prospectus, had his own proof of the appreciation of 'the multitude'. On 12 March 1830 his worries boiled over:

March 12, 1831.

Dear Lucas

My indisposition sadly worries me and makes me think (perhaps too darkly) on almost every subject—nevertheless, my "seven infants", my *time of life*, and state of health, and other serious matters, make me desirous of lightening my mind as much as possible of unnecessary oppression—as I fear it is already overweighted.

I have thought much on my book, and all my reflections on the subject go to oppress me—*its duration, its expence, its hopelessness of remuneration*, all are unfavorable—added to which I now discover that the printsellers "are watching it as their lawfull prey", and they alone could help me: for "I cannot dig, & to beg I am ashamed". I can only dispose of it by giving it away. My plan is to make the whole number of plates now in hand only to form the book, for which I see we have about twenty. The three present numbers make 12—others begun are about

eight or ten more, some of which may not be resumed—& we must begin the frontispeice.

I am led to conclude of this definition of our book—finding that it greivously harrasses my days, and disturbs my rest of nights. The expence is too enormous for a work that has nothing but your beautifull feeling and execution to recommend it—the painter himself is totally unpopular and ever will be, on this side of the grave certainly—the subjects nothing, but "*The Arts*," and "buyers" are totally ignorant of that. I am harrassed by the lengthened prospect of its duration—which seems quite undefined. Therefore I am come to my first plan, of *twenty*, including frontispeice & vignette—& we can now see our way out of the wood. I can bear this perhaps—because I then know the worst. I can bear the irritation of delay (from which I have suffered so much that I attribute my present illness to it in part) no longer. Consider, not a real fortnight's work has been done towards the whole in the last four months—years upon years must roll to produce the 26 prints—& all this time I shall not sell a copy, but must stand ready to part with every *fifty* or *hundred* pounds of my ready money—till it comes to £1000.

Remember dear Lucas that I mean not to think one reflection on you—every *thing* with the *plan* is my own—and I want to releive my mind of that which now harrasses it like a disease—& looking forward as I now do I think of it with delight as an occupation, though utterly hopeless in its result. Do not for a moment think I blame

you—or that I do not sympathize with you in those lamentable causes of hindrance which have afflicted your house. Nobody will do me any good—even that man who thinks he is sure of going to heaven by dipping his arse under water—I mean Mr. White of Brownlow Street—offers to propagate & guarantee the money for Turner and his liber stupidorum for 15 *per cent*, & will not do the same for me under 35 *per cent*. Therefore let us protect ourselves, by drawing the circle a little closer—& compleat & that as rapidly as possible whatever is began, be these what they are. We have no really bad subjects amongst them, at least one is as good as another of them, & let us get them out of hand—the sooner the better.

Pray let me see you soon. I am not wholly unable to work, thank God. I hope poor Mrs. Lucas is better. Dr. Davis has been to see me & my poor boy John, who is very ill, Mr. Drew giving me medecine & pills—so that both of their medecines (which I take together) may get me well at double quick time.

Yours truly
John Constable

Despite a letter of encouragement from Sir Francis Chantrey on 22 March saying that the only fault with the engravings was that they were too few in number, even more serious problems were beginning to emerge. Constable had become almost addicted to correcting and improving the plates, and though the many touched proofs and different states that resulted provide a feast for collectors, the corrections themselves were not always to the

advantage of the plates. On 24 March 1831 the engraving of *Hampstead Heath* (Pl. 9) became the first casualty of this obsession: 'I have no wish to see the Heath — unless indeed I could see it as it was two months ago — I have touched and retouched, and trifled away, all the fine sentiment you once had in it, & it now gives me no pleasure in comparison.' Such was his despair that he 'formed a serious resolution to make the work consist of 3 numbers only, adding a title & vignette. The work worries me greatly. It was indeed thought of "in evil hour".' Fortunately this was not the first or last 'serious resolution' that he broke. On 15 July, however, he decided to prune the project down from six parts to five, plus the title and vignette, and this did indeed form the final plan of the work. The third part was issued in September 1831, a full two years after it was begun.

Constable now had more than enough plates to fill the two remaining parts, and completing 'English Landscape' should at this point have been quite a simple matter. The fourth part came out in November, and Lucas might have confidently expected that the fifth would follow quickly. At this stage Constable managed to turn the home-straight into a nightmare. On 4 December he wrote to Lucas:

Dear Lucas

Perhaps you had better send the picture of the *Glebe Farm* to Charlotte Street, where I will if possible try to look it over with your last proof—*hopeless* as it *now is* & I know *ever must be.*

How could you dear Lucas think of touching it after bringing me *such a proof* &

without consulting me—had I dreamt of such a thing I should not have slept—besides I wanted at least *a dozen* of it in that state.

I know very well it can be *blotched* up, with *dry point burr*, regrounding, &c, &c, but that is hatefull.

But I will say no more on so painfull a subject, for I wish you not to be vexed. It will retard the work—but we must not mind.

I am now writing with the *two proofs* before me and I frankly tell you I could burst into tears—never was there such a *wreck*. Do not touch the plate again on any account—it is not worth while.

But lose no time in grounding another, for I will not lose so interesting a subject. It would have saved the 5th number, & was it *now* in its first state, I would rejoice to publish it just so.

As to the London—it will do very well for the Londoners, & I should not have published it in the work had it not sufficed—but that plate is still safe. What caused you to *scrape off* the tree I do not know—*that dark* was most essential there.

I could cry for my poor wretched wreck of the Glebe Farm—a name that once cheered me in progress—now become painfull to the last degree.

As the subject of the Glebe Farm is now lost, I have thoughts of substituting two new ones—the *Old House & Ford with a Waggon,* & the *Hadleigh Castle*—but that we will arrange on Tuesday.

I could cry at this sad change—& that too with the *bird* once in my hand. I know very

well what you will say—that it can soon be brought about. *I* know better—our "blasted Heath" proves what can be done only, in that way.

My opinion cannot change—my experience is now too great. If we keep the G.F. in the book, *ground a new plate instanter.* This is my dear boy's birthday—this day 14 years ago gave me my *first child*—we have had a party, & a feast—but my joy is utterly alloyed by the wreck of my poor Glebe Farm—which has not quitted my sight all day, though stretched & locked up in a drawer.

I attend a Council tomorrow & leave Charlotte Street at seven o'clock. Pitt will take any pictures out of your way as he has 'knot & board'. Do not attempt to say you can bring this Glebe Farm about. You may do as you like with it—but *not* with my assistance—that is impossible. It is *far, far,* out of my reach.

I greive for the loss of time—but we have now two plates to begin—and that quickly. Do not be abashed, or think I mean to vex you—I mean no nonsense of any kind—I mean only to perfect the work and not to distress you or myself.

You will judge on Tuesday, of what two subjects will be next chosen. How could you *touch* the dear Glebe Farm—& not even tell tell me of what you were doing. I wish I could get at that old villain in Pall Mall—I would send him to the Devil before his time.

Ever truly yours J. Constable.
Give Pitt the Glebe Farm picture.
Yours J.C.

Nov. 4 [sic.]

Sunday Evening.

I come to Charlotte Street tomorrow afternoon to attend the Council.

God knows how I shall now proceed—& when will my work end. Besides it returns me nothing & takes away all my ready money—& these terrible failures take away all the profit, that ever can come. But like all travellers in an unknown land we have proceeded too far to return—& we must proceed at all events. 'Tis true we ought to calculate on failures—this I know—but the last failure is with the cup at the lip—the bird I calculated was already netted.

But be assured, dear Lucas, the plate of the G.F. is utterly utterly aborted. It is & must ever be of that nature (do what you will), that it is *all*—*all*—that I have wished to avoid in the whole nature of the work. The book is made by me to avoid all that is to be found there—a total absence of breadth, richness, tone, chiaroscuro—& substituting soot, black fog, smoke, crackle, prickly rubble, scratches, edginess, want of keeping, & an intolerable & restless irritation.

J.C.

Dear Lucas—do not be abashed—but I should not sleep, if I did not releive my mind of this distressing failure. I saw all I now say the moment you unrolled the pacquet last night—certainly, & you saw I did so.

The phrase 'intolerable & restless irritation' probably describes the cause more accurately than the effect of the overworked plates.

Though Lucas had meddled with the plate, Constable was unfair to blame the engraver for his own failure to derive any pleasure from the result. The fact is that the more Constable became separated from his subject, the less pleasure he derived from any of his work, and the more he looked for it, the more anxious he became until anxiety brought on overwork, and overwork led to a disappointing result.

On 28 February 1832 Constable perpetrated the same mischief on the plate of *Salisbury* (Pl. 35). 'I really consider the state of the Salisbury plate,' he wrote, 'is so *utterly* hopeless that I have come to the determination to abandon it —& substitute the New Sarum of which you have a plate ready grounded in its place. As I told Alfred, this will throw us back again — but as we do not *advance* that is not very material. Consider — we are not one whit forwarder with our 5th number than we were in the middle of last November. Both the "Salisbury" and the "Glebe Farm", on looking at the proofs, I find to be in a *far* very *far* preferable state than they are at present — nay, were then more than fit for publication. The Glebe Farm, I compounded for with many regrets — but the Salisbury I never can nor never will!!' Constable managed to drive himself to the point almost of despair and on 27 April he told Lucas: 'I am greivously anxious about this affair altogether. I feel I have too many ties in life to be happy — I often wish I had the wings of a dove — & then would I flee away.' His depression drove him to abuse. Just over a week later he lashed Lucas unfairly: 'Your art may have resources of which I know nothing — but so deplorably deficient in all feeling is the

present state of the plate [of *Hadleigh Castle*, (Pl. 21)] that I can suggest nothing at all — to me it is *utterly, utterly hopeless*.' He was lucky to find an engraver with so much respect and patience for his employer. It is difficult to imagine many other engravers standing for this sort of treatment. Lucas, however, needed Constable as much as Constable needed him, and it has been rightly observed that Lucas's work tailed off dramatically after Constable's death. Indeed, the relationship seems to have taken these trials in its stride.

Even after the difficulties with the prints were overcome, there was one final matter to settle before the fifth part could be issued — the writing of an introduction. Constable had put this in hand by 28 March 1832, when he told Lucas that a Brighton friend, Henry Phillips, was drafting one 'which as far as it goes I do not like at all. Still I let him do it.' Adding ominously, 'I can overhaul it.' After the Academy exhibition had opened in May he found the time to sit down and compose one of his own. He was as fussy in tinkering with it as he was with his engravings — as three successive, corrected drafts in his handwriting testify. The last draft is dated 28 May, but further corrections were necessary at proofing stage. The first paragraph expressed his relief that the ordeal was finally over: 'The present collection of English Landscape, after much pains and considerable expence bestowed upon it, is at length completed, and is offered to the notice of the Public; not without anxiety as to the kind of reception it may meet with. The very favourable opinion, however, passed upon it while in progress, by professional and other

intelligent friends, at the same time that it has encouraged its publication, has also served to lessen that anxiety in no small degree.' When Constable revised and expanded the introduction the next year this paragraph was, perhaps wisely, dropped. One of the most revealing passages he wrote, however, never found its way into print. In a draft letter to Fisher he paid tribute to Lucas: 'His great urbanity and integrity are only equalled by his skill as an engraver; and the scenes now transmitted by his hand are such as I have ever preferred. For the most part, they are those with which I have the strongest associations — those of my earliest years, when "in the cheerful morn of life, I looked to nature with increasing joy".' The search for joy in these engravings had been far from easy, but most of the subjects selected for 'English Landscape' were those that recorded it most clearly. For Constable, the series was a survey of some of the most positive and optimistic moments in his life. The fifth and final part was issued in July 1832.

Constable was not one to leave a project so easily. He had, after all, hardly sold a single part, and so the next step was to sort the prints into bound editions. Since he had a number of unused plates he considered an appendix, and revised the order several times after this. He also took every opportunity to make further improvements to the plates he could find. He was not, however, unaware of his faults and was quite capable of finding his actions comical. On 7 October 1832 he devised a particularly appropriate alteration to the spoiled plate of *The Glebe Farm* (Pl. 20): 'I have added a "Ruin" [Mezzotint No. 20A], to the little

Glebe Farm — for, *not* to have a symbol in the book of myself, and of the "Work" which I have projected, would be missing the opportunity.' On 20 November he was still enjoying the joke: 'Pray bring me some sort of a proof of my Ruin that I may contemplate my fate — God help us, for no doubt our mutual ruin is at hand.' Constable's estimate of £1000 as the total expense on 12 March 1831 may not have been far from the truth. So far, eighteen months later, he had hardly recouped any of it. On 23 March 1833 he reduced the price to five guineas for a complete book of 22 prints. The *Literary Gazette* published a review of the book on 18 May 1833, quoting from Constable's introduction on the matter of an original artist's style being of necessity an impediment to the public's appreciation, which seemed to underline the theme taken by *The Spectator* that the prints would not be popular with the public. Once again S.W. Reynolds came to Constable's aid in *The Athenaeum* of 1 June 1833:

FINE ARTS

Constable's Landscapes.

How quickly time passes, this work has made us sensible of. We remember to have announced the first and forthcoming Number; and on reference to the pages of the Athenaeum, it appears to have been three years ago! Three years then we have been labouring in this vocation,—and let us hope, not without rendering some service to literature. All lovers of natural landscape know and admire Mr. Constable's works:

they are all distinguished by poetic feeling, and by a deep sense of the beauties of wood and stream, hill and dale, the shaggy mountain and the stormy sea. They are all essentially English, and wholly original; no school, save that of Nature, claims any share in his inspiration. Much as we admire him, we have not remained ignorant of the faults which critics and connoisseurs impute to him. Fuseli, we know, called his landscape wintry. It is because Constable resembles no other painter that men who can judge only by precedent dislike his colouring; compare him with nature—the true test—and he is safe; he is an original, and must be looked on as such; it is because he neither resembles Claude nor Calcott that we like him; and, like all originals, he has less to fear from future ages than from the present. The publication before us will go far to dispel prejudice; his colours are not in the way of his fame here. Lucas has engraved his pictures with much effect and feeling. None of these are landscapes of the fancy: some scenes are half real and half imaginary; but the greater number are transcripts of spots remarkable for picturesque beauty. They all wear the hue and aspect of Old England: 'Morning', 'Noon', and 'Evening', together with 'Summerland', are exquisite things: 'Hampstead Heath' will induce us, even in these burning days, to visit the spot. But 'the Glebe House', 'The Mill Stream' and 'Head of a Lock on the Stour', are, we think, surpassed by nothing in art. Nor do we look with other eyes than those of reverence on the 'The Birthplace of the Artist' himself—it

is (like that of Gainsborough) in Suffolk, and a very lovely spot.

The reviews had little effect. Constable tried to enliven the prints by adding letterpress to each plate, hoping that 'Many can read print & cannot read mezzotint', but the project was not carried through to its conclusion. On 15 December 1834 in a fit of anger with Lucas he revealed exactly what a 'great and irretreivable loss I have sustained ... I mean by my loss, my unfortunate book — a dead loss of at least £600 — besides full a hundred at Sparrow's [the printer], in consequence of it'. By 30 July 1835 he had, privately, further reduced the price of the book to £3, although according to an 1835 letter the price was '2½ guineas for prints, 3½ for Proofs, 5½ for India proofs; individual parts being 12 shillings, 15 shillings and £1.5.0 respectively'. He considered selling the whole lot, 'stock and stone', to a Paris dealer for £500, but in the event nothing was done. After Constable's death in 1837 Lucas issued six of the unpublished plates with the *Ruin* at their head as an appendix in 1838. Eventually the artist's children agreed with James Carpenter in 1843 that he should receive 186 of the unsold sets, with which to illustrate the first edition of Leslie's *Life of Constable*, in return for thirty copies of the book when it was published in that year. Paying in kind, not cash, had been a favourite ploy in Carpenter's dealings with their father. It is estimated that Constable must have had well over two hundred sets left on his hands at his death, which, since he gave away dozens, means that he had hardly sold any. Finally, in 1846, Lucas issued a second series of prints after Constable, 'calculated from their

size to form a continuation of the series engraved by Mr. Lucas during the lifetime of Mr. Constable and [which] may therefore be so made use of by all who possess that series'. The new series was published in 1846 under the title of 'English Landscape, or Mr. David Lucas's New Series of Engravings'. If Lucas was hoping to sell to those who possessed the original set, he cannot have been expecting to sell very many.

Though few more pathetic commercial ventures will be found in the history of art, the series was a considerable artistic achievement, and the liaison between artist and engraver remarkable in its closeness. Mezzotint, however, does not appeal easily to the modern taste. The 'English Landscape' prints seem at first sight irritatingly soft and fuzzy, as if there is something disconcertingly wrong with our ability to focus. In the letterpress to Old Sarum (Pl. 14) Constable quoted a passage which seems to describe fairly accurately the effect of many of his plates: 'flinging half an image on the straining sight'. It is not for want of work, as we have seen, that the plates remain indistinct, nor for any inherent incapacity in the medium, which with judicious use of the burin can convey as much detail as required (as indeed many of these plates do). Nor was specific detail always lacking in the first place. It is mostly that they need time to work, not an endearing quality in an age where images have to be immediate, easy and disposable, as the audience rushes from one bright medium to another, past a hundred paintings in an hour before pressing on to the next gallery. Note the effect, for example, on our reaction to the

Frontispiece (Mezzotint No. 1), of Constable's instructions to Lucas: 'Before you print the frontispiece, pray drypoint down the light on the bank on which the man sits — it is too bare, from the man to the right hand edge of the picture. Also a line or two on the water over the lightest part, as it is too bare — a very little will do it. The dog's snout must be tipped with a light touch ... The light by the man drawing to which I object is [near] the sunshine over the pales — it is a grand thing.' The degree of thought and knowledge, the precision of the direction of light, the length of shadow cast by the fence, the fact that we see only a thin ribbon of light created by the sun slanting in under the low boughs of the trees, denotes extraordinary familiarity with nature, and provides us with increasingly rich rewards the closer we care to look. In terms of our modern expectations there may be only 'half an image on the straining sight', but once we adjust to the search we find that this is a virtue. It is crucial to our understanding of Constable that we are first prepared to invest the necessary time in looking at the images and that we are ready to recognise something in them for ourselves. Although Constable's art was often a means of realising his own memories, perhaps the greatest part of his achievement was the capacity of his images to reflect our own memories and impressions of the English landscape. This is sometimes strongest in those very images which are half-defined, for they are suggestive enough to force our imaginations into play. Thus we may find our world reflected in Constable's pictures and our memories coloured by his sensibility.

THE LANDSCAPES

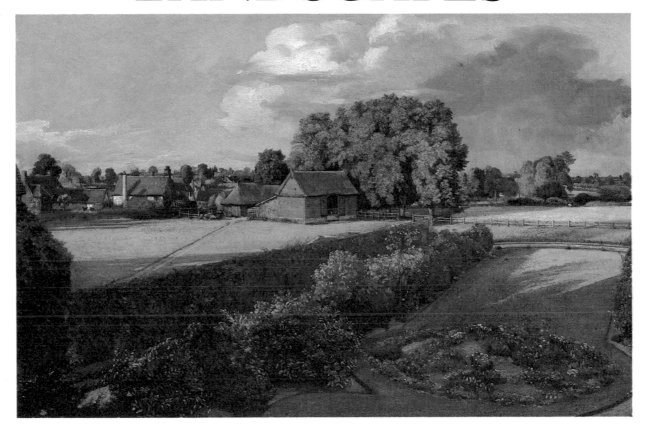

ILL. 1
Golding Constables's Flower Garden, 1815.

Painted in the evening from a back window of Constable's home at East Bergholt. The same clump of trees can be seen from the other side in the view of the house from the lane (Pl. 1). There is a companion view to this of the kitchen garden which continues the view to the right. To judge from the light in each, Constable worked on the *Kitchen Garden* in the mornings and on the *Flower Garden* in the evenings.

33

CONSTABLE'S LANDSCAPES would prove hard to find if his picture titles were our only guide. He could hardly have provided less information about his first exhibit at the Royal Academy in 1802, *A Landscape*, and the following year saw two more 'Landscapes', together with two 'Studies from Nature'. In 1805 he managed his most elaborate literary composition so far, *A Landscape: Moonlight*. What these pictures were and what part of the world they showed, if any, still provides material for conjecture. In 1807, however, he had a trio of paintings to exhibit, the subjects of which he evidently felt confident enough to reveal, a *View in Westmoreland*, *Keswick Lake* and *Bow Fell, Cumberland*. He had made an expedition to the north of England in 1806 (see Ill. 2) and this provided him with enough Lakeland material to exhibit identified subjects for the next two years. After that he reverted to his old ways and except for pictures of well-known places such as Hampstead, Salisbury, Weymouth, Brighton and a few gentlemen's seats, the majority of his exhibits consisted of unidentified landscapes, cottages, mills, and navigable rivers, punctuated by the occasional reference to the time of day or year, activity shown or prevailing weather conditions.

Despite Constable's efforts to the contrary we may be sure that of his one hundred and four Academy exhibits about half were Stour valley subjects. At the beginning of the nineteenth century the River Stour was a little-known waterway in a little-known corner of southern East Anglia. When discussing Stratford Bridge, one of Constable's favourite subjects, all that Daniel Defoe could find to say about it in 1722 was that 150,000 turkeys had been driven over it in a single season. Suffolk's famous eighteenth-century son, Thomas Gainsborough, had been born on the Stour at Sudbury about ten miles upstream from Stratford and had worked at Ipswich about ten miles to the north, but nevertheless had ignored Constable's part of the valley.

Constable's reticence as regards his subject-matter is understandable. To an audience used to pictures of Rome, the Cascades of Tivoli and the Val d'Aosta, or at the very least the mountains of North Wales and the Lake District, Constable's celebrations of East Bergholt and Flatford Mill were likely to seem at best parochial, at worst meaningless and obscure. Even *Dedham Vale* (Pl. 42), one of his most important Suffolk landscapes, was

exhibited at the Royal Academy in 1828 under the title merely of 'Landscape'. He seems to have thought the area worth promoting five years later, for when he exhibited the same picture at the British Institution in 1933 he did so with a title giving elaborate directions as to where in the world the subject might be found: 'The Stour Valley, which divided the Counties of Suffolk and Essex; Dedham and Harwich Water in the distance'. Constable's country remained unknown because it had little to recommend it to the seeker of Romantic scenery. It could boast no precipitous heights, no foaming cataracts, no mist-shrouded clifftop castles, no abbey ruins in wooded dales. It offered instead a navigable river, a few windmills and watermills, stretches of meadow and

ILL. 2
Saddleback and part of Skiddaw, 21 September 1806. Constable's tour to the Lake District was the last of his picturesque tours. Thereafter he preferred to travel only to visit his friends or family and to paint the places with which he was thus personally associated. He spent September and October 1806 in the Lakes and made more than 70 sketches. The season provided him with some impressive effects. A note on the back of this tells us that it was made on '*21 Sep. 1806 Stormy Day noon*'.

farmland, five churches and buildings made picturesque by their advanced state of decay. Nevertheless the village of East Bergholt with its straggling street of cottages, some larger houses, a mill at the end of a narrow lane, and a half-built church was Constable's birthright, and out of this unpromising material he made pictures, reproductions of which are now found in almost every home in Britain.

The Stour valley was known in some circles. In 1795 Arthur Young the well-known agriculturalist noticed that '... one of the finest views to be seen in Suffolk, is from the hills above Bardfield [i.e. Bergholt] ... where Dedham is seen in the vale'. And in the world of art, the mother of Sir George Beaumont Bt, the leading connoisseur and founder of the British Institution, lived for a time at Dedham and her son visited her and even sketched there. On one occasion he brought a Royal Academician with him, Joseph Farington, a pupil of the famous Richard Wilson. Farington is now known more for his diaries than his painting but from his entry for 15 September 1794 we learn that he was pleased with what he found:

Fine Day. After breakfast walked with Sir George, and made a sketch of Dedham Vale from the grounds above the Revd Mr Hurlocks. — afterwards went towards Langham and made sketches. We then went in the carriage to Mistley, and the village of Thorn, and crossing a Bridge returned through Bergholt and Stratford. The country about Dedham presents a rich English Landscape, the distance towards Harwich particularly beautiful.

Both Joseph Farington and Sir George Beaumont were important figures in Constable's life. The former offered an *entrée* to the London art scene when the young artist was first establishing himself in the city, and continued to give valuable information and neighbourly advice up to his death in 1821. The latter was a vital contact in the world of aristocratic patronage. He offered Constable support, advice and access to his Old Masters, and entertained him at Coleorton Hall in Derbyshire in 1823. It is worth noting that one of the first Suffolk landscapes exhibited by Constable at the Academy was probably the very same view over Dedham towards Harwich that Farington had described. It was a view that Constable returned to on many subsequent occasions. The first Stour valley subject to be identified as such in the Royal Academy catalogues was *Dedham Vale: Morning* (Ill. 3), exhibited in 1811, more or less that view described by Arthur Young. However two notices hardly amount to widespread fame, and the fact remains that Constable spent most of his life painting a landscape which few knew about and even fewer cared for, to the extent that he frequently suppressed its identity.

Constable liked to concentrate on scenery with which he was personally involved, and while this must have greatly enriched his relationship with his surroundings and his memory, it was bound to prove something of a handicap financially. He made a virtue of this in his introduction to the 'English Landscape' series: 'It originated in no mercenary views, but merely as a pleasing professional occupation'. As it turned out the returns did not even justify its claim to have been a professional project. Constable revealed his real motive in his text to the Frontispiece: '... this work was begun and pursued by the Author solely with a view to his own feelings, as well as his own notions of Art ...'. He painted, first and foremost, for his own benefit, to enrich his own view of the world.

He apologised for prefacing the 'English Landscape' plates with a picture of his own house, 'for introducing a spot to which he must naturally feel so much attached; and though to others it may be void of interest or associations, to him it is fraught with every endearing association'. Constable had been born in the large house built by his father near the church at East Bergholt, and his art was as personal as the contents of a family photograph album might be today. Even at the age of twenty-six this sense of his personal past had assumed an importance uncommon among artists of his generation. He had left his native village in 1799 to 'fag' after his career in London. A year later he was beginning to miss the world he had left: 'This fine weather almost

ILL. 3
Dedham Vale: Morning, exhibited Royal Academy 1811.
Showing the junction of Flatford Lane and Fen Bridge Lane, with Dedham to the left, Langham Church on rising ground to the left of centre and Stratford St. Mary Church to the right. Constable painted this view many times, including a sketch (Ill. 9) and two further views taken from a little further down Flatford Lane (Ill. 8 & Pl. 15). The two young oak trees seen in the field immediately to the right of Stratford Church can be recognised today, although now gnarled in appearance.

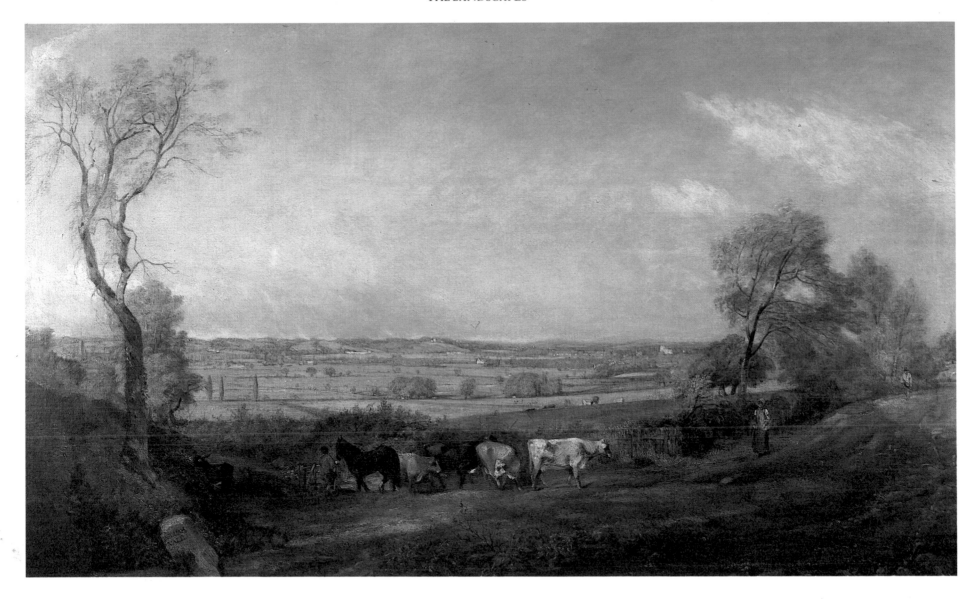

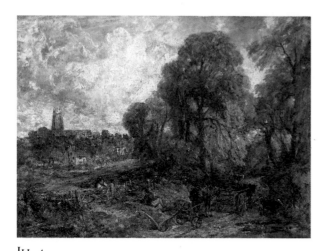

Ill. 4
Stoke-by-Nayland, 1834–7.
Stoke is four miles west of Higham. Constable used this road many times especially around 1810 when visting his Aunt Martha in Nayland. This final recollection of Stoke seen from the road to Nayland suggests that Constable's vision was lightened occasionally in his last years, showing an earlier and sunnier effect than the 'English Landscape' engraving of the same subject.

Ill. 5
The Valley of the Stour, c.1805.
The view towards Dedham with Harwich water beyond taken from above Stratford Bridge. Between 1800 and 1828 he sketched or painted this view no less than twenty times. A helicopter is the only means of surveying the scene today, for the foreground is choked by a dense growth of trees.

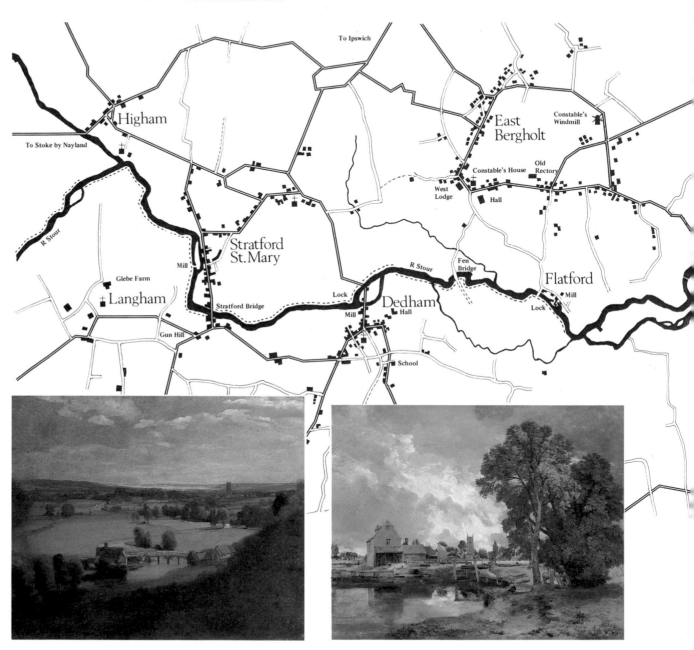

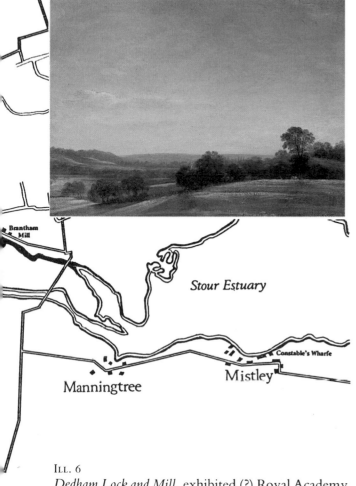

Dedham Vale: Evening, July 1802.
Taken from the gardens of West Lodge (now called 'Stour') immediately opposite Constable's home at East Bergholt. Mrs. Roberts's gardens provided an ideal spot from which to survey evening effects over the Stour Valley. Constable included a similar *Summer Evening* view (Pl. 7) in 'English Landscape'.

makes me melancholy; it recalls so forcibly every scene we have visited and drawn together. I even love every stile and stump, and every lane in the village, so deep rooted are early impressions ...' By May 1812 Constable had settled down to pursue these early impressions steadfastly: 'I am still looking towards Suffolk where I hope to pass the greater part of the summer, as much for the sake of pursueing my favourite study as for any other account. You know I have succeeded most with my native scenes. They have always charmed me & I hope they always will — I wish not to forget early impressions. I have now distinctly marked out a path for myself, and I am desirous of pursuing it uninterruptedly.' The previous year Constable's *Dedham Vale: Morning* had been noticed by no less a person than Sir Thomas Lawrence, twice and 'with approbation'. At the time he wrote the above lines another Suffolk subject, his first of *Flatford Mill* (Ill. 16), was still hanging on the walls of the Academy, coyly described as 'A watermill'. From then on hardly a year went by without some new major celebration of the Stour valley, the size swelling to reach six feet across by 1819.

Constable's world in the Stour valley is a very small world indeed. From East Bergholt

it extends west to Stratford and south to Flatford, Dedham and Langham. This is an area of little more than three square miles, yet it contained the sites of literally hundreds of sketches, drawings and paintings. Most of the important sites can be visited in a few hours' walk from East Bergholt, following the various routes he took from his father's house. He went to school at Dedham and would walk there from home turning right into Flatford Lane by the church, passing the Old Hall on the left, before turning right down Fen Bridge Lane. The junction here provided the subject of many pictures, the *Dedham Vale: Morning* of 1811 among them. Fen Bridge Lane itself is thought to have provided the basis of *The Cornfield* (Pl. 38) and Fen Bridge itself, together with most of his route to school, can be traced in the *View of Dedham* painted in 1814 (Ill. 8), taken from a viewpoint about two hundred yards further down Flatford Lane towards the Mill, the same site providing the viewpoint of *Landscape: A Ploughing Scene in Suffolk (A Summerland)* (Pl. 15) continuing the same panorama around to the right. As an example of how personally involved Constable was with the landscape he painted, he wrote to his village friend John Dunthorne about the subject of the last: 'I dread these fields falling into Coleman's hands as I think he will clear them a good deal and cut the trees — but we cannot help these things.'

Constable's interest in these subjects was also financial; part of his income was derived from them. His father had an interest in the mill at Dedham, and this provided the subject of another famous painting (Ill. 6). His father's

ILL. 6
Dedham Lock and Mill, exhibited (?) Royal Academy 1818.
Dedham Mill was the largest of those operated by Golding Constable and the artist worked in it as a boy. The view is taken from the north bank of the river looking towards Dedham Church. A barge is negotiating the lock on its way downstream to Flatford. Constable included a sketch of the mill from the left in the 'English Landscape' series (Pl. 17).

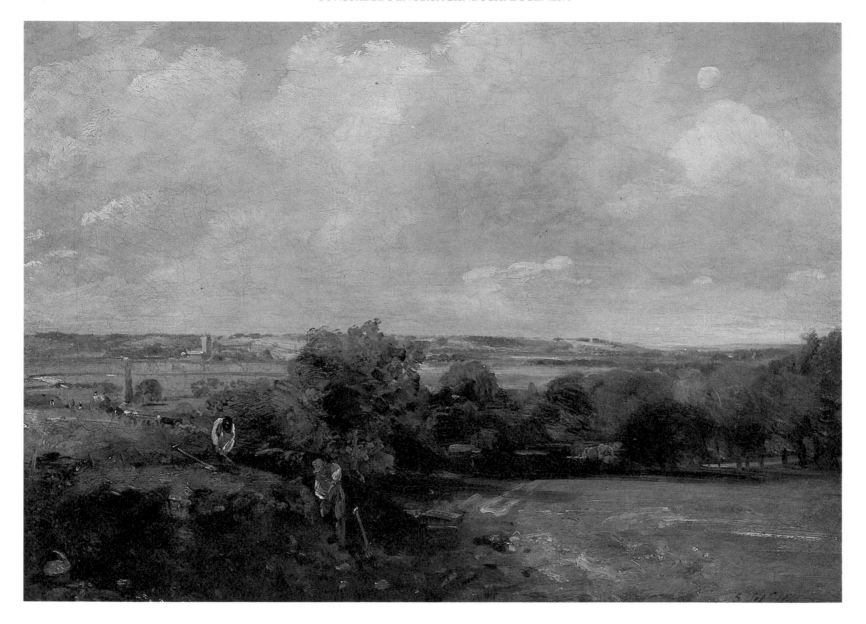

ILL. 8*(Opposite)*
Stour Valley and Dedham Village, 5 September 1814.
Taken from Flatford Lane, about 150 yards beyond the
junction with Fen Bridge Lane, looking towards Đedham
Village and Fen Bridge on the left, and Langham on the
right. The viewpoint is very near that of *Landscape:
Ploughing Scene in Suffolk (A Summerland)* (Pl. 15) which
shows the field to the left the previous year.

ILL. 9
Dedham Vale, c. 1809.
A sketch of the view worked up for exhibition in 1811
(Ill. 3).

ILL. 10
A Village Fair at East Bergholt, July 1811.
An annual fair was held in the street between the
Constables' house and West Lodge at the end of July.
This view is taken from a first-floor window looking
across the busy scene to West Lodge, which can seen at
the left.

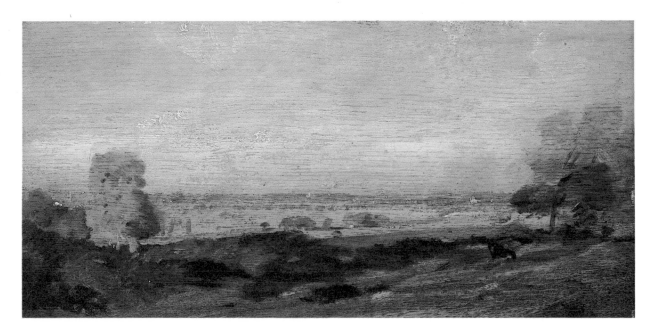

windmill on the common at East Bergholt pro-
vided another subject for the 'English Land-
scape' (Pl. 2), and could be seen from the
windows of the family home. From Bergholt
he could also have walked towards Stratford,
down the lane past the present post office,
passing the small cottage on the left which he
owned and used as a studio until 1816. After a
hundred and fifty yards or so the road dips to
Vale Farm, and at the top of the dip a view
opens up westwards to Stratford St. Mary
Church, an ideal place from which to survey
the setting of the sun, and the viewpoint of the
'English Landscape' plate *Autumnal Sunset*
(Pl. 3) showing rooks making their way back
to the rookery by the church, inhabited by
their descendants to this day. From here a foot-

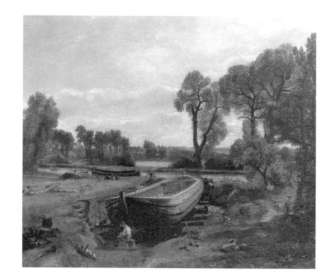

ILL. 11
Boat Building, 1815.
A view of the boat dock at Flatford, with the lock to the left and the same trees as seen in *Flatford Mill from the Bridge* (Ill. 12) to the right.

path leads across the fields to Stratford and the site of the old paper mill painted by Constable (Pl. 41) and thence by a bridge and a green lane to the Glebe Farm and Langham Church (Pl. 20). From here he could turn back towards Dedham and follow the lane to Gun Hill, the site of many of his famous views over Dedham towards Harwich. These views are now almost totally obscured by trees, though Dedham Church still presents a striking feature from the road down to Stratford Bridge, especially in the evening when glimpsed over the trees bathed in evening sunlight. From here it is but a short walk into Dedham village and thence along the riverbank to Flatford, or across the

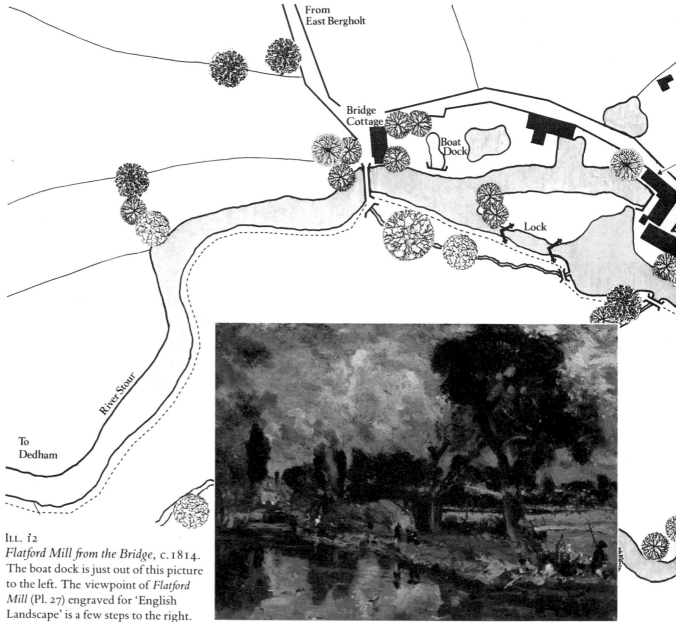

ILL. 12
Flatford Mill from the Bridge, c.1814.
The boat dock is just out of this picture to the left. The viewpoint of *Flatford Mill* (Pl. 27) engraved for 'English Landscape' is a few steps to the right.

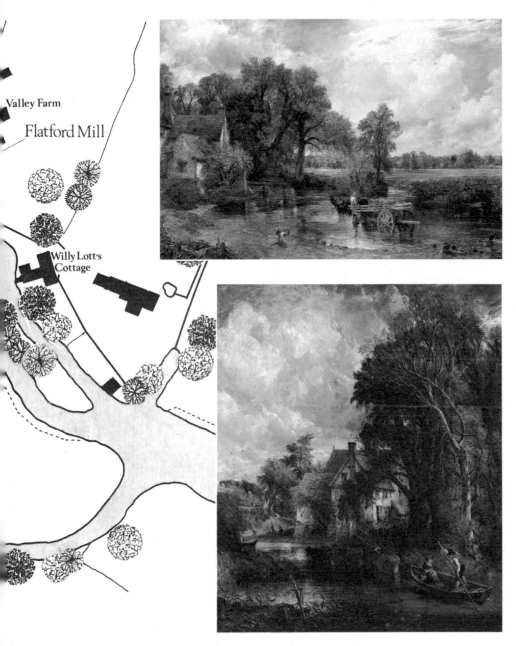

ILL. 13
The Hay Wain, exhibited Royal Academy 1821. Constable's most famous Flatford subject, looking across the tail-race of the mill to Willy Lott's house.

ILL. 14
The Valley Farm, exhibited Royal Academy 1835. Constable's last picture of Willy Lott's cottage, taken from the south bank of the river looking through the ferry cut seen beyond the cart in *The Hay Wain*. In this rather over-wrought and overworked scene, painted at the end of Constable's life, the river seems to have taken on the character of the Styx rather than of the Stour.

bridge and over the fields to East Bergholt.

Flatford Mill had been the core of Constable's father's business. Golding Constable had lived there before building his new house in the village in 1774. When Constable's younger brother Abram took over the business after Golding's death in 1816 he moved back to Flatford having agreed with his brothers and sisters that the new house in the village should be sold. For John Constable, therefore, the cluster of buildings with its miller's house of 1620 and the mill building of 1733 was of personal significance. The wheat from the fields was brought here for threshing and grinding into flour before being taken down river by barge to the Constables' wharfe at Mistley and thence by ship to London. It was also as obscure a place as a painter might possibly exhibit at the Royal Academy. In January 1821 after Abram had moved in at Flatford he wrote to his artist brother: 'We live very retir'd round here, but we reap the advantages of it in many instances, one of which is the riddance of Beggars, very few finding their way down, not being a thorofare, and another, callers, or idlers, don't interrupt, & those who really wish to come or we wish to see, can always find their way.'

Flatford offered Constable endless subjects to record: the traffic on the river, barges being poled through the bridge or negotiating the lock; Willy Lott's cottage, the home of the prosperous yeoman farmer who lived more than eighty years in it without spending more than four whole days away; the little thatched cottage by the wooded bridge; and, of course, the mill buildings themselves, recorded from every possible angle. By 1812 his attachment to

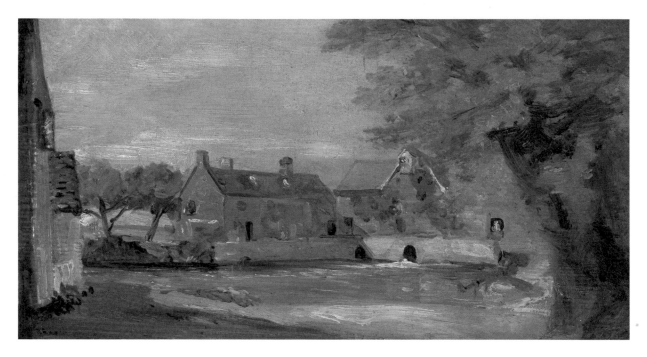

ILL. 15
Flatford Mill from Willy Lott's Cottage, c.1811.
The viewpoints of *The Mill Stream* (Pl. 12) and *The Hay Wain* (Ill. 13) can be seen in this picture, the former above the mill-race, and the latter to the right.

the subject was beginning to embarrass him, especially since he was trying to impress Maria Bicknell: 'I am sure you will laugh when I tell you I have found another very promising subject at *Flatford Mill*.' He had just exhibited his first important painting of the subject at the Academy and if his public had paid any attention it would have noticed that Constable's embarrassment had not deterred him one jot. In the next few years it would have been

possible to get to know Flatford intimately without ever going any further than Somerset House in the Strand. He followed his 1812 exhibit with pictures of Flatford Lock with the bridge and bridge cottage in 1813 (Pl. 13), Willy Lott's cottage in 1814, the boat-building dock at Flatford in 1815 (Ill. 11), a view of the whole complex from the bridge in 1817 (Pl. 27), and a horse being ferried across the river near Willy Lott's cottage in 1819 (Pl. 34). His most famous Flatford picture of all, *The Hay Wain* (Ill. 13), a view of Willy Lott's cottage from outside the mill, was on his easel being prepared for exhibition when Constable received the letter from Abram quoted above in January 1821. There was more to come: the

view looking across the head of the boat dock over the bridge towards Dedham in 1822 (Pl. 16), a view of a boat passing the lock in 1824, *The Leaping Horse* in 1825, a recollection of the Stour near Flatford, looking towards Dedham church, and *The Valley Farm* (Ill. 14), his final memory of Willy Lott's cottage in 1835. These were only the finished works, there were hundreds of pencil sketches, watercolours and oil sketches besides.

With the aid of a map, we can pick out landmarks in the paintings and relate the various views to one another. The two tall poplars which grew on the island called 'The Spong' near Willy Lott's cottage can be seen in the centre of the 1812 view from the head of the lock (Ill. 16), again to the right of *The Mill Stream* (Pl. 12), behind other trees, and again in the centre of the view from by the bridge (Pl. 27), more distant than in the 1812 painting. The trees by the towpath between the bridge and the lock can be seen from various angles in different paintings: in *Boat Building* (Ill. 11) from the opposite side of the river, in *Flatford Mill* (Pl. 27) from by the bridge, in *The Lock* (Pl. 39) from downstream to the right of the painting, and to the left of *View on the Stour* (Pl. 16), seen from the exit from the boat dock to the river. It is even possible to note that one of the trees lost one of its main branches between 1814 and 1817. In a pencil sketch made from the bridge in 1814 the nearest tree forks clearly. In another pencil sketch made from a similar viewpoint in 1817 the right-hand fork has disappeared and this amputation was accurately recorded in the 1817 painting. Such a small stretch of the world had hardly ever

been recorded so minutely by one man. So detailed is the record, in fact, that it is possible to construct a complete geography of the place from his pictures. The visitor to Flatford today will find the site much as it might be imagined. The river seems less spacious than Constable would have us believe, the trees are much changed; and a flood dyke has appeared on the tow-path side of the river, but most of the buildings (Willy Lott's cottage and the Mill, especially) are almost exactly as Constable painted them. Willy Lott's cottage has been restored, and is bigger than one expected, Bridge Cottage now sports sun-chairs, tables and a tea room, and is smaller. The accompanying map will enable visitors to locate Constable's sites and measure the changes to the landscape for themselves.

Constable's mother died at the end of March 1815 and his father followed fourteen months later on 14 May 1816. Constable was forty and would be independent when the estate was settled. He married Maria Bicknell on 2 October following. For their honeymoon the couple went to stay at Osmington, near Weymouth, with Constable's friend John Fisher. Constable made a number of sketches and paintings in the area, and no doubt because of its associations a painting of Weymouth Bay was duly included in the 'English Landscape' (Pl. 18). Returning to London in December the Constables set up home in the painter's bachelor lodgings in Charlotte Street. From now on Constable's home was in London, and he returned to East Bergholt only as a visitor. He made arrangements for his studio in the village to be emptied and after taking his new

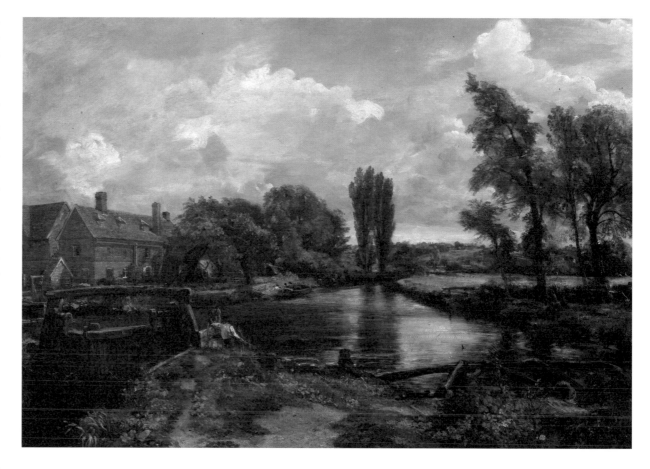

wife down to stay with the family the following summer, he made few subsequent sketches of his native landscape. His brothers and sisters were living temporarily in the family home and making preparations to sell up, and on a flying visit to participate in the arrangements in 1818 he reflected to Maria on his new relationship to it: 'I never enter this dear village without many regrets — the affecting sentiment of

ILL. 16
Flatford Mill, exhibited Royal Academy 1812. Constable's first exhibited Flatford Mill picture, giving the view from the lock. The pair of tall poplars can also be seen from different angles in *The Mill Stream* (Pl. 12), *Flatford Mill* (Pl. 27) and *Flatford Mill from the Bridge* (Ill. 12). The lock itself is seen from the left, looking back, in the large picture engraved by Lucas, *The Lock* (Pl. 39).

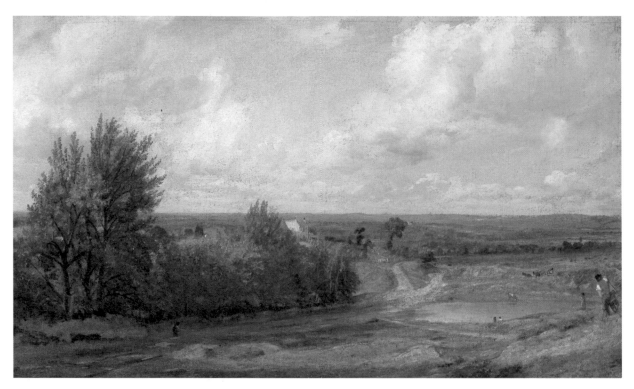

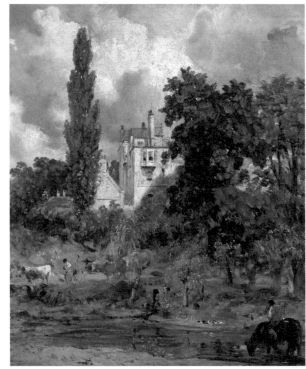

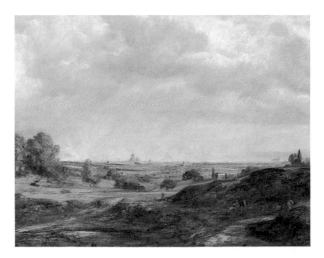

ILL. 17
Hampstead Heath: The House called the Salt Box in the Distance, 1821.
Taken from Prospect Walk, with Branch Hill Road and the house called the Salt Box (now 'The Grange') in the centre and Harrow Hill at the extreme left. Most of Constable's Branch Hill Pond compositions can be related to this view, although many of them are further round to the right looking more directly towards Harrow.

ILL. 18
The Grove, Hampstead, 1821.
Constable needed only to cross the street from his house in Lower Terrace to find this view looking over Crockett's Pond. The Grove is now known as the

'Admiral's House' after Matthew Barton (1715-95) who made the roof like the quarter-deck of a man o'war, complete with cannon, which he fired to celebrate naval victories.

ILL. 19
Hampstead Heath, 1830 (detail).
Part of a view from the end of Well Walk looking towards London with the Dome of St. Paul's to the left and Westminster Abbey to the right. The view is recognisable today and is perhaps even more impressive than when Constable knew it, now boasting the NatWest tower and its companions. The view, especially as seen from the windows of Well Walk, was a source of considerable delight and study to Constable (see Ill. 24).

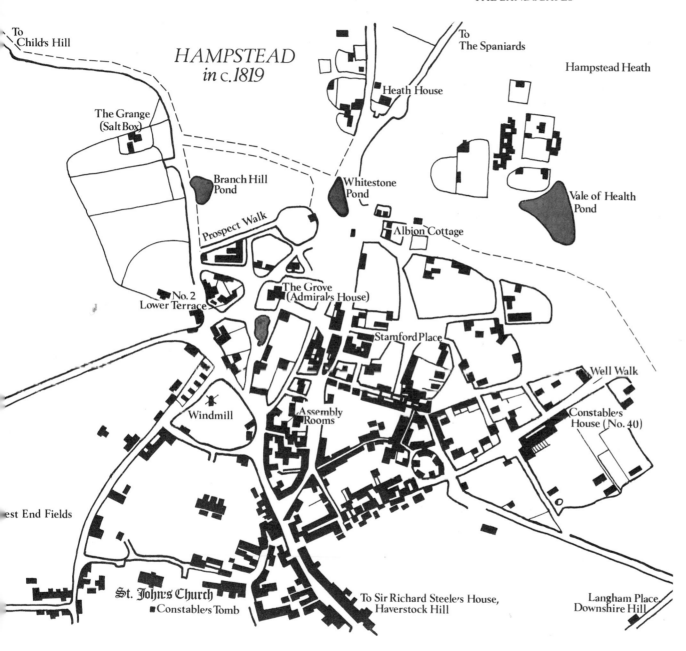

HAMPSTEAD
in c.1819

To Child's Hill

The Grange
(Salt Box)

Branch Hill
Pond

Prospect Walk

No. 2
Lower Terrace

The Grove
(Admiral's House)

Windmill

West End Fields

St. John's Church
Constable's Tomb

Heath House

To The Spaniards

Hampstead Heath

Whitestone
Pond

Albion Cottage

Vale of Health
Pond

Stamford Place

Assembly
Rooms

Well Walk

Constable's
House (No. 40)

To Sir Richard Steele's House,
Haverstock Hill

Langham Place
Downshire Hill

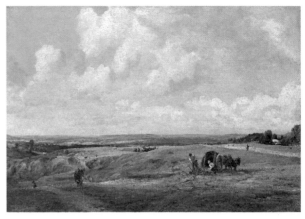

ILL. 20
Hampstead Heath, 1821.
Taken from near Whitestone Pond looking north and north-west with the Salt Box and Harrow Church to the left. The constant activity of carts on the heath taking sand to provide materials for the expansion of suburban London, or as seen here, road mending, provided the theme for many of Constable's Hampstead subjects. This particular location provided the viewpoint of two 'English Landscape' scenes (Pl. 9 and 37).

this roof containing now no more those who nourished my childhood & indulged my early years in almost every wish. The thoughts of these dear memories fill my eyes with tears while I am now writing —.' With the severance of Constable's links with East Bergholt these memories became so vital to him that he began to build a monument to them in six-foot canvases and paint.

After living for a few months in Charlotte Street, the Constables moved to 1 Keppel Street, a few hundred yards from the British Museum in what was then semi-rural Blooms-

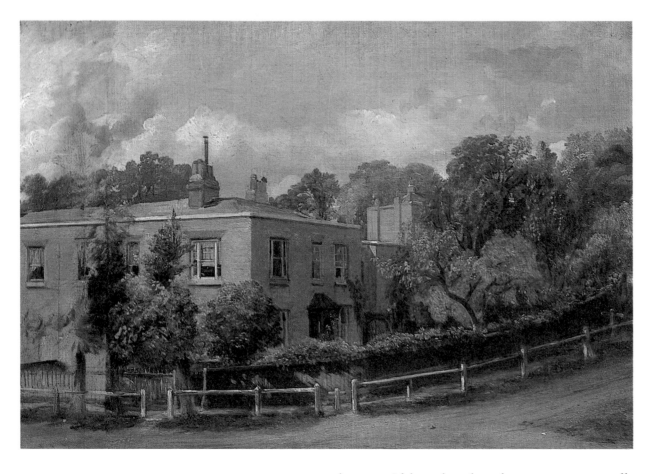

ILL. 21
Lower Terrace, Hampstead, 1821.
Constable rented No. 2 Lower Terrace for himself and his family in 1821 and 1822.

most productive periods of his life: '... we wanted room — & were like "bottled wasps upon a southern wall" — but the 5 happiest & most interesting years of my life were passed in Keppel St. I got my children & my fame in that house, neither of which would I exchange with any other man.' Constable was writing in 1822 having just completed his move to a larger house which he could now afford, 35 Charlotte Street, previously the home of Joseph Farington, who had died in 1821. Despite appearances, Constable's world was not all prosperity and security. Maria was not well and in August 1819 Constable removed her and the two infants to Albion Cottage, Upper Heath, Hampstead, so that they might benefit from clear country air, being four miles from the sickly atmosphere of the metropolis.

So began Constable's association with Hampstead. Every summer he rented a house in the village so that Mrs. Constable and her growing and ever-expanding family might recuperate from winters spent in the city. In 1821 and 1822 the family stayed at No. 2 Lower Terrace and in 1823 at Stratford Lodge, Stratford Place. The stays were lengthy ones and Constable had to find some way of working while away from the convenience of his London studio. Life at Lower Terrace was rewarding and on 4 August 1821 Constable sent a report to John Fisher: 'I am as much here [as] possible with my dear family. My placid & contented companion with her three infants [Charles Golding had been born on 29 March] are well. I have got a room at the glaziers down town as a workshop where is my large picture — and at this little place I have [sundry] small

bury. Although the house was small, Constable began filling it with children. His first, John Charles, was born on 4 December 1817 and his second, Maria Louisa, on 19 July 1819. In between times he painted some of his best pictures, *The White Horse* (Pl. 34), *Stratford Mill* (Pl. 41) and *The Hay Wain* (Ill. 13), all six-footers, and so big that the window on the stairs at Keppel Street had to be removed to get them out of the studio. This was one of the

works going on — for which purpose I have cleared a small shed in the garden, which held sand, coals, mops & brooms & that is literally a coal hole, and have made it a workshop, & a place of refuge — when I am down from the house. I have done a good deal of work here.' Constable's lodgings were all close to the Heath, and he did not stray far from home in search of subjects. He painted Lower Terrace from across the street (Ill. 21), 'The Grove', across Crockett's Pond near Lower Terrace (Ill. 18), views towards Harrow from the Heath around Branch Hill Pond and Prospect Walk (Ills. 17 and 22 and Pls. 9 and 37), and the wide sky-swept spaces on the top of the Heath near Heath House (Ill. 23). After writing to Fisher enthusing about skies on 23 October 1821 and reporting that he had 'done a good deal of skying', he wrote again on 3 November, as we have seen, to summarise his season: 'The last day of Octr was indeed lovely so much that I could not paint for looking — my wife was walking with me all the middle of the day on the beautifull heath. I made two evening effects. The panorama of this place include[s] what I have named [*a diagram follows:*]

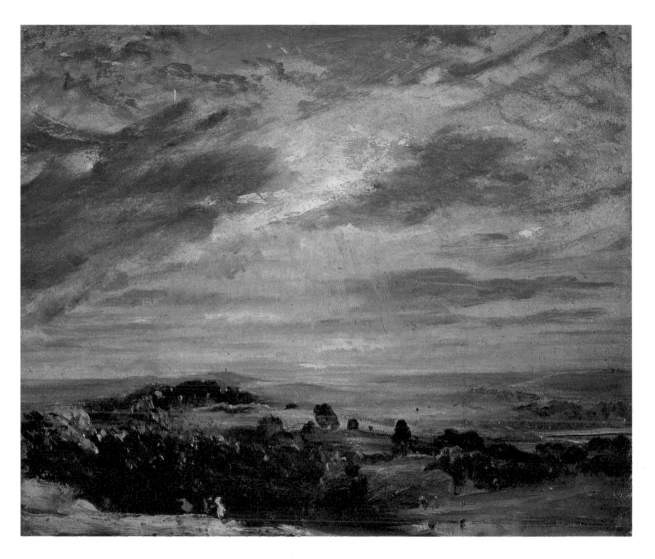

ILL. 22
View from Hampstead Heath, looking towards Harrow, August 1821.
Constable's interest in changes of light and weather was at its most intense on the sky-swept spaces of Hampstead Heath. Many of his sketches include exact details of when they were made and under what conditions. A label on the stretcher of this reads: '*5 Oclock afternoon: August 1821 very fine bright & wind after rain slightly in the morning*'.

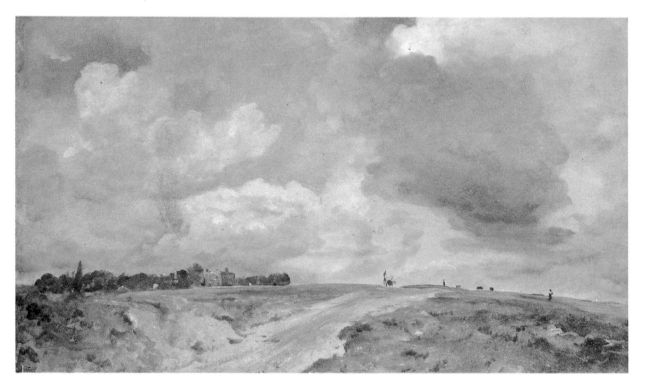

ILL. 23
The Road to the Spaniards, Hampstead, July 1822.
A note on the back reads: '*[Hamp]stead Monday 2(...) July 1822 looking N E 3 PM [? previous to] a thunder squall wind N West'.* The building has been identified as the Spaniards public house but, being a good mile from Lower Terrace, this seems be too far afield for Constable. It looks more like Heath House, as seen from near Albion Cottage; a view which would still be adequately described by the title.

— and has the addition of the finest fore-grounds — in roads, heath, trees, ponds &c & every description of mooveable — both dead and alive.'

Hampstead provided Constable with the opportunity to widen the range of his subjects and he had pictures entitled *Hampstead Heath* and *Harrow* to show in 1821 and *Hampstead Heath* and *View from the Terrace, Hampstead* in 1822. He seems to have enjoyed a good season at Lower Terrace in 1822 and on 7 October reported to Fisher that he had made 'about 50 carefull studies of *skies* tolerably large, to be carefull.' The financial strain and the absence

from his studio at Charlotte Street was, how-ever, proving frustrating. On 4 October he had told Fisher: 'This place ruins me — but it is quite as necessary as food to my children & wife. This did not come into my original cal-culations — when I married.' Three days later he wrote: 'This is I hope my last week here — at least this season. It is a ruinous place to me — I lose time here sadly — one of my motives for taking [the] Charlotte St. house was to remain longer in London.' Constable profited from the exile from Charlotte Street more than he would admit or could recognise. His Hamp-stead Heath sketches are among the freshest and most beautiful paintings from his hand.

His frustration was caused principally by being unable to work on his six-foot canvases. When he wrote that he 'got his fame' in the Keppel Street house he meant that he had painted three of his biggest and best pictures there, two of which he had already sold. The purchaser was his friend John Fisher, Con-stable's ideal patron, patient, generous and in-terested in him even more perhaps than in his pictures. Constable had first met him in Salis-bury in 1811 while staying with his uncle, Dr John Fisher, ex-rector of Langham, now Bishop of Salisbury. Constable went down to Salisbury with his wife in 1820 for a stay of seven weeks, again in 1821 and 1823 and returned in 1829 after his wife's death. From Salisbury he made excursions to Old Sarum (Pl. 14) and Harnham Ridge (Ill. 24), and further afield to Gillingham (Pl. 30), the living of which John Fisher had been granted by his uncle in 1819. He also visited Stonehenge and country houses in the area, including Fonthill and Stourhead.

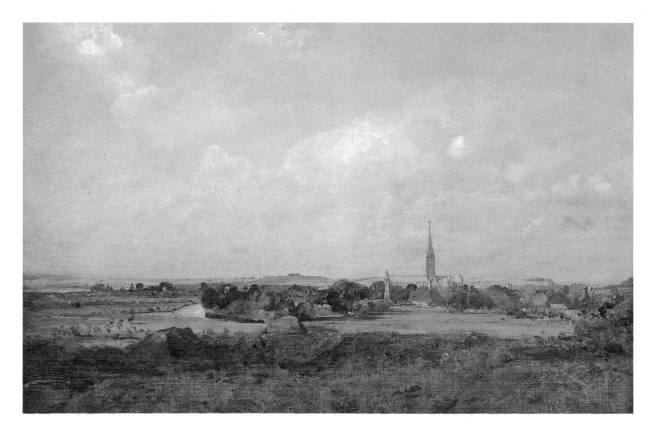

ILL. 24
A view of Salisbury from the south, 1820.
The city and cathedral close seen from Harnham Ridge, looking north to Old Sarum in the distance.

Most of all, however, his work was concerned with the world within the Close bounded by the sweep of the River Avon, taking views of and from the Bishop's Palace, the Archdeacon's residence, Leydenhall, and the Cathedral. Through Fisher, Constable became attached to both Salisbury and Gillingham, and when in

1823 Fisher told Constable that a storm had wrecked the trees at Gillingham the artist replied: 'How much I regret the grove at the bottom of your garden — this has really vexed me — I had promised myself the passing of many summer noons in their shade. The figures met there were perhaps not the most classical — nymphs darting out of a cotton mill in parties — to add to the rippling of the stream — or to quote Shakespeare & be poetical — "augmenting it with" — not tears.'

The last of Constable's worlds was that of

Brighton. His wife's health continued to deteriorate despite the air and expense of Hampstead, and in 1824 they resolved to try the therapeutic power of sea breezes. Initially Constable disliked the resort:

Brighton is the receptacle of the fashion and offscouring of London. The magnificence of the sea, and its (to use your own beautifull expression) everlasting voice, is drowned in the din & lost in the tumult of stage coaches — gigs — "flys" &c. — and the beach is only Piccadilly (that part of it where we dined) by the sea-side. Ladies dressed & *undressed* — gentlemen in morning gowns & slippers on, or without them altogether about *knee deep* in the breakers — footmen — children — nursey maids, dogs, boys, fishermen — *preventive service men* (with hangers & pistols), rotten fish & those hideous amphibious animals the old bathing women, whose language both in oaths & voice resembles men — all are mixed up together in endless & indecent confusion. The genteeler part, the marine parade, is still more unnatural — with its trimmed and neat appearance & the dandy jetty or chain pier, with its long & elegant strides into the sea a full ¼ of a mile. In short there is nothing here for a painter but the breakers — & sky — which have been lovely indeed and always varying.

Maria had to return for a lengthy stay in 1825-26 and Constable was forced to make the best of it. The 'dandy jetty' interested him enough to make a large painting of it for the Royal Academy exhibition of 1827 (Ill. 25),

ILL. 25
The Chain Pier Brighton, exhibited Royal Academy
1827.

though it would have done little to advance Brighton's fame as a resort today with its chill clouds billowing in from the sea. The breakers and sky, however, provided material enough for a whole series of studies, continuing the practice established at Hampstead, vital and alive with the impress of direct observation, and capturing every fleeting effect of the weather over the sea (Ill. 26 and Pl. 10).

In 1825 Constable seemed happier with a convalescence by the sea:

We determined to give our boy the chance of the sea — and about a week ago I took them all to Brighton. We chose this place — it is cheaper than any other — it is near — and we have several friends there. John is certainly better, & he is now fond of bathing which we are told will help him — we can hardly judge yet of the effect it will have. It is better for me that they are so far off — if we must part — Hampstead is a wretched place — so expensive — and as it was so near I make my home at neither place — I was between two chairs — & could do nothing.

On 7 July 1826 he could report to Fisher from Charlotte Street that his wife was well: 'I trust we shall not need a country excursion [or to Brighton], in which we leave this convenient house, and pay four guineas a week for the privilege of sleeping in a hen-coop for the sake of country air.' He was wrong. Two months later on 9 September he reported: 'My children are well and my wife for her very tolerable. They are in a small house — a Hampstead, Downshire Hill [called Langham Place, affording recollections of the Stour valley].' He had solved his problems with work, however, and continued: 'I am but little there — but it is an easy walk from here.' On 28 November after Maria had been delivered of their sixth child, 'an awfull concern' as the father described it, Constable had to report that he was looking for a permanent Hampstead home: 'My wife is at Hampstead, where she was confined. She has a beautifull son ... and both are doing well, but it was a month before the time. I am endeavouring to secure a per-

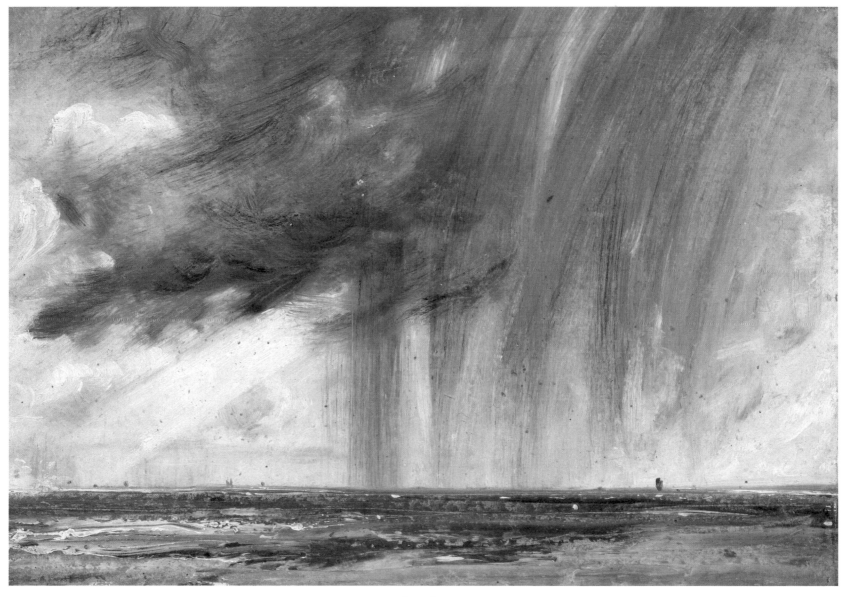

ILL. 26
A Rain storm over the sea, 1824

manent small house there, to prevent if possible the sad rambling life which my married life has been, flying from London to seek health in the country ... I am three miles from door to door — can have a message in an hour — & I can get always away from idle callers — and above all see nature — & unite a town & country life.'

With Maria's health declining in 1827, Constable's search became urgent and he took the lease of No. 6 Well Walk (now No. 40) some time before 26 August 1827. The house was all he could have wished except for the expense. He wrote to Fisher on that day to describe it and to ask for a loan:

I am at length fixed in our comfortable little house in the 'Well Walk', Hampstead — & we are once more enjoying our own furniture and sleeping on our own beds. My plans in the search of health for my family have been ruinous — but I hope now that my movable camp no longer exists — and that I am settled for life. So hatefull is moving about to me, that I could gladly exclaim — 'Here let me take my everlasting *Rest*' — no moss gathers 'on the rolling stone'. The rent of this house is 52 £ per ann. Taxes &c, 25 — and what I have spent on repairs 10 £, or 15 at interest, and money sunk on lease 23 gns. I let Charlotte Street at 82 £, to a very agreeable man and his wife — Mr Sykes — he is a teacher in most of the genteel families here in the (dancing line): I have no doubt of their being very permanent. I retain my 2 parlors, large front attic — painting rooms, kitchen &c.

All this account of myself is a little prelude, to an entreaty on my part on you for help — can you let me have 100 £, on any account. If as a loan, I will give you security and pay you full interest, or any way that you please. It is to pay my workmens bills — of painting — & repairs of various sorts to this house. I throw myself my dear Fisher on you — in this case — the weight of debt to me is next to the weight of guilt. *Help to establish me in this house!* It is indeed everything we can wish. It is to my wife's heart's content — it is situate on the eminence at the back of the spot in which you saw us — and our little drawing room commands a view unequalled in Europe — from Westminster Abbey to Gravesend. The *dome* of *St Paul's* in the air, realizes Michael Angelo's idea on seeing that of the Pantheon — 'I will build such a thing in the sky'. We see the woods & lofty grounds of the land of the 'East Saxons' to the N. East.

They hardly had time to settle in before Maria had their seventh child, Lionel Bicknell, born on 2 January 1828. The experience exhausted her reserves of strength. On 11 June Constable wrote to Fisher: 'My wife is sadly ill at Brighton — so is my dear sweet Alfred [their sixth child born 14 November 1826] ... Hampstead — sweet Hampstead that cost me so much is deserted.' She did not show the usual signs of improvement and returned to Hampstead. On 22 August she rallied enough for her husband to write: 'I believe Mrs Constable to be gaining ground. Her cough — is pretty well gone and she has some appetite, and the nightly perspirations are, in a great measure,

ceased.' In November Constable's friend and biographer C. R. Leslie called on the couple at Hampstead: 'Mrs Constable ... was then on a sofa in their cheerful parlour, and although Constable appeared in his usual spirits in her presence, yet before I left the house, he took me into another room, wrung my hand, and burst into tears, without speaking.' She died on 23 November and was buried in the churchyard at Hampstead.

Constable was fifty-two, a widower with seven children, with a house in Hampstead which he would never use as home, and another in Charlotte Street where for the time being he installed his children. On 19 December he wrote to his brother Golding:

Hourly do I feel the loss of my departed Angel — God only know[s] how my children will be brought up — nothing can supply the loss of such a devoted — sensible — industrious — religious mother — who was all affection — but I cannot trust myself on the subject — I shall never feel again as I have felt — the face of the World is totally changed to me ... — I should like to come to see You all for a day or two — but poor dear Bergholt will fill me full of — sad — sad — associations — espccially the sight of the Rectory — & its dark trees — but a few year will set all these sorrows at rest — but I cannot recover my lost happiness — the loss grows upon me — but I must turn to my dear Infants. J. C.

In these circumstances he began his 'English Landscape' project, his review of the landscapes with which he had been associated.

THE
PAINTINGS

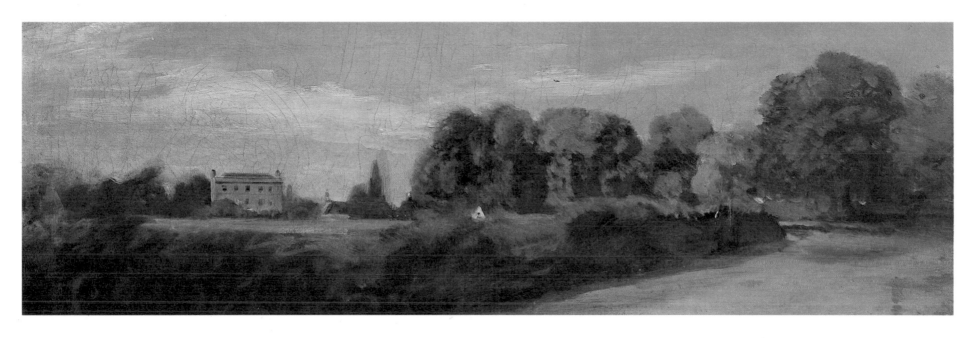

PLATE 1
Golding Constable's House, East Bergholt

55

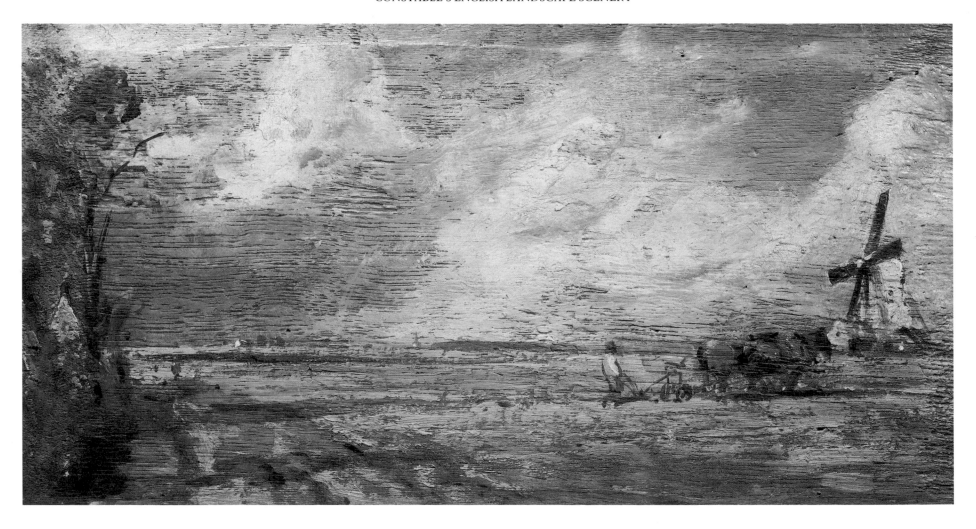

PLATE 2
Spring: East Bergholt Common

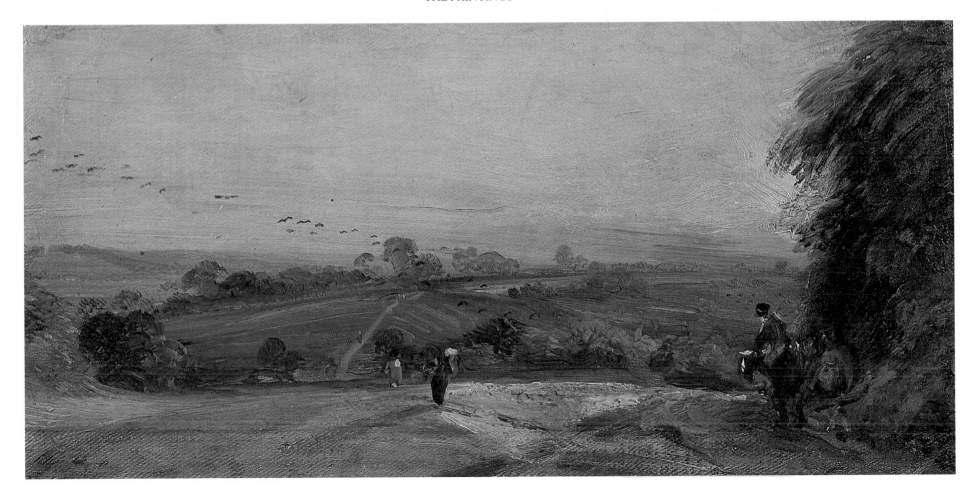

PLATE 3
Autumnal Sunset

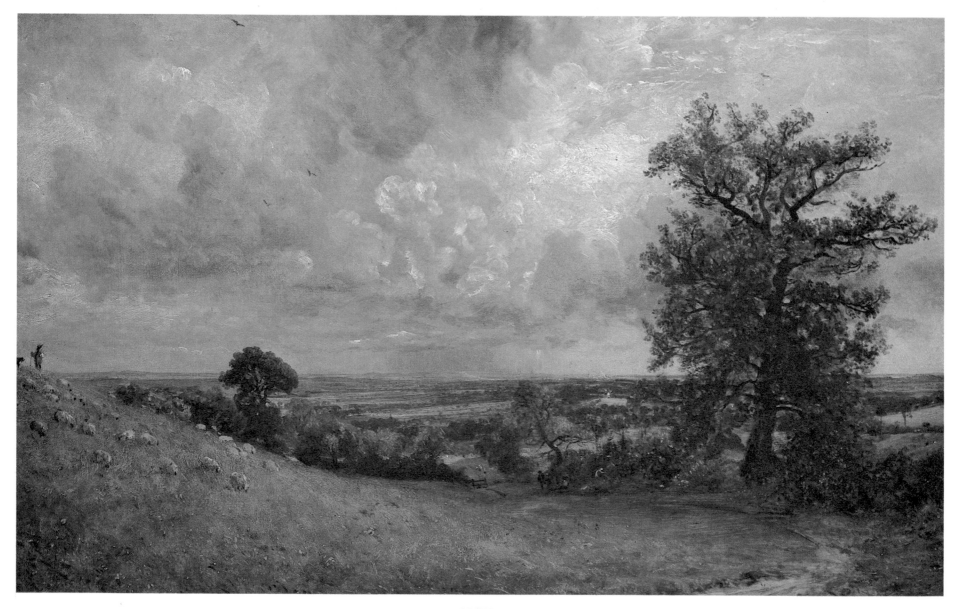

PLATE 4
West End Fields, Hampstead: Noon

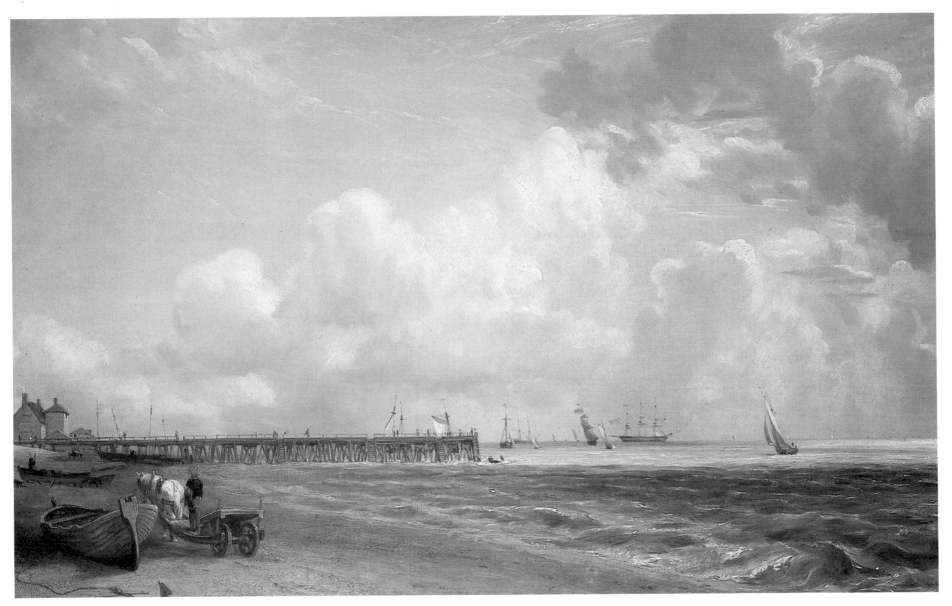

PLATE 5
Yarmouth Jetty

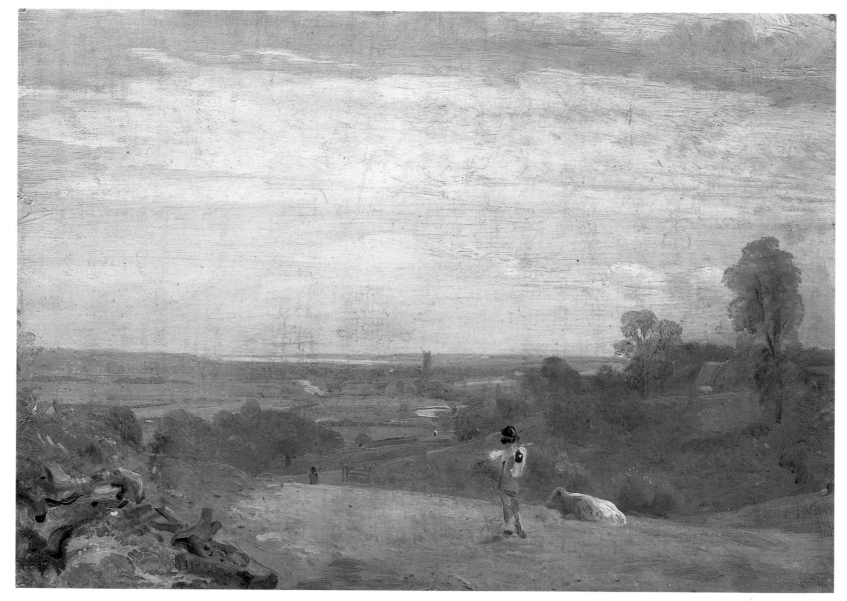

PLATE 6
Summer Morning: Dedham from Langham

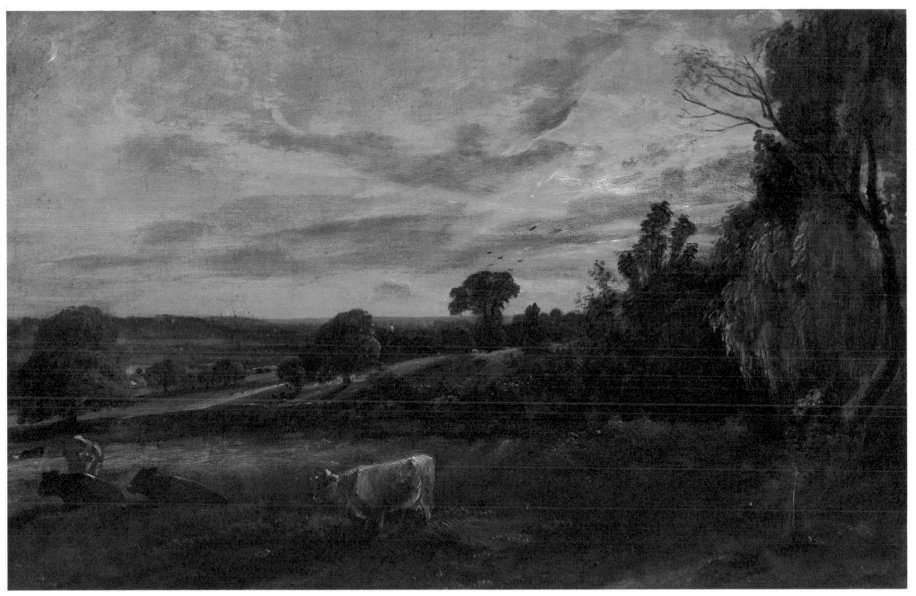

PLATE 7
Summer Evening: View near East Bergholt showing Langham Church, Stratford Church and Stoke-by-Nayland Church

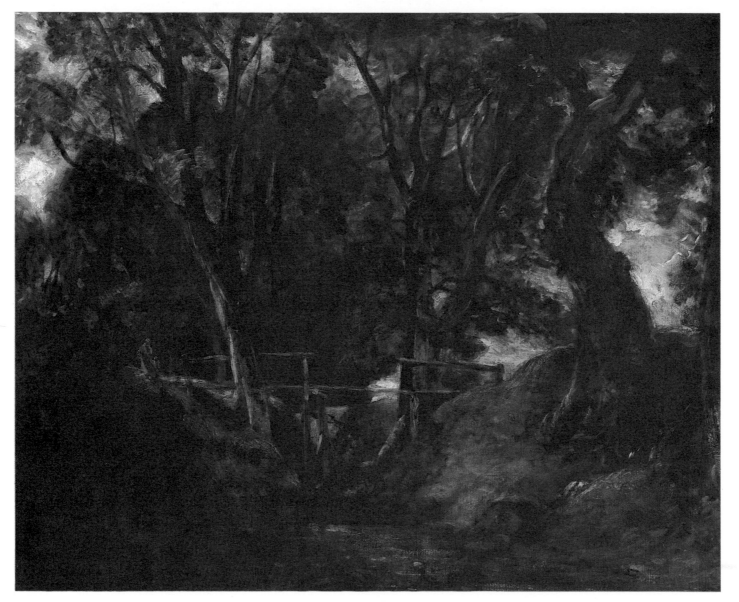

PLATE 8
Helmingham Dell

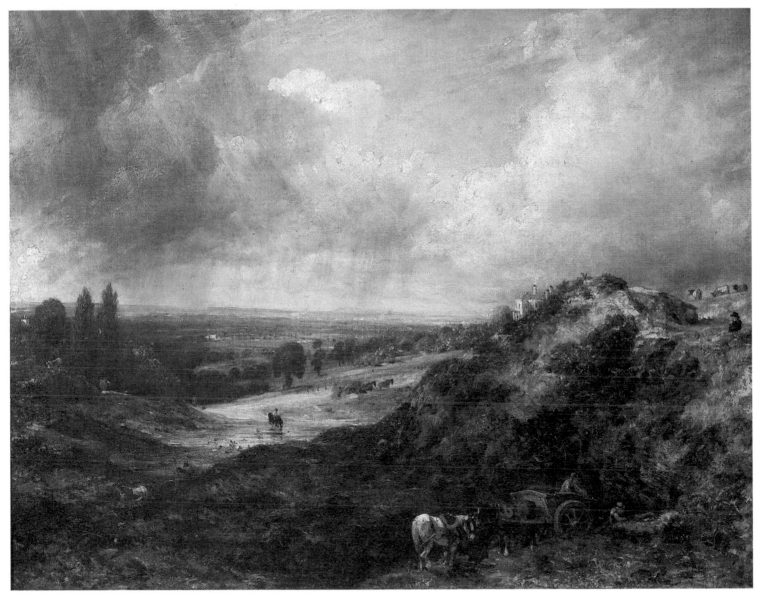

PLATE 9
Hampstead Heath: Branch Hill Pond

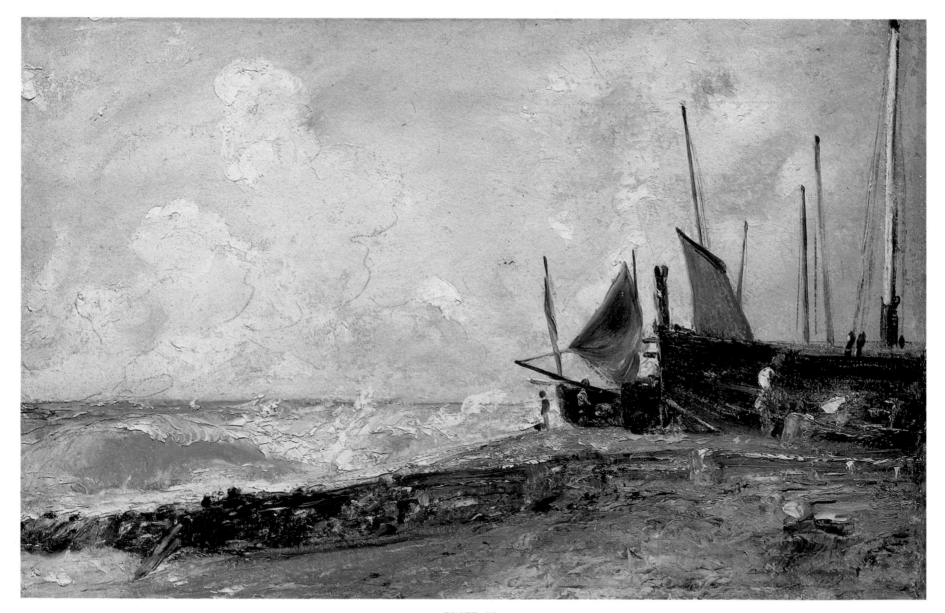

PLATE 10
A Sea Beach, Brighton

PLATE I I
Stoke-by-Nayland

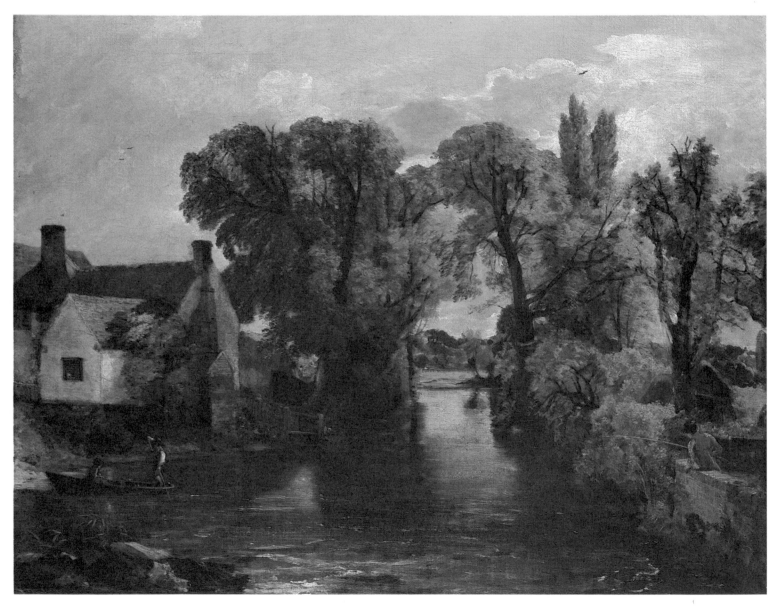

PLATE 12
The Mill Stream

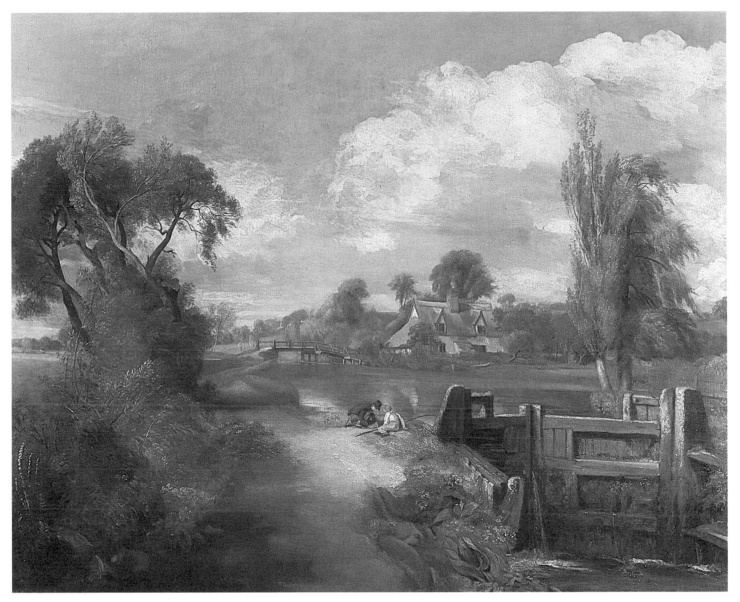

PLATE 13
Landscape: Boys fishing

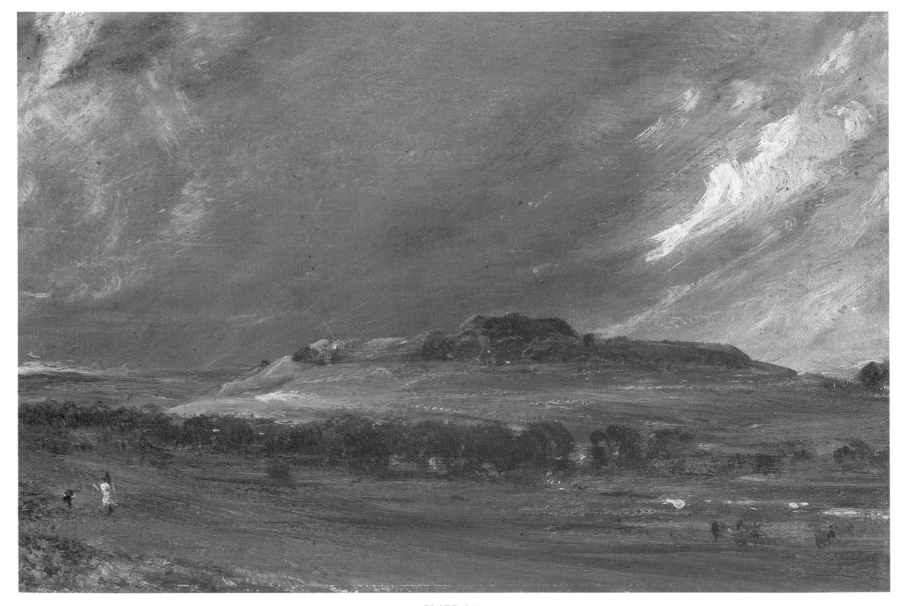

PLATE 14
Old Sarum

PLATE 15
Landscape: Ploughing scene in Suffolk (A Summerland)

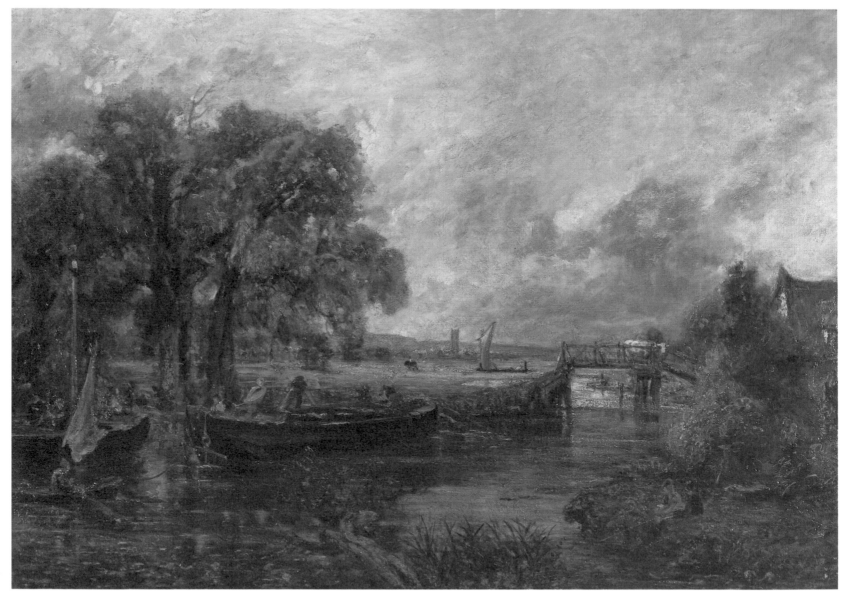

PLATE 16
View on the Stour near Dedham

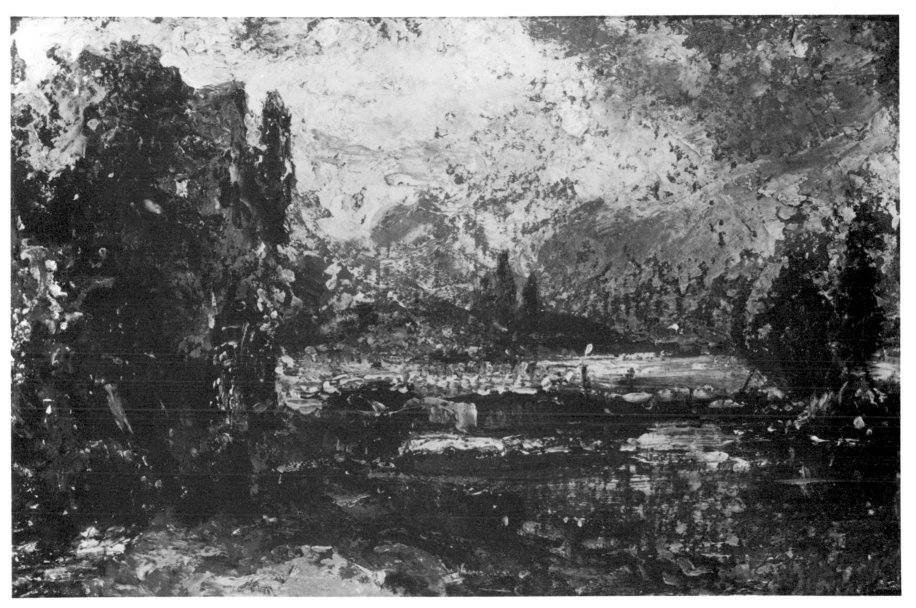

PLATE 17
Dedham Mill

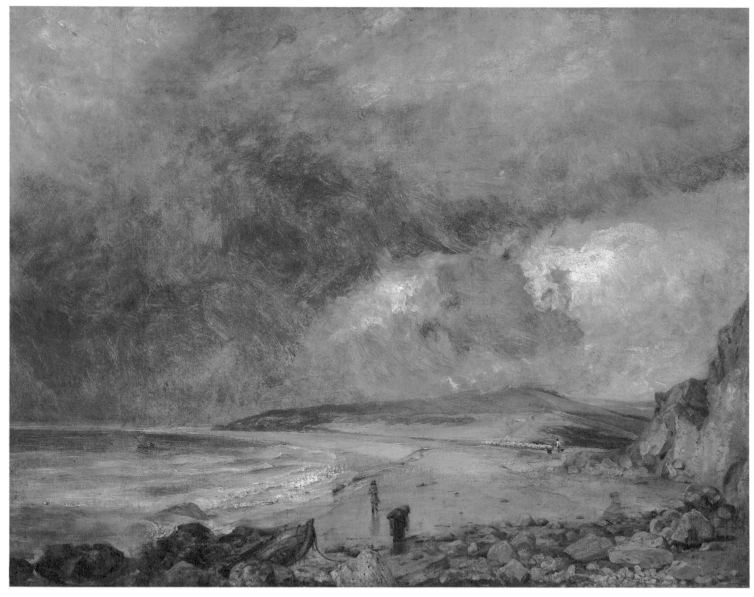

PLATE 18
Weymouth Bay

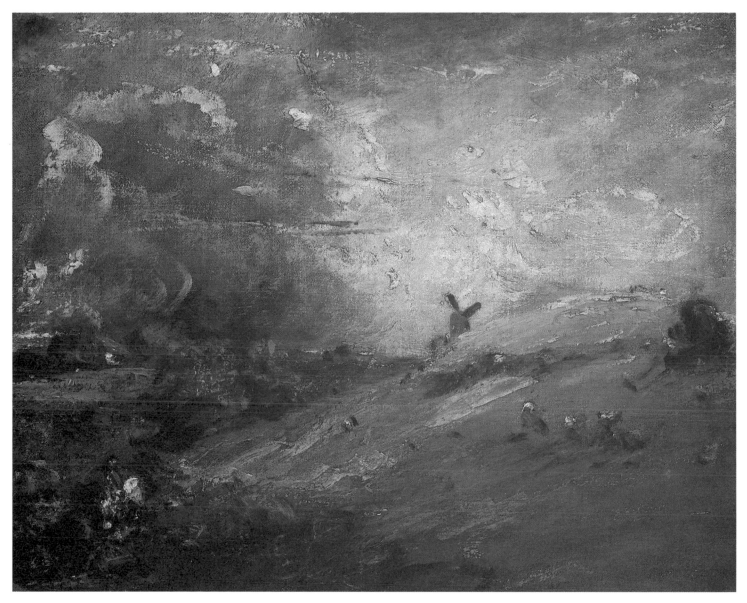

PLATE 19
Summer, Afternoon after a Shower

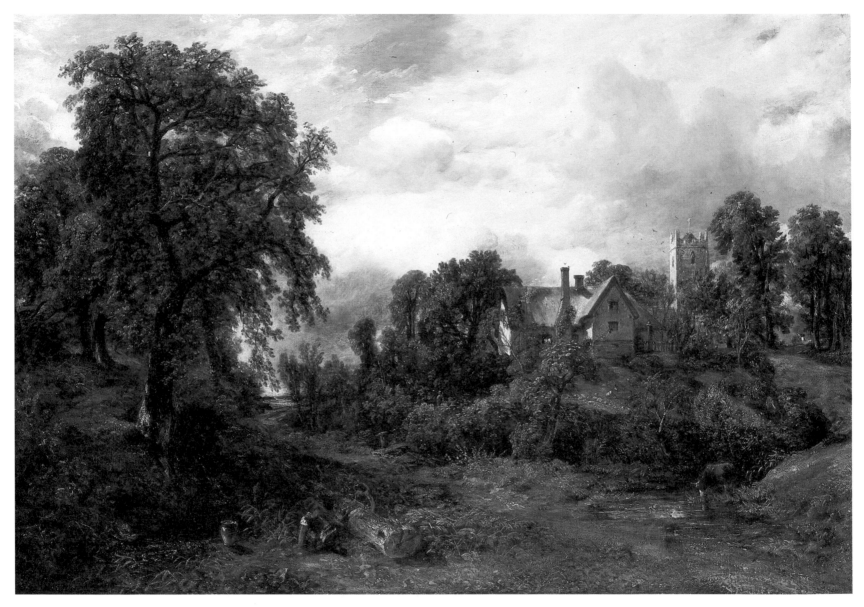

PLATE 20
The Glebe Farm

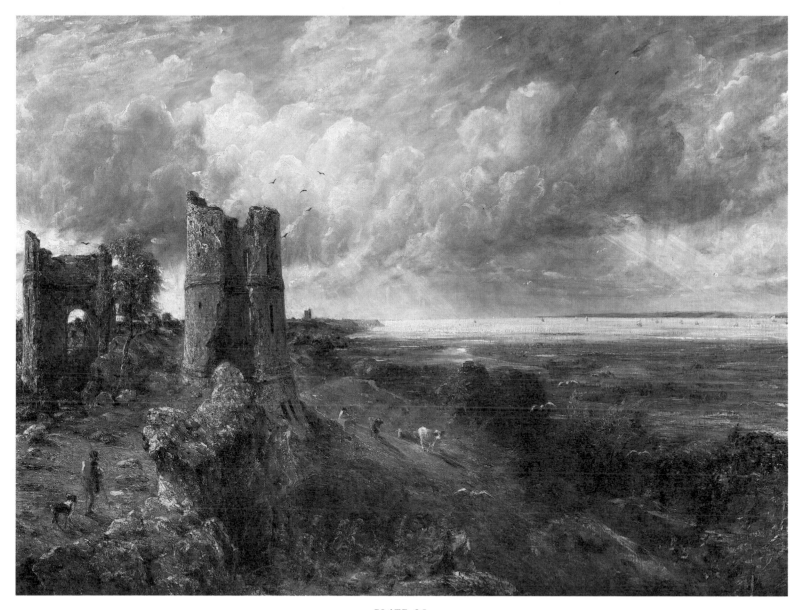

PLATE 21
Hadleigh Castle

PLATE 22
A Sandbank at Hampstead Heath

PLATE 23
Jaques and the Wounded Stag

PLATE 24
A Church Porch (The Church Porch, East Bergholt)

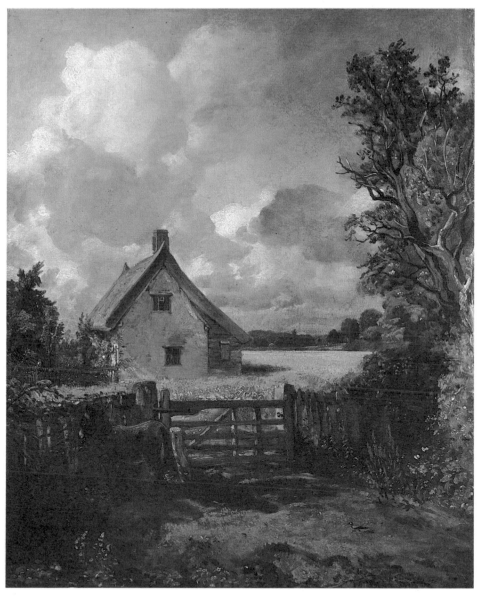

PLATE 25
The Cottage in a Cornfield

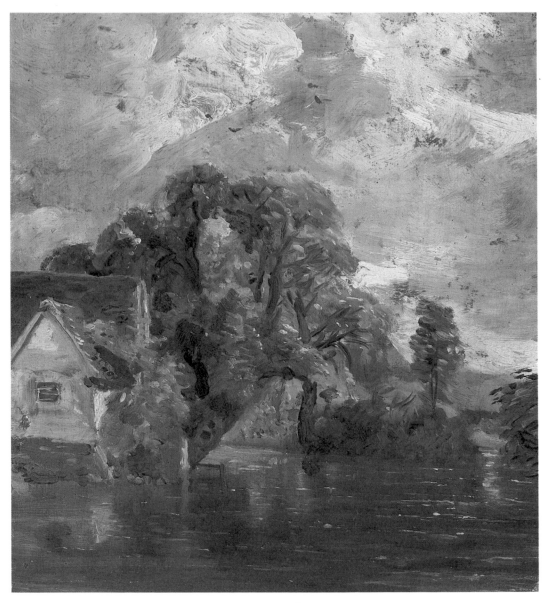

PLATE 26
Willy Lott's House

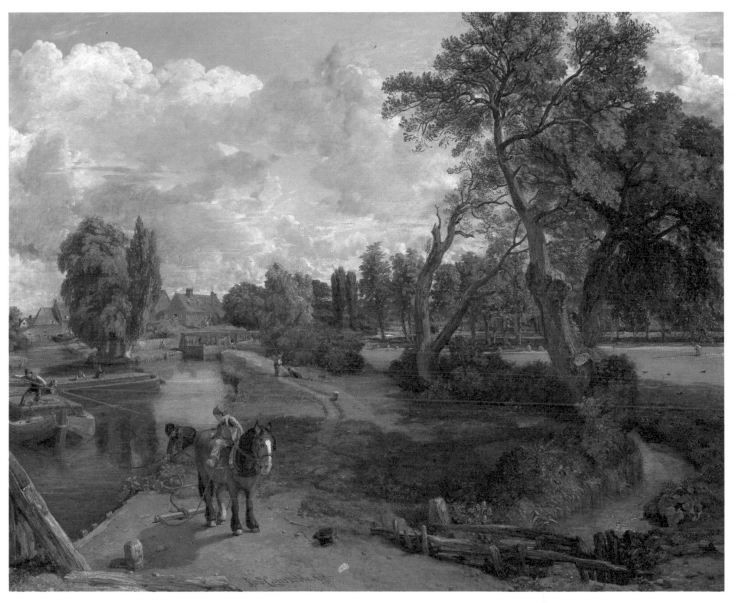

PLATE 27
Flatford Mill

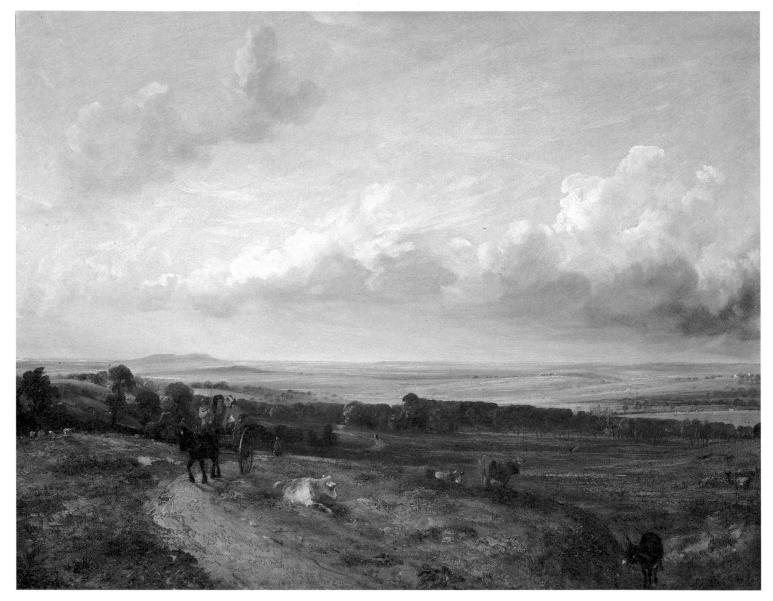

PLATE 28
Child's Hill: Harrow in the Distance

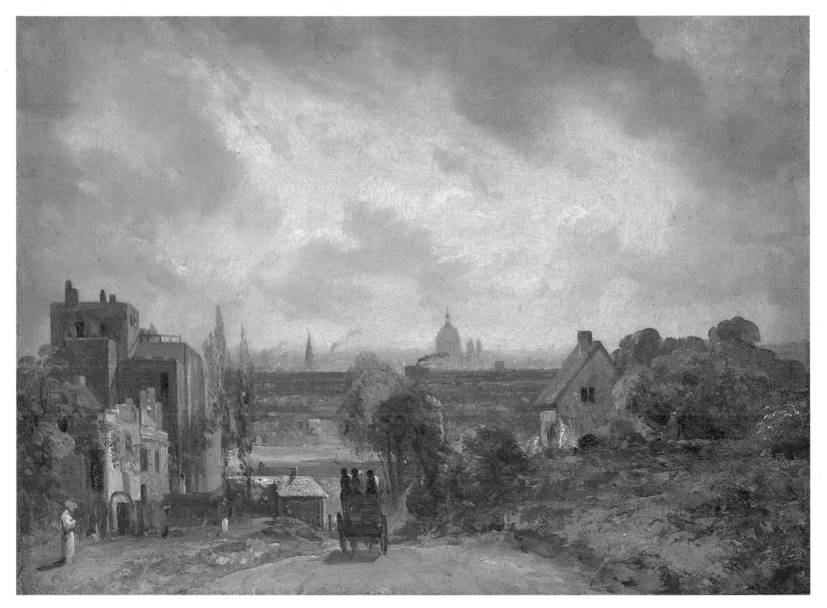

PLATE 29
Sir Richard Steele's Cottage, Hampstead

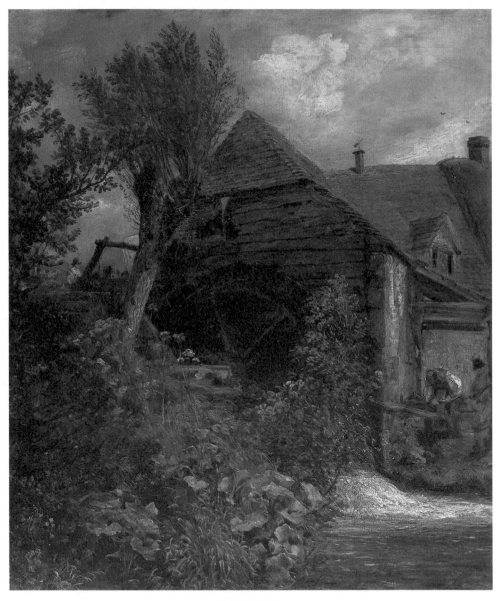

PLATE 30
Gillingham Mill, Dorset

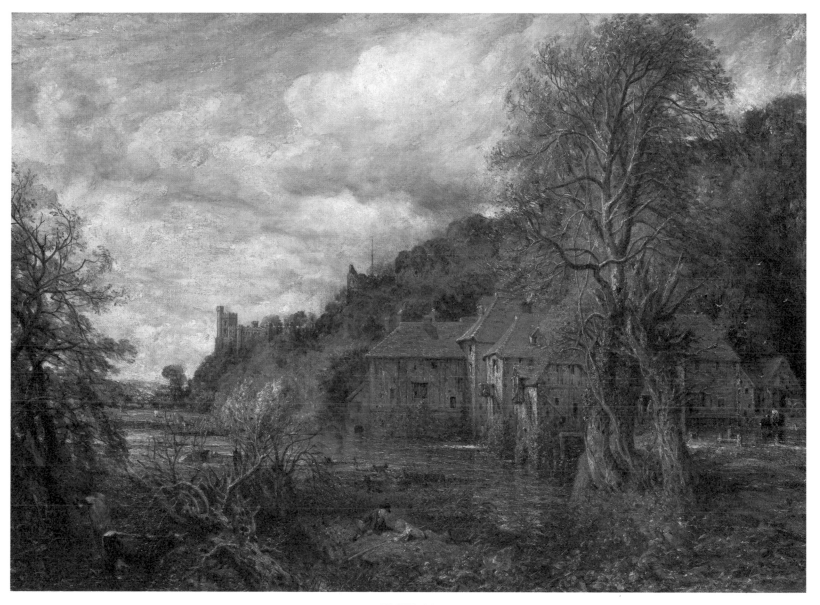

PLATE 31
Arundel Mill and Castle

PLATE 32
Shipping in the Orwell, near Ipswich

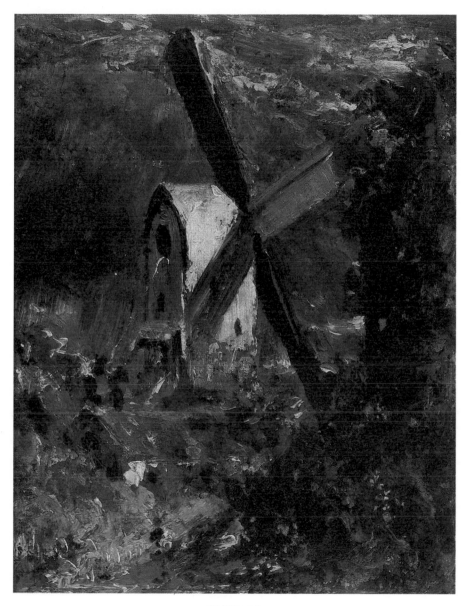

PLATE 33
A Windmill near Brighton

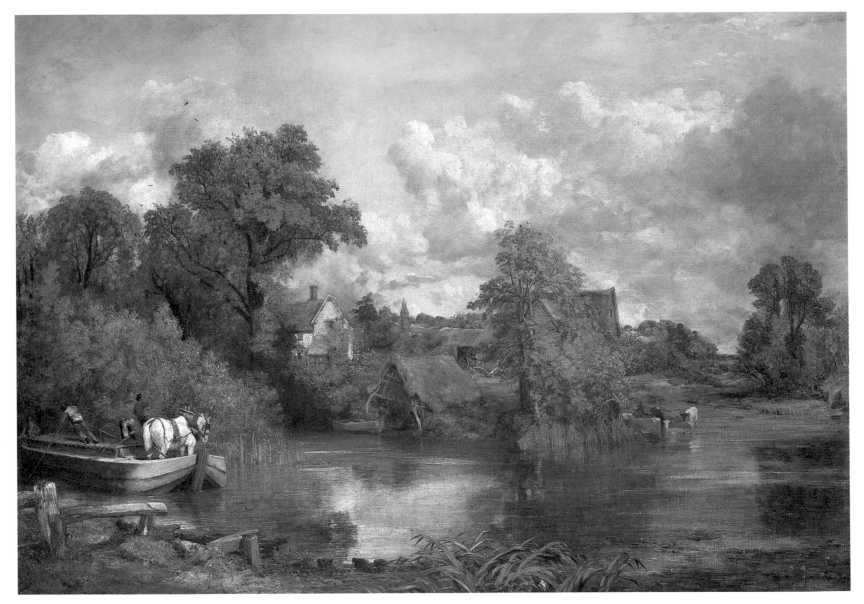

PLATE 34
The White Horse

Sketch for *Salisbury Cathedral from the Meadows*

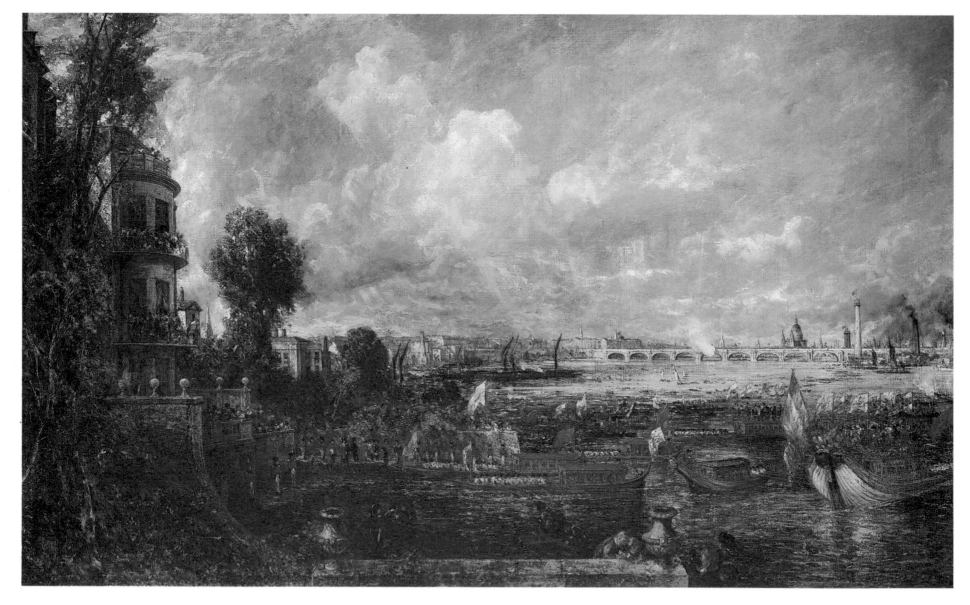

PLATE 36
Waterloo Bridge from Whitehall Stairs

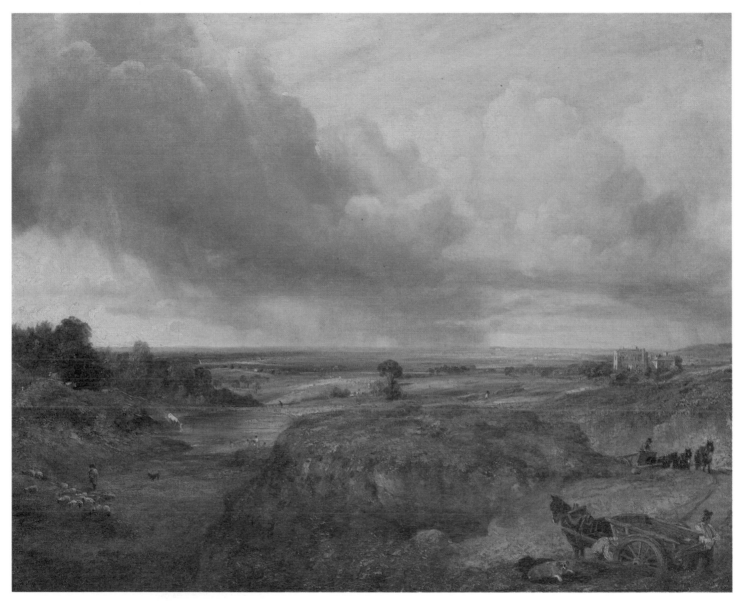

PLATE 37
Branch Hill Pond, Hampstead

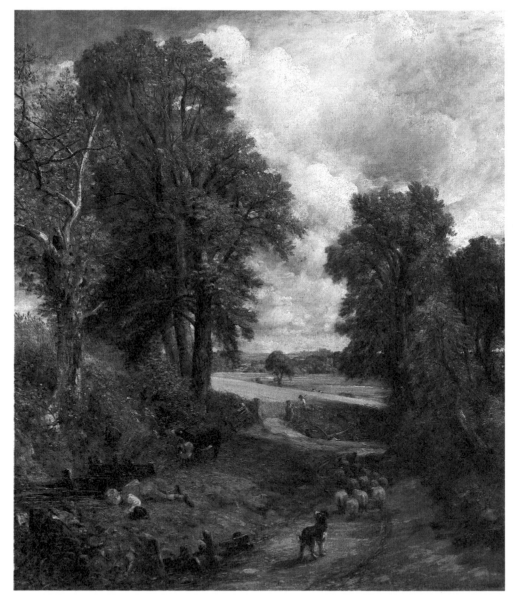

PLATE 38
The Cornfield

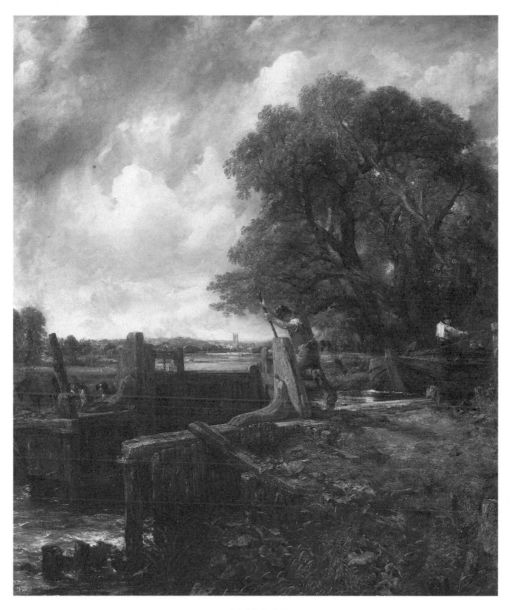

PLATE 39
The Lock

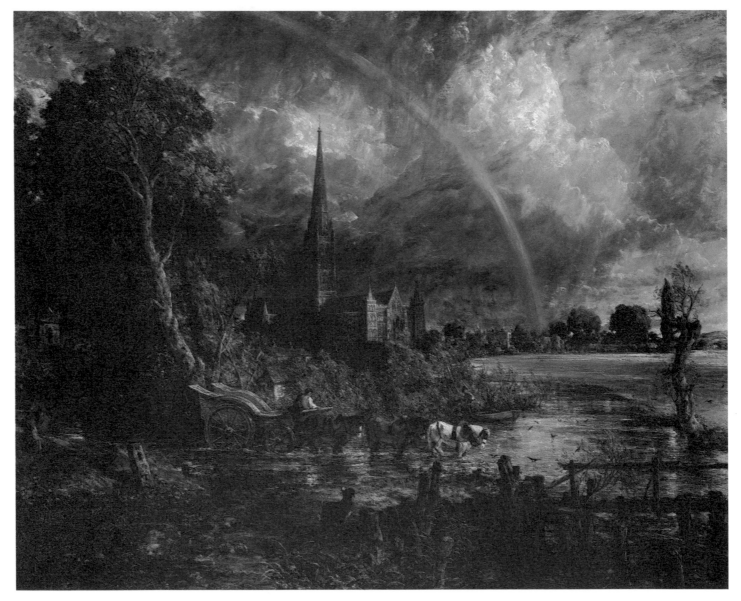

PLATE 40
Salisbury Cathedral from the Meadows

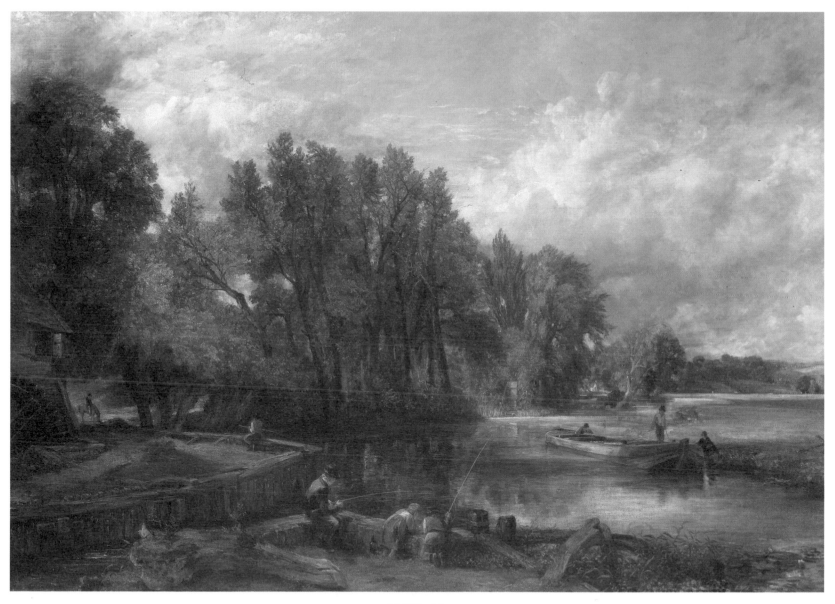

PLATE 41
Stratford Mill

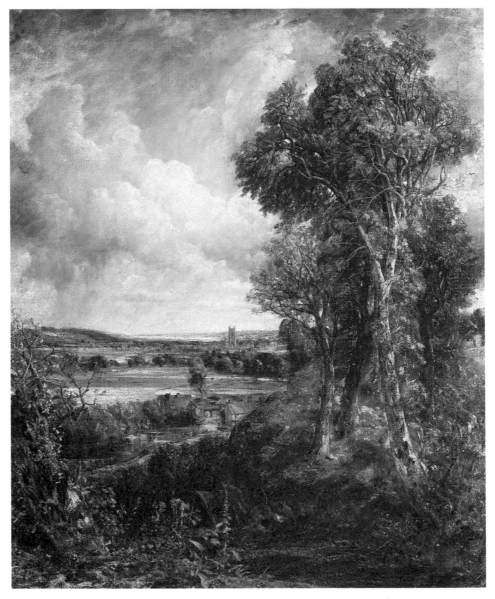

PLATE 42
Dedham Vale

THE MEZZOTINTS

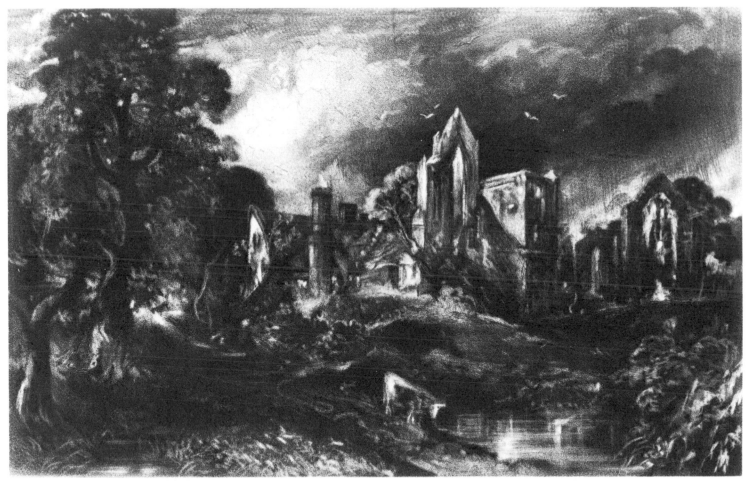

A Ruin
See No. 20a, p.109

Note:

The mezzotints are arranged in the following order:

Nos. 1-22 represent the final order of the plates, as arranged by Constable in a prospectus issued in 1834, under the titles given then. This prospectus is given in full by Shirley, Appendix C 8. The list is given by Beckett, *JCD* 11.

Nos. 28-32 and 43-45 (works available for reproduction in black-and-white only) represent the plates published by Lucas in the '2nd Series of English Landscape', 1846.

Nos. 33-36, together with Nos. 32 and 20A, were issued in 1838 by Moon, but these prints are extremely rare, and it is doubtful whether this publication actually took place. Nos. 32 and 20A were afterwards included in the '2nd Series' by Lucas. No. 37 seems to have been engraved by Lucas for the '2nd Series', but not published until 1855.

Nos. 38-42 represent the five large plates engraved by Lucas alongside the 'English Landscape' at his own expense, and are included here since they represent the culmination of many of the concerns explored in the main series.

Details of the engraving history are given on pp. 124-5. A list of references and abbreviations is given on page 126.

1. Frontispiece, Paternal House and Grounds of the Artist. — Evening or *House of the late Golding Constable, Esq. and Birth Place of the Artist*

Based on an unknown work, possibly the unidentified watercolour, *A Miller's House*, exhibited RA 1833, No. 645 (R. 33.6). A painting in the Tate Gallery, London, *Golding Constable's House, East Bergholt* (Pl. 1), *c.*1810, oil on canvas 8⅞ × 27in, 22.5 × 68.5cm (T. 1235), shows a more distant view from a similar angle. Issued in Part 5, July 1832.

Golding Constable built his house at East Bergholt in 1774, two years before John Constable was born. The engraving shows the east front from the family farm at the back of the house. The light direction is exactly that of summer's evening, and rooks still gather noisily in the rookery near the church. The house was demolished before 1845, but the stables to the right, with the bell tower on top, survive, now converted to a private house.

Constable included an artist sketching, and laid particular stress on his own intimate association with the place in the lettering on the plate: 'This spot saw the day spring of my Life, Hours of Joy, and years of Happiness. This place first tinged my boyish fancy with a love of the art, This place was the origin of my fame.'

'Respiciens rura, laremque suum.'

> With frequent foot
> Pleased have I in my cheerful morn of life,
> When nursed by careless solitude I lived
> And sung of Nature with unceasing joy,
> Pleased have I wandered o'er your fair domain.

As this work was begun and pursued by the Author solely with a view of his own feelings, as well as his own notions of Art, he may be pardoned for introducing a spot to which he must naturally feel so much attached; and though to others it may be void of interest or any associations, to him it is fraught with every endearing recollection.

In this plate the endeavour has been to give, by richness of Light and Shadow, an interest to a subject otherwise by no means attractive. The broad still lights of a Summer evening, with the solemn and far-extended shadows cast around by the intervening objects, small portions of them only and of the Landscape gilded by the setting sun, cannot fail to give an interest to the most simple or barren subject, and even to mark it with pathos and effect.

East Bergholt, or as its Saxon derivation implies, 'Wooded Hill,' is thus mentioned in 'The Beauties of England and Wales': — 'South of the church is "Old Hall," the Manor House, the seat of Peter Godfrey, Esq., which, with the residences of the rector, the Reverend Dr Rhudde, Mrs Roberts, and Golding Constable, Esq, give this place an appearance far superior to that of most villages.' It is pleasantly situated in the most cultivated part of Suffolk, on a spot which overlooks the fertile valley of the Stour, which river divides that county on the south from Essex. The beauty of the surrounding scenery, the gentle declivities, the luxuriant meadow flats sprinkled with flocks and herds, and well cultivated uplands, the woods and rivers, the numerous scattered villages and churches, with farms and picturesque cottages, all impart to this particular spot an amenity and elegance hardly anywhere else to be found; and which has always caused it to be admired by all persons of taste, who have been lovers of Painting, and who can feel a

pleasure in its pursuit when united with the contemplation of Nature.

Perhaps the Author with an over-weening affection for these scenes may estimate them too highly, and may have dwelt too exclusively upon them; but interwoven as they are with his thoughts, it would have been difficult to have avoided doing so; besides, every recollection associated with the Vale of Dedham must always be dear to him, and he delights to retrace those scenes, 'where once his careless childhood strayed,' among which the happy years of the morning of his life were passed, and where by a fortunate chance of events he early met those, by whose valuable and encouraging friendship he was invited to pursue his first youthful wish, and to realize his cherished hopes, and that ultimately led to fix him in that pursuit to which he felt his mind directed: and where is the student of Landscape, who in the ardour of youth, would not willingly forego the vainer pleasures of society, and seek his reward in the delights resulting from the love and study of Nature, and in his successful attempts to imitate her in the features of the scenery with which he is surrounded, so that in whatever spot he may be placed, he shall be impressed with the beauty and majesty of Nature under all her appearances, and, thus, be led to adore the hand that has, with such lavish beneficence, scattered the principles of enjoyment and happiness throughout every department of the Creation. It was in scenes such as these, and he trusts with such a feeling, that the Author's ideas of Landscape were formed; and he dwells on the retrospect of those happy days and years of 'sweet retired solitude,' passed in the calm of an undisturbed congenial study, with a fondness and delight which must ever be to him a source of happiness and contentment.

> Nature! enchanting Nature! in whose form
> And lineaments divine I trace a hand
> That errs not, and find raptures still renew'd,
> Is free to all men — universal prize.

Constable's letterpress, written 1833-34, to accompany *Frontispiece, Paternal House and Grounds*

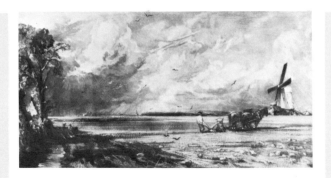

2. Spring. East Bergholt Common, Hail Squalls. — Noon

Based on *Spring: East Bergholt Common* (Pl. 2), 1829?, oil on panel, 7½ × 14¼in, 19.0 × 36.2cm, Victoria & Albert Museum, London (144-1888).
Issued in Part 1, June 1830.

A view of Pitt's mill near East Bergholt, the Constable family windmill, looking towards Holton Church. Constable worked here as a boy and showed his true inclination, whiling away his time in 1792 by carving a windmill on one of the mill's timbers. Lucas the engraver recorded: 'from this Mill his earliest observations on atmospheric phoenomena where made and his deep Knowledge acquired that so materially contributed to his successful practice ... [some] accompanying diagrams are curious to shew his anxiety that all should be mechanically correct in the representation of this Mill and where drawn by him that I might correctly understand the mechanical construction of the vanes in order to avoid a common fault to be found in the Wind mills of uninformed artists in Making Sails as they are commonly called that no amount of wind would be able to turn round.'

The painting was based on two sketches, one dated 19 April 1821. In the painting, however, there seems to be too much leaf on the trees for so early a date in the year and it seems possible that the painting was made in the studio in 1829 especially for Lucas, as were most of the first subjects to be engraved.

> Hence the breath
> Of life informing each organic frame;
> Hence the green earth, and wild resounding waves;
> Hence light and shade alternate, warmth and cold,
> And bright and dewy clouds, and vernal show'rs,
> And all the fair variety of things.

This plate may perhaps give some idea of one of those bright and animated days of the early year, when all nature bears so exhilarating an aspect; when at noon large garish clouds, surcharged with hail or sleet, sweep with their broad cool shadows the fields, woods, and hills; and by the contrast of their depths and bloom enhance the value of the vivid greens and yellows, so peculiar to this season; heightening also their brightness, and by their motion causing that playful change, always so much desired by the painter.

The natural history — if the expression may be used — of the skies above alluded to, which are so particularly marked in the squalls at this time of the year, is this: — the clouds accumulate in very large and dense masses, and from their loftiness seem to move but slowly: immediately upon these large clouds appear numerous opaque patches, which, however, are only small clouds passing rapidly before them, and consisting of isolated pieces, detached probably from the larger cloud. These floating much nearer the earth, may perhaps fall in with a stronger current of wind, which as well as their comparative lightness, causes them to move with greater rapidity; hence they are called by windmillers and sailors 'messengers,' being always the forerunners of bad weather. They float about midway in what may be termed the *lanes* of the clouds; and from being so situated, are almost uniformly in shadow, receiving only a reflected light from the clear blue sky immediately above, and which descends perpendicularly upon them into these *lanes*. In passing over the bright parts of the large clouds, they appear as 'darks'; but in passing the shadowed parts they assume a gray, a pale, or lurid hue ...

Constable's letterpress, written 1833-34, to accompany *Spring*

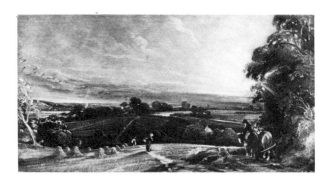

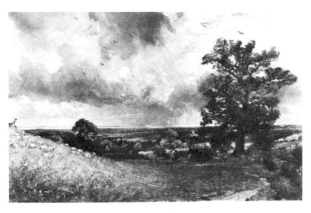

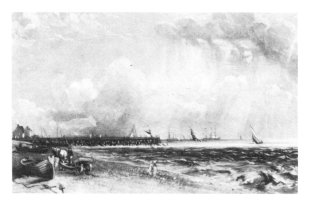

3. Sunset. Peasants returning homeward or *Autumnal Sunset*

Based on *Autumnal Sunset* (Pl. 3), 1813, oil on paper laid on canvas, 6¾ × 13¼in, 17.1 × 33.6cm, Victoria & Albert Museum, London (127-1888).
Issued in Part 5, July 1832.

Taken where the lane from Constable's studio dips to Vale Farm looking westward to Langham Church, seen in the engraving on the left, Stratford St. Mary Church, centre (between trees) and Stoke-by-Nayland Church silhouetted on the hilltop to the right. Although the path now takes a slightly different route by the side of the field from Vale Farm, the view is perfectly recognisable today. A sketch dated 13 July 1813 shows exactly the same view with a child walking on the path through head-high corn. The oil-sketch selected by Constable for engraving shows stubble in the field after the harvest. The engraving is set a little earlier, for it shows the corn stooks still in the field. To the right a figure with two horses surveys the scene, perhaps the ploughman contemplating the work which now needs to be done.

Rooks again play a leading role in the work, winging their way back to the rookery for the night. Their importance was one of the reasons for the delays in engraving. On 2 June 1832 Constable complained to Lucas: 'The evening, is spoiled owing to your having fooled with the rooks — they were the cheif [sic] feature, which caused me to adopt the subject. Nobody knew what they are — but took them for blemishes on the plate ...' (IV 376).

4. Noon. — The West-End Fields, Hampstead or *Summer Noon, The West End Fields, Hampstead*

Based on *West End Fields, Hampstead: Noon* (Pl. 4), c. 1824?, oil on canvas, 13 × 20½in, 33 × 52cm, National Gallery of Victoria, Melbourne (467/2).
Issued in Part 2, 29 Dec. 1830 (IV 338).

West End was a hamlet on the Finchley Road, now swallowed up in West Hampstead. West End Lane began near Hampstead Church, and the viewpoint of this picture may be quite near the church, where the land falls away to the west quite steeply. Lucas described the view as 'looking over the West end/fields Hampstead. Berkshire and Windsor Castle in the extreme distance the Windmill on the hill is at Kilburn.' The same windmill appears in the view of approximately the same stretch of the Thames Valley seen from Branch Hill Pond. This was also engraved for 'English Landscape' (Pl. 9).

Apart from the vignette (No. 22), this was the first Hampstead subject to be included in 'English Landscape'. Why he chose it is a mystery, except that he evidently felt the series needed a pastoral subject at the time. It is quite unrepresentative of Constable's Hampstead work as a whole and is the only occasion on which he painted this view — it was not near any of his known residences at Hampstead.

5. Yarmouth Pier, Norfolk. — Morning Breeze

There are three accepted versions of the composition *Yarmouth Jetty*, first exhibited at the British Institution in 1823 (148), but it is not known on which, if any, the engraving was based. All three were exhibited at the Tate Gallery in 1976 (213, 214, 215), and a full discussion of the problems is given in the catalogue. Presumably the engraving was based on the picture exhibited at the Royal Academy in 1831 (123) as 'Yarmouth pier'. This seems unlikely to have been the same as that exhibited in 1823, for which the version dated 1822 (Tate 1976 No. 213) is the most likely candidate. Of those remaining, that produced here (Pl. 5), from a private collection loan to the Laing Art Gallery, Newcastle, oil on canvas 13 × 20½in, 33 × 52.1cm, seems much stronger than that at the Tate Gallery, London (T.2650, Parris 1981 No. 26).
Issued in Part 5, July 1832.

Constable's seapieces were very popular. On 18 April 1823 he told Fisher: 'I Have not a sea piece — or *"Windmill Coast Scene" "at all"*. I gave it to Gooch [the family doctor] for his kind attention to my children. Half an hour ago I received a letter from Woodburne to purchase one of my seapieces — but I am without one — they are much liked.' On 23 July 1831 he recalled: 'Dr Gooch used to put a ... picture of Yarmouth — which I did for him on the sopha while he breakfasted as he used to say on the seashore enjoying it breezes'.

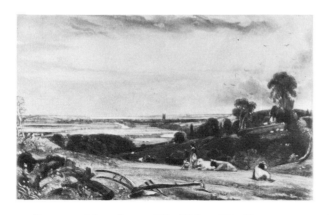

the left of Langham Church on the distant hillside. It is possible that Constable did, in fact, exhibit a version of this view, for an 1813 exhibit (No. 325) 'Landscape: Morning' has not yet been identified.

A number of changes were made between the painting and engraving. The figure in the oil-sketch has been replaced by a milkmaid, two more cows have appeared and a plough has been brought into the field. Constable was concerned about the accuracy of his ploughs and that shown here was carefully recorded in an oil-sketch on 2 November 1814. Only the High Gallows plough was

used around East Bergholt (see Pl. 15), and the Suffolk swing plough, seen here, in the heavier soil elsewhere in the country. A true countryman would have been able to tell what part of the world he was looking at from this detail alone.

It is interesting that during the work on the engraving, Constable allowed the milkmaid to turn from attending to her cows to admire the landscape as we do. The 'breezy freshness, the serenity and the cheerfulness' which she enjoys was made the theme of Constable's letterpress:

6. Summer Morning.— The Vale of Dedham or
Summer Morning. Harwich Harbour in the Distance or
Summer Morning. The Home-Field. Dedham

Based on a sketch *Summer Morning: Dedham from Langham* (Pl. 6), 1812, oil on canvas, 8½ × 12in, 21.6 × 30.5cm, Victoria & Albert Museum, London (1832-1888). Issued in Part 3, Sep. 1831.

This view of Dedham Vale from near Langham Church was sketched and painted many times by Constable. Stratford village can be seen to the left, East Bergholt on the hill above, Dedham Church silhouetted against Harwich Water, and Dedham Mill above the Stour to the left. The well-known view of Dedham Vale from Gun Hill (Pl. 42) was taken from beyond the trees above the milkmaid in the engraving.

The oil-sketch was probably made in 1812, not long before the *Dedham from Langham* dated 13 July 1812 in the Ashmolean Museum, Oxford, which was used for the general lighting effect, the rooks, and the middle-distance figures and cows in the engraving. It has been suggested that Constable was thinking about exhibiting a picture of this view at the Royal Academy in 1813, to continue the theme established by *Dedham Vale: Morning* exhibited in 1811 (Ill. 3) and *Summer Evening* (Pl. 7) exhibited as 'Landscape: Evening' in 1812, which show the view from Bergholt looking in this direction. The viewpoint of the present picture can be made out in both, in the fields to

The morning shines, and the fresh field
Calls on; we lose the prime, to mark how spring
The tender plants.
How Nature paints her colours: how the bee
Sits on the bloom extracting liquid sweets.

The morning — from the dawn to the hour when the sun has gained greater power, and higher above the horizons, "flames in the forehead of the eastern sky" — has always been marked as one of the most grateful by the lovers of Nature; nor is there any time more delicious or exhilarating. The breezy freshness, the serenity, and cheerfulness which attend the early part of the day, never fail to impart a kindred feeling to every living thing, and doubtless the most sublime and lovely descriptions of the poets are those which relate to the Morning.
perfection than at about nine o'clock in the mornings of July and August, when the sun has gained sufficient strength to give splendour to the landscape, "still gemmed with the morning dew", without its oppressive heat; and it is still more delightful if vegetation has been refreshed with a shower during the night.

It may be well to mention the different appearances which characterize the Morning and Evening effects. The dews and moisture which the earth has imbibed during the night cause a greater depth and coolness in the shadows of the Morning; also, from the same cause, the lights are at that time more silvery and sparkling; the

lights and shadows of Evening are of a more saffron or ruddy hue, vegetation being parched during the day from the drought and heat.

And Sture, that parteth with his pleasant floods
The Eastern Saxons from the Southern nigh,
And Clare, and Harwich both doth beautify.

This view of the beautiful valley of the Stour — the river that divides the counties of Suffolk and Essex — is taken from Langham, an elevated spot to the N.W. of Dedham, where the elegance of the tower of Dedham church is seen to much advantage, being opposed to a branch of the sea at Harwich, where this meandering river loses itself. This tower from all points forms a characteristic feature of the Vale; it was the gift of Margaret, Countess of Richmond, mother of Henry VII.

The chancel of Dedham church is perhaps unequalled in the beauty of its proportion and details, especially the windows, which are lofty and of the most graceful forms: it is a fine instance of what the style of architecture termed Gothic is capable of, when in the hands of a master. In it is a stately monument, erected to the memory of the Reverend William Burkitt, M.A., Vicar of this parish, the excellent commentator on the New Testament...

From Constable's letterpress written 1833-34 to accompany *Summer Morning*

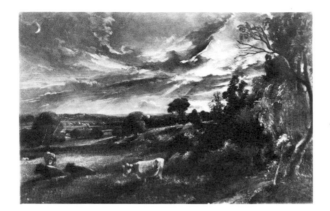

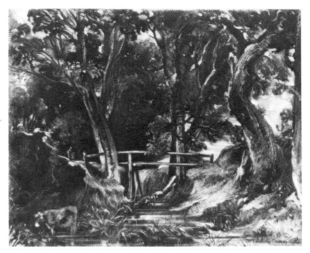

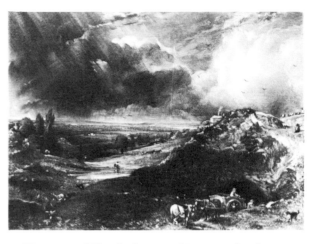

7. Summer Evening. — A Homestead, Cattle reposing or *Summer Evening. Cattle Reposing. East Bergholt*

Based on *Summer Evening View near East Bergholt showing Langham Church, Stratford Church and Stoke-by-Nayland* (Pl. 7), exhibited at the Royal Academy, 1812 (No. 72, 'Landscape: Evening'), oil on canvas, 12½ × 19½in, 31.7 × 49.5cm, Victoria & Albert Museum, London (585-1888).
Issued in Part 3, Sep. 1831.

On 12 November 1811 Constable described his summer's work: 'I have tried Flatford Mill again, from the lock [Ill. 16] ... and some smaller things, one of them (a view of Mrs Roberts's Lawn, by the summer's evening) — has been quite a pet with me.' Mrs. Sarah Roberts lived at West Lodge (now called 'Stour') across the street from Constable's home. The grounds, more knee-deep pasture in this case than 'Lawn', were a favourite resort of the artist, so much so that on 12 August 1809 Constable's mother could report: 'Mrs Roberts ... says she always thinks of you at the setting sun, thro' her trees.' The viewpoint of the present picture is in Flatford Lane, which appears in the bottom right-hand corner, not far from the church, looking across the grounds of West Lodge to Langham on the hillside to the left and Stratford St. Mary Church in the centre.

8. Dell in the Woods of Helmingham Park. — Autumn

Based on *Helmingham Dell* (Pl. 8), 1823, oil on canvas, 40½ × 50¾in, 103 × 129cm, Louvre, Paris (RF 1948.5).
Issued in Part 1, June 1830.

Helmingham Park is about 16 miles from East Bergholt, north of Ipswich. It was the Suffolk seat of the Earl of Dysart of Ham House near Richmond in Surrey. Constable was particularly proud of the Dysarts' patronage and he often visited the widowed Countess at Ham. His first recorded visit to Helmingham is 25 July 1800 when he wrote: 'Here I am quite alone amongst the oaks and solitude of Helmingham Park. I have quite taken possession of the parsonage finding it quite empty. A woman comes from the farm house (where I eat) and makes the bed, and I am left at liberty to wander where I please during the day. There are abundances of fine trees of all sorts; though the place upon the whole affords good subjects rather than fine scenery; ... I have made one or two drawings that may be useful.' One such drawing became the basis of several paintings and the present engraving. The wooden bridge was replaced by a stone one in 1815, but the twisted elm at the right is quite recognisable today.

9. Hampstead Heath, Stormy Noon. — Sand Diggers

Based on *Hampstead Heath: Branch Hill Pond* (Pl. 9), exhibited at the Royal Academy, 1828 (No. 7 or 232, both entitled 'Landscape'), oil on canvas, 23½ × 30½in, 59.6 × 77.6cm, Victoria & Albert Museum, London (FA 35).
Issued in Part 3, Sep. 1831.

Constable sketched the view looking south-west over Branch Hill Pond past the Salt Box to Kilburn and the Thames Valley on his first visit to Hampstead in 1819 and on many subsequent occasions, but took nine years to come round to considering his first impression of 1819 in an exhibited picture. As Graham Reynolds has pointed out, 1828 was a reflective year for Constable. His other exhibit at the Academy, *Dedham Vale* (Pl. 42) was a reworking of his first concept of that scene.

Constable was perhaps lucky that this picture passed the hanging committee. The Academy had a rule that the same picture or composition could not be exhibited twice. In 1825 he had exhibited a view looking in almost exactly the same direction (see Pl. 37). The pond has dried up today and the view to the distance and the left is mostly obscured by housing along Branch Hill Road.

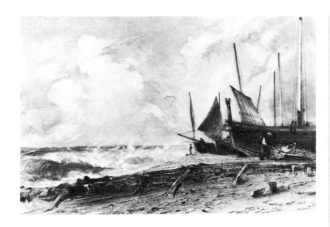

10. A Sea Beach, Brighton, Heavy Surf. — Windy Noon

Based on the sketch *A Sea Beach, Brighton* (Pl. 10), *c.*1824, oil on paper laid on canvas, 12⅝ × 19¾in, 32.1 × 50.2cm, Detroit Institute of Arts (53.364).
Issued in Part 2, 20 Dec. 1830.

On 9 December 1835 Constable told Leslie that a customer had asked for 'a picture which I have not got nor ever had. But through the kindness of your sister he has seen the book ['English Landscape'] and has taken a liking to the "Sea Beach" — thinking, no doubt, that it was done from something more than the sketch'. It is interesting that Constable should have represented Brighton with a sketch that includes no sign of the town, especially when one considers that he still had in his studio the large picture of *The Chain Pier, Brighton* (Ill. 25) which he had exhibited at the Academy in 1827. Brighton itself did not appeal to him, however, and he preferred his beach, waves and sky untainted by the pleasures of the resort. This sketch is typical of the work he produced at Brighton while his wife sought relief from consumption. At first glance it may seem slight, scrappy and careless, but closer contemplation is amply repaid. Note, for example, the luminosity of the wave trough at the left, and the almost palpable presence of the wind whipping flecks of foam from the wave crests.

But nearer land you may the billows trace,
As if contending in their watery chase;
Curl'd as they come they strike with furious force
And then re-flowing, take their grating course.

The magnitude of a coming wave when viewed beneath the shelter of a Groyne — and which is the subject of the present plate — is most imposing; as, from being close under it, it seems overwhelming in its approach — at the same time, from its transparency, becoming illumined by the freshest and most beautiful colours . . .

Of all the works of the Creation none is so imposing as the Ocean; nor does Nature anywhere present a scene that is more exhilarating than a sea-beach, or one so replete with interesting material to fill the canvass of the Painter; the continual change and ever-varying aspect of its surface always suggesting the most impressive and agreeable sentiments, — whether like the Poet he enjoys in solitude 'The wild music of the waves,' or when more actively engaged he exercises his pencil amongst the busy haunts of fishermen, or in the bustle and animation of the port or harbour.

It is intended in this print to give one of those animated days when the masses of clouds, agitated and torn, are passing rapidly; the wind at the same time meeting with a certain set of the tide, causes the sea to rise and swell with great animation; when perhaps a larger wave, easily distinguished by its scroll-like crest, may be seen running along over the rest coming rapidly forward; on nearing the shore it curls over, then in the elegant form of an alcove suddenly falling upon the beach, it spreads itself and retires. In such weather the voice of a solitary sea-fowl is heard from time to time 'Mingling its note with those of wind and wave'; when he may be observed beating his steady course for miles along the beach just above the breakers, and ready 'To drop for prey within the sweeping surge.' These birds, whether solitary or in flocks, add to the wildness and to the sentiments of melancholy always attendant on the ocean . . .

From Constable's letterpress, written 1833-34, to accompany *A Sea Beach*

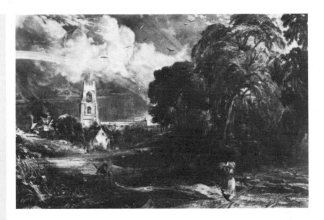

11. Stoke Church, by Neyland, Suffolk. — Rainbow at Noon

Started from an unknown work, but later based on the sketch *Stoke-by-Nayland* (Pl. 11), *c.*1829, oil on paper laid on card, 9¾ × 13in, 24.8 × 33.0cm, Victoria & Albert Museum, London (150-1888).
Issued in Part 2, 20 Dec. 1830.

Constable had very little interest in ruins or historic buildings. The print-buying public, however, loved them, and the only buildings of any description to feature in Part 1 of 'English Landscape' were the two mills in which the artist had worked as a boy. The church of Stoke-by-Nayland was drafted into Part 2 to fill the gap.

Stoke is about seven miles west of East Bergholt and Constable passed through occasionally, especially around 1810-11 when visiting his Aunt Martha in Nayland in connection with the altarpiece he was painting for St. James's Church. He made a number of sketches of Stoke about this time. At an early stage during the development of the engraving the church was moved to the left (its ghost can be seen in some impressions midway between the tower and the trees) and a rainbow was introduced. Constable wrote about the natural history and poetry of the rainbow in his letterpress, paying tribute to what was a central image throughout his career. He also managed to find a good deal of historical material to go with it.

Through the lighten'd air
A higher lustre and a clearer calm
Diffusive tremble.

The solemn stillness of Nature in a Summer's Noon, when attended by thunder-clouds, is the sentiment attempted in this print; at the same time an endeavour has been made to give an additional interest to this Landscape by the introduction of the Rainbow, and other attending circumstances that might occur at such an hour. The effect of light and shadow on the sky and landscape are such as would be observed when looking to the northward at noon; that time of the day being decidedly marked by the direction of the shadows and the sun shining full on the south side of the Church.

Of the Rainbow — the following observations can hardly fail to be useful to the Landscape Painter. When the Rainbow appears at Noon, the height of the sun at that hour of the day causes but a small segment of the circle to be seen, and this gives the Bow its low or flat appearance: the Noonday-bow is therefore best seen 'Smiling in a Winter's day,' as in the Summer, after the sun has passed a certain altitude, a Rainbow cannot appear: it must be observed that a Rainbow can never appear foreshortened, or be seen obliquely, as it must be parallel with the plane of the picture, thought a part of it only may be introduced; nor can a Rainbow be seen through any intervening cloud, however small or thin, as the reflected rays are dispersed by it, and are thus prevented from reaching the eye; consequently the Bow is imperfect in that part. Nature, in all the varied aspects of her beauty, exhibits no feature more lovely nor any that awaken a more soothing reflection than the Rainbow, 'Mild arch of promise'; and when this phaenomenon appears under unusual circumstances it excites a more lively interest. This is the case with the 'Noon-tide Bow,' but more especially with that most beautiful and rare occurrence, the 'Lunar Bow.' The morning and evening Bows are more frequent than those at noon, and are far more imposing and attractive from their loftiness and span; the colours are also more brilliant, 'Flashing brief

splendour through the clouds awhile.' For the same reason the exterior or secondary Bow is at these times also brighter, but the colours of it are reversed. A third, and even fourth Bow, may sometimes be seen, with the colours alternating in each; these are always necessarily fainter, from the quantity of light lost at each reflection within the drop, according to the received principle of the Bow. Perhaps more remains yet to be discovered as to the cause of this most beautiful Phenomenon of Light, recent experiments having proved that the primitive colours are further refrangible. Though not generally observed, the space within the Bow is always lighter than the outer portion of the cloud on which it is seen. This circumstance has not escaped the notice of the Poet, who with that intuitive feeling which has so often anticipated the discoveries of the Philosopher, remarks:

And all within the arch appeared to be
Brighter than that without.

Suffolk, and many of the other eastern counties, abounds in noble Gothic Churches: the size of many of them, and seen as they now are standing in solitary and imposing grandeur in neglected and almost deserted spots, imparts a peculiar sentiment, and gives a solemn air to even the country itself, and they cannot fail to impress the mind of the stranger with the mingled emotions of melancholy and admiration. These magnificent structures are often found in scattered villages and sequestered places, out of the high roads, surrounded by a few poor dwellings, the remains only of former opulence and comfort; but ill according with such large and beautiful speciments of architecture. These spots were once the seats of the clothing manufactories, so long established in these counties, and which were so flourishing during the reigns of Henry VII and VIII being greatly increased by the continual arrival of the Flemings, bringing with them the bay trade, who found here a refuge from the cruel persecutions of their own Country, enjoying many privileges in return for their skill and industry; and also afterwards, when by a wise policy still greater encouragement was held out to

them by Elizabeth, whom the course of events had raised to be the glory and support of Protestant Europe. The venerable grandeur of these religious edificces, with the charm that the mellowing hand of time hath cast over them, gives them an aspect of extreme solemnity and pathos; and they stand lasting and impressive monuments of the power and munificence of our Ecclesiastical Government. The church of Stoke, though by no means one of the largest, must be classed with these: it was probably erected about the fifteenth century; and there is reason to suppose that the same architect also built the two neighbouring churches, Lavenham and Dedham. The nave of Stoke church, with its long continued line of embattled parapet, the finely proportioned chancel, with the bold projection of the buttresses throughout the building, would be the admiration of the student, while its grandest feature the Tower, from its commanding height, seems to impress on the surrounding country its own sacred dignity of character.

In this Church are many interesting monuments, giving their frail memorial of departed worth and power: amongst them are several of the noble family of the Howards; one in particular, in the south part between the high altar and the choir, where is interred, 'The Right Honourable Woman and Ladye, Catherine, some time Wife unto John Duke of Norfolke,' who fell at the Battle of Bosworth Field. She died AD 1452. Also one to Margaret, second wife of the Duke. Here, as well as at Nayland, are many tombstones of the clothiers; being mostly laid on the pavement they are much worn and defaced, but are known to belong to them by peculiar small brasses in the form of a shield still remaining, on which are engraved the figure used by the defunct as 'The mark' by which his own manufactures were known, and usually here applied as supplying the place of armorial bearings . . .

From Constable's letterpress, written 1833-34, to accompany *Stoke Church, by Neyland*

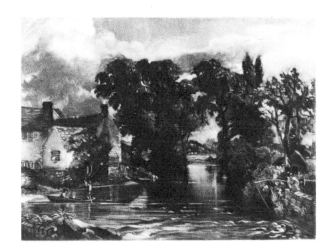

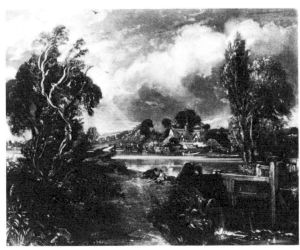

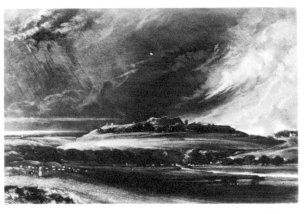

14. Mound of the City of Old Sarum. — Thunder Clouds

12. River Stour, Suffolk, near Flatford Mill. — An Avenue or *Mill Stream*

Based on *The Mill Stream* (Pl. 12), *c.*1812(?), oil on canvas, 28 × 36in, 71.1 × 91.5cm, Ipswich Borough Council, Christchurch Mansion, Ipswich.
Issued in Part 3, Sep. 1831.

Constable painted an oil-sketch of this view of Willy Lott's cottage from the forecourt of Flatford Mill, possibly in 1811. The larger painting engraved in 'English Landscape' was no doubt begun soon after. Constable used a similar viewpoint, a few yards to the left, for *The Hay Wain* (Ill. 13) in 1821. The running water in the foreground represents the tail-race of the mill at Constable's back, and the parapet at the right from which a boy is fishing reappears at the extreme right of *The Hay Wain*. A ferry carried passengers from Willy Lott's across the mill pool and through a cutting just beyond the parapet to reach the opposite bank of the Stour. This cutting is more clearly seen in *The Hay Wain*. In 1814 Constable exhibited a picture of the view through the cutting to Willy Lott's, and returned to the subject towards the end of his life in 1835 in *The Valley Farm* (Ill. 14). By that time the subject had lost the youthful freshness it has here. The scene is perfectly recognisable today.

13. Head of a Lock on the Stour. — Rolling Clouds

Based on *Landscape: Boys fishing* (Pl. 13), exhibited Royal Academy 1813 (266), oil on canvas, 40 × 49½in, 101.6 × 125.8cm, National Trust, Fairhaven Collection, Anglesey Abbey, Cambridgeshire.
Issued in Part 4, Nov. 1831.

Constable was unusually satisfied with this plate and wrote to Lucas on 31 August 1831 to tell him so: 'I like the Head of the lock exceedingly'. The view from the head of Flatford Lock to Flatford Bridge and Bridge Cottage is perfectly recognisable today. Constable added the detail of Dedham Church at the extreme left of the engraving to make the location even more particular.

Constable exhibited this picture at the Royal Academy in 1813 and again at the British Institution the following year, where it was bought by the bookseller James Carpenter. His uncle, David Pike Watts, had been considering buying it but was unhappy with the degree of finish. When Constable sold the picture elsewhere he wrote to his uncle, on 12 April 1814: '... the picture has become the property of Mr Carpenter, who purchased it this morning. He is a stranger, and bought it because he liked it'. Paid £20 in cash and books *in lieu*.

Based on the sketch *Old Sarum* (Pl. 14), 1829, oil on card, 5⅝ × 8¼in, 14.3 × 21.0cm, Victoria & Albert Museum, London (163-1888).
Issued in Part 2, 20 Dec. 1830.

Constable made visits to Old Sarum, just north of Salisbury, while staying with John Fisher in 1820 and 1829. The barren scene may have seemed appropriate after his wife's death in November 1828. On 20 July 1829 he made two sketches, the first at noon and another in the evening under more dramatic conditions. The oil-sketch shows Old Sarum from the south, based on the drawing made at noon, but shows the stormy conditions observed later in the day and the light comes from the left, in fact the north-west, as it does on a summer's evening.

In 1829 he sent a proof to Sir Thomas Lawrence, and on 27 October received a note of acknowledgement: 'Many thanks My Dear Sir, for the Print you have sent me, which is exceedingly well executed... I suppose you mean to dedicate it to The House of Commons?'. This may have been a reference to the fact that before Reform in 1832 Old Sarum returned two members to Parliament. It had a population of seven. It may also have been to acknowledge the fact that the first Parliament was held in the city of Old Sarum in the reign of King John.

The pomp of Kings, is now the Shepherd's humble pride.

In no department of Painting is the want of its first attractive quality, 'General Effect,' so immediately felt, or its absence so much to be regretted, as in Landscape; nor is there any class of Painting, where the Artist may more confidently rely on the principles of 'Colour' and 'Chiar'oscuro' for making his work efficient. Capable as this aid of 'Light and Shadow' is of varying the aspect of everything it touches, it is, from the nature of the subject, nowhere more required than in Landscape; and happily there is no kind of subject in which the Artist is less controlled in its application: he ought, indeed, to have these powerful organs of expression entirely at his command, that he may use them in every possible form, as well as that he may do so with the most perfect freedom; therefore, whether he wishes to make the subject of a joyous, solemn, or meditative character, by flinging over it the cheerful aspects which the sun bestows, by a proper disposition of shade, or by the appearances that beautify its rising or its setting, a true 'General Effect' should never be lost sight of by him throughout the production of his work, as the sentiment he intends to convey will be wholly influenced by it.

The subject of this plate, which from its barren and deserted character seems to embody the words of the poet — 'Paint me a desolation,' — is grand in itself, and interesting in its associations, so that no kind of effect could be introduced too striking, or too impressive to portray it; and among the various appearances of the elements, we naturally look to the grander phenomena of Nature, as according best with the character of such a scene. Sudden and abrupt appearances of light, thunder clouds, wild autumnal evenings, solemn and shadowy twilights, 'flinging half an image on the straining sight,' with variously tinted clouds, dark, cold, and gray, or ruddy and bright, with transitory gleams of light, even conflicts of the elements, to heighten, if possible, the sentiment which belongs to a subject so awful and impressive.

'*Non enim hic habemus stabilem civitatem.*' The present appearance of Old Sarum — wild, desolate, and dreary — contrasts strongly with its former greatness. This proud and 'towered city,' once giving laws to the whole kingdom — for it was here our earliest parliaments on record were convened can now be traced but by vast embankments and ditches, tracked only by sheep-walks: 'The plough has passed over it.' It was on this spot the wily Conqueror, in 1086, confirmed that great political event, the establishment of the feudal system, which enjoined the allegiance of the nobles; other succeeding monarchs held their courts here, but during these periods, much must always be involved in that almost impenetrable gloom, which clouds the dark history of our Middle Ages; yet, doubtless, many were the ruthless acts of tyranny and deeds of violence perpetrated on this far-famed mount, but which have, alike with their agents, sunk into that repose of which its present appearance presents so striking an image. In the days of chivalry, it poured forth its Longspees and other valiant knights over Palestine. It was the seat of the ecclesiastical government, when the pious Osmond and the succeeding bishops diffused the blessing of religion over the western part of the kingdom; thus it became the resort of ecclesiastics and warriors, 'Of throngs of knights and barons bold,' till their feuds, and mutual animosities, augmented by the insults of the soldiery, at length caused the separation of the clergy, and the transfer of the cathedral from within its walls, which took place in 1227, and this event was followed by the removal of the most respectable inhabitants. In less than half a century after the completion of the new church, the building of a bridge adjoining it over the river at Harnham diverted the great western road, and turned it from the old through the new city. This last step completed the desertion, and led to the final decay of Old Sarum. The site now only remains of this once proud and populous city, whose almost impregnable castle, and lofty and embattled walls, whose churches, and even every vestage of human habitation, have long since passed away.

The beautiful imagination of the poet Thomson, when he makes a spot like this the haunt of a shepherd with his flock, happily contrasts the playfulness of peaceful innocence with the horrors of war and bloodshed, of which it was so often the scene:—

Lead me to the mountain's brow,
Where sits the shepherd on the grassy turf
Inhaling healthful the descending sun.
Around him feeds his many-bleating flock,
Of various cadence; and his sportive lambs,
This way and that convolv'd, in friskful glee,
Their frolics play. And now the sprightly race
Invites them forth: when swift the signal giv'n
They start away, AND SWEEP THE MASSY MOUND
THAT RUNS AROUND THE HILL, THE RAMPART ONCE
OF IRON WAR' in ancient barbarous times,
When disunited BRITAIN ever bled.

Constable's letterpress, written 1833-34 to accompany *Mound of the City of Old Sarum*

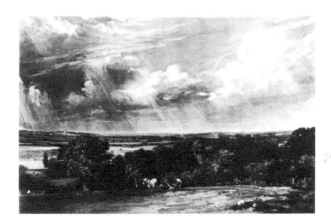

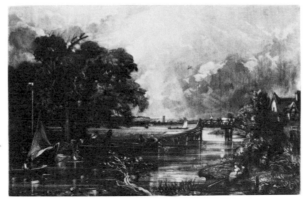

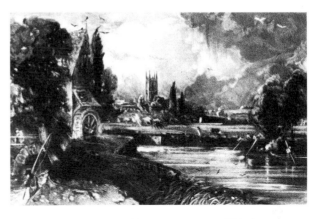

15. A Summerland, Rainy Day; Ploughmen. — Noon

Based on *Landscape: Ploughing Scene in Suffolk (A Summerland)* (Pl. 15), exhibited Royal Academy 1814 (28), oil on canvas, 20¼ × 30¼in, 51.4 × 76.8cm, Private collection.
Issued in Part 4, Nov. 1831

This view is taken from Flatford Lane, about 200 yards beyond the junction with Fen Bridge Lane, looking west to Langham Church, seen on the hillside to the left, Stoke-by-Nayland Church on the skyline towards the right, with Stratford St. Mary Church slightly below to the right. The same tree stump in the hedgerow can be seen from the other side in a sketch made the following year (Ill. 8).

A 'summerland' is land ploughed and left fallow during the summer before being manured and sown with winter wheat for harvest the following year. This painting shows the field in 1813. The sketch made on 5 September 1814 (Ill. 8) shows the wheat being harvested. It is remarkable evidence of Constable's interest in farming cycles that his pictures can be related to one another in this way. His interest in ploughing has already been discussed (Mezzotint 6). Here we see the High Gallows plough in action as in *Spring* (Pl. 2).

16. Barges on the Stour: Gleams of Light on the Meadows or *Scene on the River Stour, Suffolk*

Based on the full-scale sketch *View on the Stour near Dedham* (Pl. 16), 1822, oil on canvas, 51 × 73in, 129.4 × 185.3cm, Royal Holloway College, University of London.
Issued in Part 4, Nov. 1831.

The view west from the entrance to the boat dock at Flatford (Ill. 11) to Flatford Bridge and Bridge Cottage at the right, and Dedham Church in the distance.

Constable used this sketch as the basis of the picture exhibited at the Academy in 1822 as 'View on the Stour, near Dedham'. In 1824 this was bought by the Paris dealer John Arrowsmith and exhibited with *The Hay Wain* (Ill. 13) at the Paris Salon where it won the gold medal of Charles X. One detail which did not appear in the finished picture was the two children fishing in the foreground. In the engraving the left one has become more obviously a girl. Constable may have been recalling his holiday at Flatford in 1827 with his eldest children John and Minna: 'Minna looks so nice in her pelisse,' he reported, 'and . . . John is crazy about fishing — he caught 6 yesterday and 10 today, some of which we are going to have for dinner . . . Minna caught two fish this morning!'

17. A Water Mill, Dedham. — Burst of Light at Noon or *An Undershot Mill, Dedham, Essex*

Based on the sketch *Dedham Mill* (Pl. 17), c.1816, oil on paper laid on canvas, 7 × 11¾in, 18 × 30cm, present whereabouts unknown.
Issued in Part 1, June 1830.

Dedham Mill lies to the north of the village and was the largest of the mills operated by Constable's father. The present view looks west across the mill building to the lock and over the meadows towards Stratford Bridge and Langham. The mill is much changed but the millrace pool and the layout of the lock are still recognisable. This is Constable's only known view of the mill from this angle, and it seems possible that the sketch is an early one, made direct from the motif, reworked with impasto for the engraving. It is a remarkably uninformative view, and although it seems to have been chosen purely for the sake of its chiaroscuro (see letterpress below) Constable included the tower of Dedham Church, quite inaccurately, in the engraving to add interest to the subject. Less than six months after this was published, however, Constable was considering having a 'Dedham Lock' engraved for Part 5, presumably a version of the more informative view exhibited at the Academy in 1818 (Ill. 6).

The subject of this print is little more than assemblage of material calculated to produce a rich Chiar'-oscuro, and is noticed solely with that view. A cloudy or stormy day at noon with partial bright and humid gleam of light over meadow scenery, and near the banks of rivers with trees, boats and buildings, are most desirable objects with a painter, who delights in Colour and Light and Shade. In this case, the middle tints are generally of a low tone and shades deep, and the lights few, and bearing a small proportion to the whole. This mode of treatment is perhaps most of all calculated for rich and solemn subjects, as it never fails to give importance to the most trivial scenery.

As the Mill, the subject of this print, is in the town and near the Church, it may not be irrelevant to fill this sheet with some little account of its beautiful church and town, so much the ornament of the rich and beautiful valley. In the pages on Stoke, notice has been taken of the clothing manufactories, which are so extensive in these eastern counties, and it was also noticed how early they must have been established in them. Dedham formed one of the most considerable, and was one of the last which survived. In proof of their early establishment in the county, we find that Richard de la Pole had a fulling mill here — this was in 1382, at least 450 years ago — and the whole county bears marks of it in the intersected roads, termed pack ways, and brooks and streams.

As in Stoke, in the Church are numerous monuments of the clothiers. There is a sentiment of melancholy in the mementos of an industrious race, of whom scarce a vestige remains. In the solemn aisle, damp-stained walls,

> And on the floor beneath
> Sepulchral stones appeared with emblems graven
> And foot-worn epitaphs — and some with small
> And skinny effigies of brass inlaid.

Constable's intended letterpress for *A Water Mill*, reconstructed from fragments in the family collection.

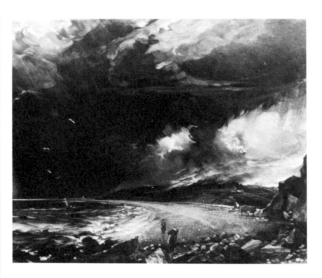

18. Weymouth Bay, Dorset. — Tempestuous Evening or *Weymouth Bay, Dorset. Tempestuous Afternoon*

Based on *Weymouth Bay* (Pl. 18), exhibited British Institution 1819 (44) as 'Osmington Shore, near Weymouth', oil on canvas, 34¾ × 44in, 88 × 112cm, Louvre, Paris (RF 39).
Issued in Part 1, June 1830.

In October 1816 Constable took his wife on honeymoon to stay with his friend John Fisher at Osmington, near Weymouth. Constable made a number of sketches in the area, from one of which the present picture was worked up for exhibition. About November 1830 Constable presented a proof to Mrs Leslie, writing: 'I shall now, to give value to the fragment I send you, apply to it the lines of Wordsworth —

> . . . "that sea in anger
> and that dismal shoar"

I think of "Wordsworth" for on that spot, perished his brother in the wreck of the Abergavenny'. John Fisher's wife, Mary, was a cousin of William and John Wordsworth, and the wreck would no doubt have coloured her response to her local beach.

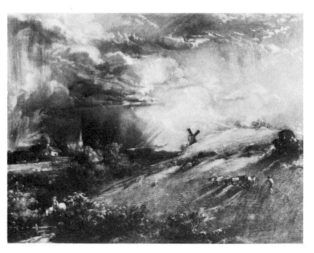

19. Summer Afternoon, Sunshine after a Shower or *Windmill at Redhill*

Based on the sketch, *Summer, Afternoon after a Shower* (Pl. 19), c.1828, oil on canvas, 13⅝ × 17⅛in, 34.5 × 43.5cm, Tate Gallery, London (1815).
Issued in Part 4, Nov. 1831.

'Immediately on alighting from the coach after one of his journeys either to or from Brighton, Constable made the beautiful sketch from which the engraving in the *English Landscape* . . . was taken; it was the recollection of an effect he had noticed near Red Hill.' According to Lucas, the painter John Jackson 'was so delighted with this sketch he offered to paint a picture any size in return for it which Mr C declined'. If the picture at the Tate is indeed the picture in question it is now difficult to understand quite what excited Jackson, to the extent that doubts have been cast on its authenticity. Constable wrote to Lucas on 29 September 1831: 'White Horse & Red Hill are lovely compositions. You may always have the large pictures from them'. *The White Horse* (Pl. 34) is six feet across, suggesting the possibility that a more considerable picture than that at the Tate has been lost. Lucas, however, described the picture as a sketch.

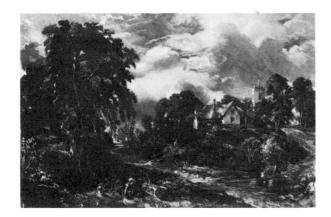

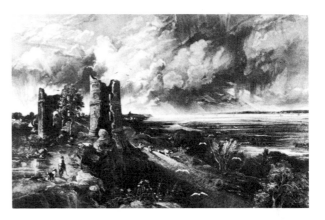

20. The Glebe Farm, Green Lane; Girl at a Spring

Based on *The Glebe Farm* (Pl. 20), *c*.1830, oil on canvas,
25½ × 37⅝in, 64.8 × 96.6cm, Tate Gallery,
London (1274).
Issued in Part 5, July 1832.

When Leslie visited the site of this painting at Langham in
1840 he found everything 'so much changed excepting
the church, that we could scarcely recognise it as the scene
of *The Glebe Farm*'. Although there is a farm next to the
church at Langham, the painting was developed from an
earlier sketch which did not include the church.
Constable was working on a version of the subject by 9
September 1826 when he wrote to John Fisher: 'My last
landscape [is] a cottage scene — with the Church of
Langham — the poor bishops first living ...'. Bishop
Fisher of Salisbury had been rector of Langham when
Constable first met him there about 1798. He died in 1825
and the picture was in many ways a tribute to him. Con-
stable considered engraving an unfinished version which
he had given to Leslie, but in the event the plate was based
on the more finished version. In 1836 when the collector
John Sheepshanks was making overtures to buy the pic-
ture Constable wrote to Leslie: 'Sheepshanks means to
have my Glebe Farm, or Green Lane, of which you have a
sketch. This is one of the pictures on which I rest my little
pretensions to futurity'.

20A. A Ruin or *Castle Acre Priory*

This plate was adapted from an earlier plate of *The Glebe
Farm* (Pl. 20) (see above). It was begun about Nov. 1830
from an unknown 'Sketch in a Lane'. By 23 Aug. 1831
Constable had abandoned this plate, writing to Lucas: 'I
wonder if the present Glebe Farm plate would work into
a new composition of the scene'. On 23 Jan. 1832 he
asked for two or three proofs of 'that small Glebe Farm
which was begun, with the burst of light!! ... for strain-
ing for experiments'. On 2 Oct. he wrote: 'I have added a
"Ruin" to the little Glebe Farm — for, *not* to have a
symbol in the book of myself, and of the 'Work' which I
have projected, would be missing the opportunity'. On
20 November 1832 he asked: 'Pray bring me some sort of
a proof of my Ruin that I may contemplate my fate —
God help us, for no doubt our mutual ruin is at hand'. At
about this time Constable seems to have been contem-
plating the addition of an appendix (to the bound sets of
published plates) including the *Ruin*. Although this did
not happen, Lucas issued the plate as an appendix himself
in 1838, and again, under the mistaken title of 'Castle
Acre Priory' in the '2nd Series', 1846.

21. The Nore, Hadleigh Castle. — Morning after a Stormy Night

Based on *Hadleigh Castle* (Pl. 21), exhibited at the Royal
Academy, 1829 (322 as *Hadleigh Castle. The mouth of the
Thames — morning, after a stormy night*), oil on canvas,
48 × 64¾in, 122 × 164.5cm, Yale Center for British Art,
New Haven, USA (B1977.14.42).
Issued in Part 5, July 1832.

Hadleigh Castle overlooks Canvey Island and the north
Thames marshes about five miles west of Southend. Con-
stable visited the ruins in 1814 and on 3 July wrote to
Maria Bicknell: 'At Hadleigh there is a ruin of a castle
which from its situation is really a fine place — it com-
mands a view of the Kent hills the nore and the north
foreland & looking many miles to sea.' On the same jour-
ney he reported that he had 'walked upon the beach at
South End. I was always delighted with the melancholy
grandeur of the sea shore'. Maria died in November 1828
and on 21 January 1829 Constable told Leslie: 'Could I get
a float on a canvas of six feet I might have a chance of
being carried away from myself'. A small sketch made
on the 1814 tour provided the catalyst for the outpour-
ing of emotion and association that became the finished
painting.

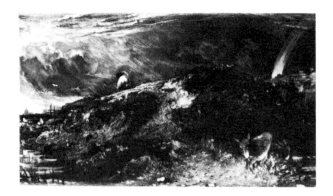

22. Vignette, Hampstead Heath. — Labourer returning

Based on an unknown painting. A similar sketch is
A sandbank at Hampstead Heath (Pl. 22), 1821, oil on paper,
9¾ × 11¾in, 24.8 × 29.8cm, inscr: 'Novr. 2nd 1821.
Hampstead Heath windy afternoon', Victoria & Albert
Museum, London (164-1888). Refs: R(V&A) 228; H 320;
R 21.66.
Issued with Part 5, July 1832.

Since this was the first plate to be started, it seems pos-
sible that Constable intended it for a frontispiece, which
would have been appropriate for an artist looking back
from Hampstead over his life and career. According to
Lucas the figure was the artist William Collins 'who hap-
pened to be sketching on the heath at the time', although
a pencil drawing made on 7 September 1820, now at Yale
(R 20.69) shows a very similar pose. The figure later
acquired a pick-axe and became the 'labourer returning'
of the title.

The published series opened with the house in which
Constable was born, and ended at Hampstead where he
was buried in 1837. It was perhaps a strange note to end
on; a barren sandbank, with a leaden sky behind. For a
motto he chose a quotation which summed up the life
described in the plates within: '*Ut Umbra sic Vita*'. It was
taken from the sundial on the porch of East Bergholt
Church.

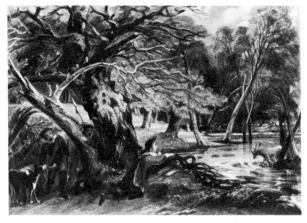

23. Jaques and the Wounded Stag

Based on *Jaques and the Wounded Stag* (Pl. 23), 1828,
watercolour, 7¾ × 11⅞in, 19.7 × 30.2cm (sight),
Private collection.
Published by Lucas, '2nd Series', 1846.

On 27 October 1823 Constable wrote to his wife from
Coleorton in Derbyshire, the home of Sir George
Beaumont, to describe a typical evening: 'We then return
to dinner. Do not sit long — hear the news paper by Lady
Beaumont (The Herald — Let us take it in town) — then
to the drawing room to meet the tea — then comes a great
treat. I am furnished with some beautifull portfolios, of
his own drawings or otherwise, and Sir George reads a
play, in a manner the most delightfull — for beyond any
pronunciation I ever heard — on Saturday evening it was
"As You Like It", and the Seven Ages I never so heard
before'.

As You Like It, with its woodland scenery, was among
Constable's favourite Shakespeare, and he sketched this
subject many times. Jaques is one of the banished Duke's
attendants, and he is prone to the melancholic contempla-
tion of nature. He is introduced thus:

[FIRST LORD]
Today my Lord of Amiens and myself
Did steal behind him as he lay along

Under an oak whose antique root peeps out
Upon the brook that brawls along this wood;
To the which place a poor sequester'd stag,
That from the hunters' aim had ta'en a hurt,
Did come to languish; and, indeed my lord,
The wretched animal heav'd forth such groans
That their discharge did stretch his leathern coat
Almost to bursting, and the big round tears
Cours'd one another down his innocent nose
In piteous chase; and thus the hairy fool,
Much marked of the melancholy Jaques,
Stood on the extremest verge of the swift brook,
Augmenting it with tears.

[DUKE S.]
But what said Jaques?
Did he not moralise this spectacle?

[FIRST LORD]
O, yes, into a thousand similes.

Sir George Beaumont died in 1827 and it seems likely
that Jaques was selected for 'English Landscape' as a
memorial to him. Whatever else may be the case, Con-
stable identified himself with the melancholy Jaques. On
2 March 1832 he wrote to C. R. Leslie: 'I love to cope
with you (like "Jaques") in my sullen moods: for I am not
fit for this world (of art at least)'.

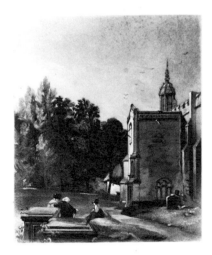

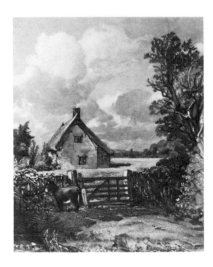

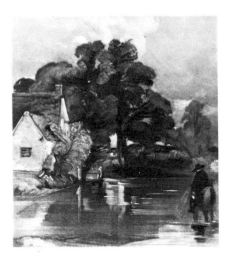

24. Porch of the Church at East Bergholt, Suffolk

Based on *A Church Porch (The Church Porch, East Bergholt)* (Pl. 24), exhibited Royal Academy, 1810 (116 as 'A church-yard'), oil on canvas, 17½ × 14⅛in, 44.5 × 35.9cm, Tate Gallery, London (1245).
Published by Lucas, '2nd Series', 1846.

Constable's home at East Bergholt was at the other side of the church, and the churchyard, shaded by tall trees, is a particularly pleasant spot in summer especially after walking up Flatford Lane (just to the left) on a hot day. Here, as Leslie described it: 'The stillness of a summer afternoon is broken only by the voice of an old man to whom a woman and girl sitting on one of the tombs are listening.'

The direction and angle of the sun would suggest late September rather than summer, and Constable was at East Bergholt from September to November 1809. This stay was noteworthy for his falling in love with the twenty-one-year-old Maria Bicknell who was staying with her sister at her grandfather's. Dr Rhudde was rector of East Bergholt and it is possible that this picture provided an excuse for Constable to keep an eye on his beloved while her grandfather expounded on some elegaic theme.

25. A Cottage in the Corn Field (Woodman's Cottage)

Based on *The Cottage in a Cornfield* (Pl. 25), 1815 (but exhibited Royal Academy 1833, No. 344), oil on canvas, 24¼ × 20¼in, 62 × 51.5cm, Victoria & Albert Museum, London (1631-1888).
Published by Lucas, '2nd Series', 1846.

On 2 March 1833 Constable wrote to Leslie: 'I have licked up my Cottage into a pretty look'. He does not, however, seem to have done very much to the picture, for it is quite clearly mostly of a much earlier period, and it has been recently argued that it was painted direct from the motif in 1815. We do not know exactly where the cottage was, but it fascinated Constable at this time to judge from the number of studies he made of it. 1815 was a particularly fine summer and Constable recorded that he had spent most of it in the fields. Leslie noticed the accuracy of Constable's observation: 'The cottage in this little picture is closely surrounded by the corn, which on the side most shaded from the sun, remains green, while over the rest of the field it has ripened; one of the many circumstances that may be discovered in Constable's landscapes, which mark them as the productions of an incessant observer of nature.'

26. Willy Lott's House, with the Painter's Father

Based on an unknown work, perhaps *Willy Lott's House* (Pl. 26), 1810(?), oil on canvas, 10¾ × 9½in, 27.3 × 24.2cm, Victoria & Albert Museum, London (787-1888).
Published by Lucas, '2nd Series', 1846.

The viewpoint from outside Flatford Mill is the same as that of *The Hay Wain* (Ill. 13), but shows only the left half of that view. Early proofs of the engraving show that there was originally a standing figure in place of the horse and rider. The full-scale sketch for *The Hay Wain* also includes a horse and rider (a boy in that case), and X-rays have shown that a mounted figure at one stage appeared in the finished painting. The painter's father was the owner of Flatford Mill, and it is not surprising that Constable should have intended to include him in the 'English Landscape' project. As Attfield Brooks has pointed out, this sketch shows a considerable flood by comparison with the water level in *The Mill Stream* and *The Hay Wain*. Constable witnessed such floods in the Autumn of 1810. In early December his mother wrote to say that they had weathered the storms: 'Much rain and great floods, and Saturday three weeks a tremendous gale of wind. Thank God, vessels, barges & windmills all safe'.

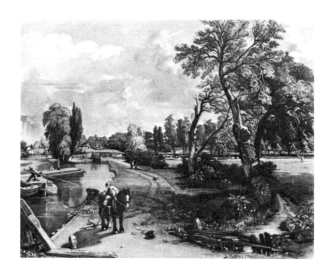

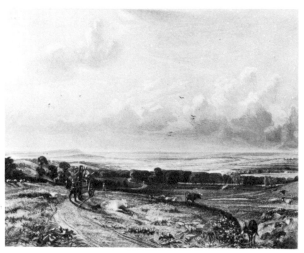

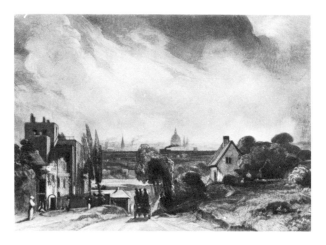

27. Flatford Mill

Based on *Flatford Mill* (Pl. 27), exhibited Royal Academy, 1817 (255 as 'Scene on a navigable river'), oil on canvas, 40 × 50in, 101.7 × 127cm, Tate Gallery, London (1273). Published by Lucas, '2nd Series', 1846 (but bears date 1884).

On 12 September 1816 Constable wrote to Maria Bicknell from East Bergholt: 'I am now in the midst of a large picture here which I had contemplated for the next Exhibition. — it would have made my mind easy had it been forwarder — I cannot help it — we must not expect to have all our wishes complete'. One of Maria's wishes was for the artist to return to London so that they might be married that month as they had arranged. Constable went on in the same letter to waver on the brink of suggesting a postponement so that he could get on with his painting. Her reply has evidently been destroyed. We might guess that she was not amused.

Constable wanted to prolong his stay at East Bergholt for several reasons, besides it being his last as a free agent. His father had died in May and plans were being made to sell the house. This would be the last occasion on which he could describe East Bergholt as home.

28. Hampstead Heath, Harrow in the Distance

Based on *Child's Hill: Harrow in the Distance* (Pl. 28), 1824, oil on canvas, 23½ × 30½in, 59.6 × 77.4cm, Private collection, on loan to the Whitworth Art Gallery, Manchester).
Published by Lucas '2nd Series', 1846.

On 22 May 1824 a Paris dealer, Charles Schroth, ordered two Hampstead views, which were finished by 17 December when Constable wrote to John Fisher: 'I have painted two of my best landscapes for Mr *Scroth* at Paris. They will soon go but I have copied them, so it is immaterial which is sent away'. The pair sent away were engraved by David Lucas for the '2nd Series' some time after they returned to England in the 1830s (see Pl. 37).

The road in the foreground is the continuation of Branch Hill Road west in the direction of Child's Hill. The companion view continues the panorama around to the left from Harrow Hill. To the extreme right can be seen St. Mary's Church, Hendon.

29. Sir Richard Steele's Cottage, Hampstead

Based on *Sir Richard Steele's Cottage, Hampstead* (Pl. 29), exhibited Royal Academy 1832 (147), oil on canvas, 8¼ × 11¼in, 21 × 28.5cm, Paul Mellon Collection, Upperville, Virginia.
Published by Lucas, '2nd Series', 1846.

This view across north London to St. Paul's was taken from Haverstock Hill, at the junction with Steele's Road. The steep hill is still recognisable, but all else is changed by modern development. The view is no longer quite so striking, but it seems probable that Constable was recording a memorable moment from his oft-travelled route from Hampstead into London.

Sir Richard Steele (1672-1729) was one of the most prominent literary figures in Georgian England. Essayist, dramatist and politician, he is particularly noted for having founded *Tatler*, 1709-11, the *Spectator*, 1711-12, and *The Guardian*, 1713. We do not know why Lucas selected this subject for inclusion, but it seems possible that Constable himself suggested it when it was exhibited in 1832.

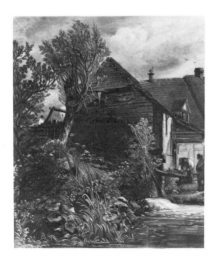

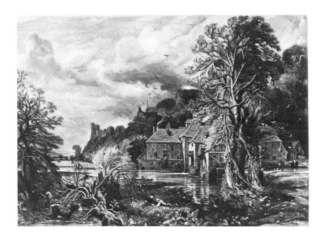

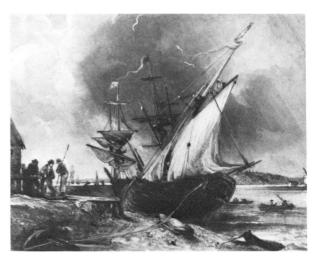

30. Gillingham Mill, Dorsetshire

Based on *Gillingham Mill, Dorset* (Pl. 30), exhibited
Royal Academy, 1827 (48 as 'Mill, Gillingham, Dorset'),
oil on canvas, 24¾ × 20½in, 63 × 52cm, Victoria &
Albert Museum, London (1632-1888).
Published by Lucas' '2nd Series', 1846.

John Fisher acquired the living of the Vicarage of Gilling-
ham in 1819 and Constable made a brief visit with him
from Salisbury in 1820, and a longer one, 22 August–10
September 1823, when he stayed at the vicarage. During
this latter stay he painted an oil-sketch of this mill and a
painting of the bridge and church in the village. On 23
October Constable wrote to Fisher to confess: 'The sound
of water escaping from Mill dams, so do Willows, Old
rotten Banks, slimy posts, & brickwork. I love such
things —'. On 5 July 1823 Fisher wrote to entice Con-
stable down to Gillingham with the promise of three
mills. Perne's Mill was presumably one of them, and was
exactly what Constable craved. Subjects such as this were
disappearing in England, however, and Perne's Mill itself
was consigned to history shortly afterwards when it
burned down in a fire in 1825 to be replaced by 'A huge
misshapen, new, bright, brick, modern, improved,
patent monster'.

31. Arundel Mill and Castle

Based on *Arundel Mill and Castle* (Pl. 31), exhibited Royal
Academy, 1837 (193), oil on canvas, 28½ × 39½in,
72.4 × 100.3cm, Toledo Museum of Art, Ohio (26.53).
Published by Lucas '2nd Series', 1846.

On 17 February 1837 Constable wrote to George
Constable (no relation), a brewer of Arundel: 'I am at
work on a beautiful subject, Arundel Mill, for which I am
indebted to your friendship. It is, and shall be, my best
picture — the size, three or four feet. It is safe for the
Exhibition, as we have as much as six weeks good'.
Constable died during the night of 31 March 1837, with
his painting very nearly finished, still on his easel. As
Leslie records: 'The scene was one entirely after his own
heart, and he had taken great pains to render it complete
in all its details; and in that silvery brightness of effect
which was a chief aim with him in the latter years of his
life, it is not surpassed by any production of his pencil.' It
was sent by his friends to the Royal Academy Exhibition,
the first in the new galleries in Trafalgar Square.

Constable visited Arundel in 1834 and 1835 and made
several sketches of the mill near Swancombe Lake. He
wrote to Leslie on 16 July 1834: 'The Castle is the cheif
ornament of this place — but all here sinks to insignifi-
cance in comparison with the woods, and hills.'

32. View on the Orwell, Near Ipswich

Based on the sketch *Shipping in the Orwell, near Ipswich*
(Pl. 32), *c*.1829?, oil on millboard, 8 × 9¼in, 20.2 ×
23.5cm, Victoria & Albert Museum, London (160-1888).
Published by Moon, 1838 and by Lucas, '2nd Series',
1846.

As early as 1824 the Paris dealer John Arrowsmith had
seen the commercial potential of having Constable's
shipping subjects engraved. Nothing had come of this at
the time, but it suggests one reason for Constable con-
sidering this work for 'English Landscape'. Another
factor may have been Gainsborough's known association
with Ipswich and the Orwell. It is not known when Con-
stable made the present sketch. The closest subjects to this
in style and content are the Brighton boat studies of 1824
and later. Constable made a visit to Ipswich at Easter
1821, and the sketch could have been made on this occas-
ion, or it could have been made especially for engraving
c.1829. On the whole Lucas made an excellent job of
translating his employer's note, transforming the subject
into a grand chilling day, in which it is almost possible to
smell the sea, blowing across the estuary towards us.

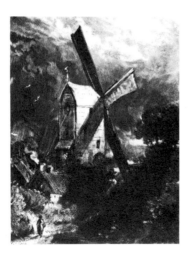

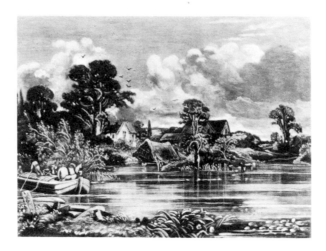

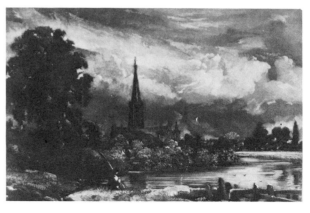

33. Upright Mill, near Brighton

Based on sketch *A Windmill near Brighton* (Pl. 33), 1829, oil on canvas, 5¾ × 4½in, 14.6 × 11.4cm, Victoria & Albert Museum, London (588–1888). Published by Moon, 1838.

Apart from the title under which the subject was published, there is nothing in the documentation to indicate that the mill was in fact at Brighton. A similar mill near Brighton can be seen in a sketch of 1824 at the Tate Gallery, but the mill on East Bergholt Common owned by Constable's father (Pl. 2) was of the same type. The painting was one of the slightest to be placed in Lucas's hands, but is typical of those that the engraver began with in 1829 (see Pl. 17). Once again he managed to carry the vigour and animation of the sketch successfully into the engraving.

34. The White Horse, River Stour

Based on *The White Horse* (Pl. 34), exhibited Royal Academy, 1819 (251 as 'A scene on the river Stour'), oil on canvas, 51¾ × 74in, 131.5 × 187.8cm, Frick Collection, New York (A520D). Published by Moon, 1838.

The White Horse was the first of Constable's six-foot canvases. It shows the view of Willy Lott's cottage from downstream, with the end of *The Mill Stream* (Pl. 12) below the cottage to the left. A laden barge is making its way downstream from Flatford Mill, no doubt on its way to the Constables' wharfe at Mistley. Early maps show that the towpath on this bank ended here, the way being barred by the old river, the presence of which is indicated by the current flowing into the main stream at the bottom right. The tow horses were trained to step onto the barge which could then be poled along by the barge boys.

Constable often referred to this picture as 'The Farm Yard'. The farmyard he meant, by Willy Lott's cottage, was more visible in the full sketch for the *White Horse* than it is in the finished picture, where it is mostly concealed by the boathouse. As a result of the success of this picture, Constable was elected Associate of the Royal Academy in November 1819 at the age of forty-three.

35. Salisbury Cathedral

Based on the sketch for *Salisbury Cathedral from the Meadows* (Pl. 35), *c.*1829–31, oil on paper mounted on card, 7¼ × 11in, 18.4 × 27.9cm, Private collection. Published by Moon, 1838.

The painting on which the engraving was based only came to light in 1982, and needs to be considered alongside the painting of *Salisbury Cathedral from the Meadows*, exhibited at the Academy in 1831 (Pl. 40). Constable went to stay with John Fisher at Salisbury during July 1829, and planned to paint a large picture of Salisbury on site later in the year. On 9 August Fisher wrote to tell Constable: 'The great easil has arrived & wants his office. Pray dont let it be long before you come & begin your work. I am quite sure the "Church under a Cloud" is the best subject you can take. It will be an amazing advantage to go every day & look afresh at your material drawn from nature herself. You may come as soon as you will'.

Circumstances prevented Constable from proceeding as he had intended, but from pencil sketches made in July he made three oil-studies exploring the possibilities of the view of the Cathedral from the north-west.

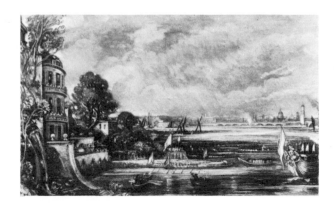

36. The opening of Waterloo Bridge, 18 June 1817

Based on the sketch *Waterloo Bridge from Whitehall Stairs* (Pl. 36), after 1826, oil on canvas, 24⅜ × 39in, 62 × 99cm, Yale Center for British Art, New Haven (B 1977.14.44). Published by Moon, 1838.

Of all Constable's subjects, this occupied him longest and caused the greatest trouble. We know that he began a picture of the celebrations held on 18 June 1817, the second anniversary of the Battle of Waterloo, as early as 1819. After various trial studies and versions a finished picture finally reached the walls of the Royal Academy in 1832. One of the main problems was that Constable found the subject uncongenial. He seems to have persevered with it mainly for the sake of his 'fame'. By 1832 he was heartily sick of it. On 28 February he told Lucas: 'I am dashing away at the great London — and why not? I may as well produce this abortion as another — for who cares for landscape'. This dislike of the subject finally led to its expulsion from 'English Landscape'.

The view is taken from Lord Pembroke's gardens, looking across Whitehall Stairs to Fife Gardens, the home of the then Prime Minister, Lord Liverpool. The bow-fronted house on the left is 5 Whitehall Yard. As we progress along the Thames we can make out the Adelphi before John Rennie's new bridge, and beyond Somerset House, the then home of the Royal Academy, and St. Paul's.

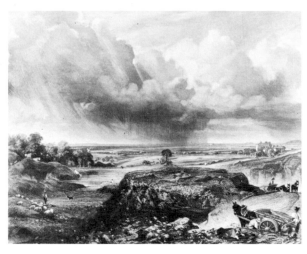

37. The Bathers, Hampstead Heath

Based on *Branch Hill Pond, Hampstead* (Pl. 37), 1824, oil on canvas, 23½ × 30in, 59.7 × 76.2cm, Oskar Reinhart Foundation, Winterthur. Published 1855.

The origin of this composition is described in the commentary on its companion, *Child's Hill: Harrow in the Distance* (Pl. 28). In a letter to Francis Darby of 1 August 1825 Constable described this view as 'No. 115. A scene on Hampstead Heath, with broken foreground and sand carts, Windsor Castle in the extreme distance on the right of the shower. The fresh greens in the distance (which you are pleased to admire) are the fields about Harrow, and the villages of Hendon, Kilburn, &c'. The house at the right is The Grange (called 'The Salt Box'), Harrow Hill is to the extreme right, Branch Hill Pond in the foreground. Lucas engraved a very similar view to this in the original series of 'English Landscape' (Pl. 9), taken from a few yards to the right of this viewpoint and a little further forward. It may only have been after engraving this plate that Lucas realised this. Kilburn Windmill, seen just above the pond, can be located in many of Constable's Hampstead views (see Pls. 4 and 9).

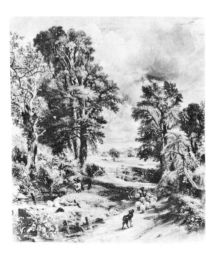

38. The Cornfield

Based on *The Cornfield* (Pl. 38), exhibited Royal Academy, 1826 (225 'Landscape'), oil on canvas, 56¼ × 48in, 143 × 122cm, National Gallery, London (130). Published by Moon, 1 July 1834.

On 8 April 1826 Constable wrote to Fisher: 'I have dispatched a large landscape to the Academy — upright, the size of my Lock — but a subject of a very different nature — inland — cornfields — a close lane, kind of thing — but it is not neglected in any part ... I at this moment, hear a rook fly over my painting room in which I am now writing — his call, transports me to Osmington and makes me think for a minute that I am speaking and not writing to you'.

The scene is thought to show Fen Bridge Lane, down which Constable walked as a boy on his way to school at Dedham, but the church is not that of Dedham and no church is visible from Fen Bridge Lane. The one shown here has been identified as that at Higham, although Higham's has no lantern tower as this does. The church does resemble that of Osmington, however, and Osmington was in his thoughts as he wrote the letter quoted above.

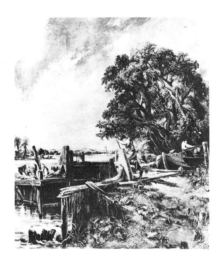

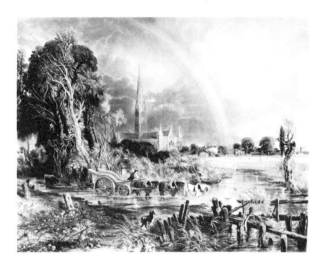

39. The Lock

Based on a replica of *The Lock* (Pl. 39), exhibited Royal Academy 1824 (180 'A Boat passing a Lock'), oil on canvas, 56 × 47½in, 142.2 × 120.7cm, Walter Morrison Collection, Sudeley Castle, Gloucestershire.
Published by Moon, 1 July 1834.

The scene is Flatford Lock from the lower gates, looking west towards Dedham Church, with a barge in the lock passing downstream. The lock sluices are being opened to allow the water-level in the lock to fall. To the left a tow horse is grazing in the meadows, waiting to be hitched up to the barge once again. On 8 May 1824 Constable could report: 'My picture is liked at the Academy. Indeed it forms a decided feature and its light cannot be put out, because it is the light of nature ... I sold this picture on the day of the opening. 150 guins including the frame'. The purchaser had to wait for Constable to make his copy and on 13 April 1825 the artist was still enjoying it in the privacy of his studio: 'My Lock is now on my easil. It looks most beautifully silvery, windy & delicious — it is all health — & the absence of every thing stagnant'. He presented a landscape version of the subject to the Royal Academy as his diploma picture in 1829.

40. Salisbury Cathedral from the Meadows (The Rainbow)

Based on *Salisbury Cathedral from the Meadows* (Pl. 40), exhibited Royal Academy 1831 (169), oil on canvas, 59¾ × 74¾in, 151.8 × 189.9cm, Private collection on loan to the National Gallery, London.
Published by E. Gambert & Co, London, and Goupil & Vibert, Paris, 1848.

Constable exhibited the picture at the Royal Academy with the following lines from Thomson's *Seasons*:

> As from the face of heaven the scatter'd clouds
> Tumultuous rove, th'interminable sky
> Sublimer swells, and o'er the world expands
> A purer azure. Through the lightened air
> A higher lustre and a clearer calm
> Diffusive tremble; while, as if in sign
> Of danger past, a glittering robe of joy,
> Set off abundant by the yellow ray,
> Invests the fields, and nature smiles reviv'd.

When Fisher referred to the planned painting as the 'Church under a cloud', it seems as if some definite theme had been discussed. Both Constable and Fisher were worried by the tide of Reform in the country, and per-

haps this was the threat alluded to. Certainly the threat was a real one, for Fisher was finding himself in financial difficulties caused by rising agricultural distress and late in 1829 his rents at Gillingham failed completely and he was forced to sell *The White Horse* (Pl. 34) and *Salisbury Cathedral from the Bishop's Grounds* back to the artist for £200.

The rainbow is an important theme in 'English Landscape' and some of the lines of Thomson quoted above accompanied a draft for the letterpress for the plate of *Stoke-by-Nayland* (Pl. 11) which included a discussion of rainbows. Throughout 'English Landscape' we are presented with the changing faces of nature, from rainbows and impending storms to sunny mornings and sea breezes. At the same time, the series allows us to note the changes which the passing years wrought on Constable's outlook. Nowhere is this more apparent than in a comparison between *Salisbury Cathedral from the Meadows* and *The Hay Wain* (Ill. 13).

For notes on origins and viewpoint see No. 35.

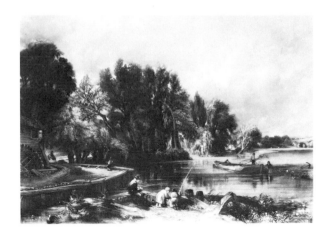

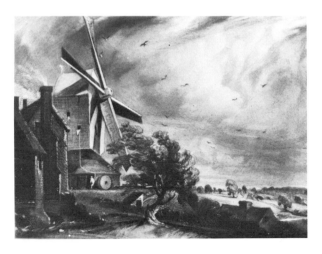

41. Stratford Mill

Based on *Stratford Mill* (Pl. 41), exhibited Royal
Academy, 1820 (17 'Landscape'), oil on canvas, 50 × 72in,
127 × 182.9cm, Private collection.
Published by Lucas, 1840.

The scene is Stratford Mill on the Stour, about two miles
west of East Bergholt, looking south towards Gun Hill
(see Pl. 42). Langham Church would be on the hill, just
out of the picture to the right. The old Stratford paper
mill was replaced about 1850 by a macaroni manufactory.
About six feet of its walls still remain, but the river banks
are recognisable today from the footbridge. The path
leads on over fields to the Glebe Farm and Langham
Church (see Pl. 20).

Lucas recorded that 'Mr C. explained to me if I may so
call it the natural history of this picture among his re-
marks were the following that when water reaches the
roots of plants or trees the action on the extremities of
their roots is such that they no longer vegetate but die
which explains the appearance of the dead tree on the
edge of the stream. The principal group of trees being
exposed to the currents of wind blowing over the
meadows continually acting on their boles inclines them
from their natural upright position and accounts for their
leaning to the right side of the picture'.

42. Dedham Vale

Based on *Dedham Vale* (Pl. 42), exhibited Royal
Academy, 1828 (7 or 232 'Landscape'), oil on canvas,
57⅛ × 48in, 145 × 122cm, National Gallery of Scotland,
Edinburgh.
Published or proved by S. Hollyer, 1838, and published
later by the Art Union of London (n.d.).

Possibly as a result of his holiday at Flatford in the
autumn of 1827 Constable turned back to the Stour
Valley for his principal exhibit of 1828, having shown the
Chain Pier, Brighton in 1827 (Ill. 25). For the present paint-
ing he returned to the view he had painted first in 1800,
the view noticed by Farington in 1794: 'The country
about Dedham presents a rich English Landscape, the
distance towards Harwich particularly beautiful.' The
view is taken from Langham Coombe looking down over
Stratford Bridge to Dedham Church, with Dedham Mill
to the left and East Bergholt on the hillside in the distance
to the left. Many of the buildings around Dedham can be
identified, including Dedham Assembly Rooms (the
white building to the right of Dedham Church tower)
and Mistley Church in the far distance just to the right of
Dedham Church tower.

43. Windmill Near Colchester (Stanway Mill)

Based on an untraced watercolour *A Mill near Colchester
(Stanway Mill)*, in the Isabel Constable sale 17 June 1892
(1817), Bt. Agnew. This in turn based on a pencil sketch,
A Windmill near Colchester (Stanway Mill), pencil,
4½ × 7in, 11.5 × 17.8cm, inscr: 'Saturday Aug 9 1817',
John C. P. Constable, loan to Tate Gallery (reproduced
here). Published by Lucas, '2nd Series', 1846.

A comparison between the drawing and the engraving
reveals the truth of Lucas's assertion that Constable's
'deep knowledge ... so materially contributed to his
successful practice'. The windmill here is of the centre-
post type, which enabled the whole building to pivot into
the wind. Lucas seems to have failed to understand this in
the engraving.

See illustration overleaf.

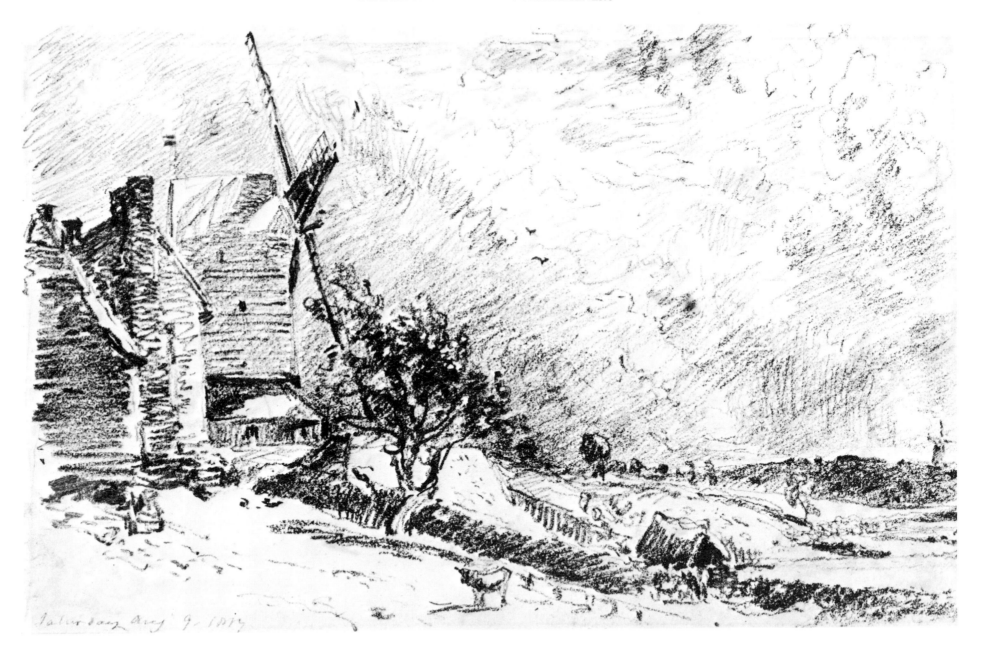

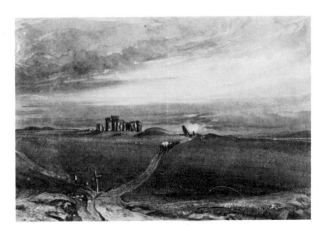

44. Stonehenge, Salisbury Plain

Based on an unknown watercolour. This in turn based on a pencil sketch, *Distant View of Stonehenge*, inscr: 'July 1820', pencil, 4½ × 7⅜in, 11.5 × 18cm, Private collection (reproduced here).
Published by Lucas, '2nd Series', 1846.

An oil-sketch formerly in the Paul Mellon Collection, thought by Beckett to have been the basis of the engraving, is rejected by Graham Reynolds (R 32.46), as a copy after the engraving. On 2 February 1834 Constable told John Britton, 'contemplated adding a view of Stonehenge to my book — but only a poetical one.'

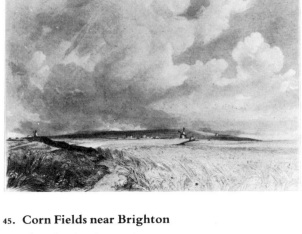

45. Corn Fields near Brighton

Based on the sketch *Cornfields near Brighton*, 1824, oil on canvas, 13 × 20in, 33 × 50.8cm, Private collection (reproduced here). Published by Lucas, '2nd Series', 1846.

According to Beckett the windmill was at Rottingdean, near Brighton.

See illustration overleaf.

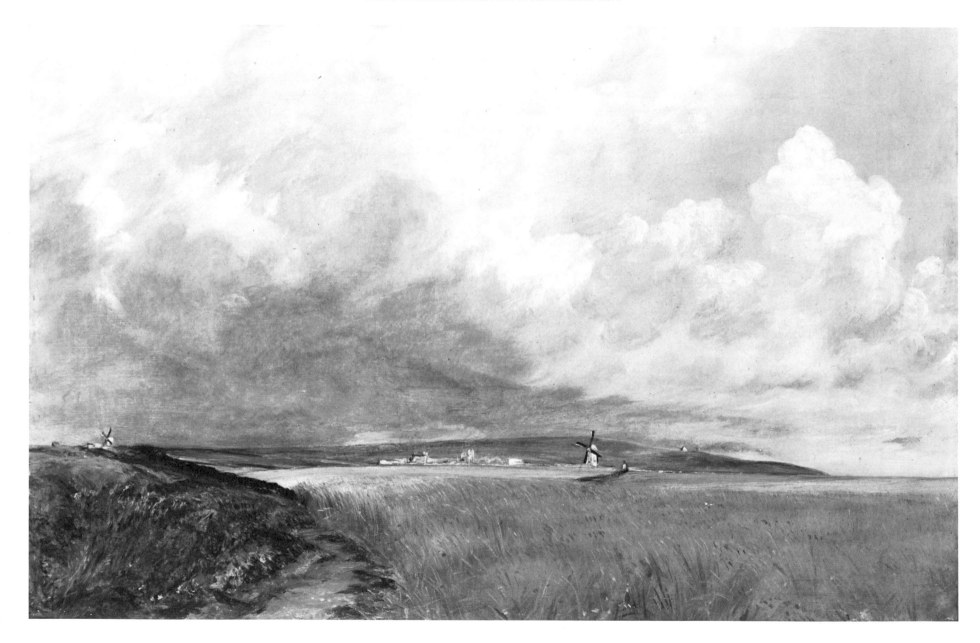

REFERENCES

Please note that original punctuation and grammar have been maintained in quotations, except in cases where these would be confusing or misleading.

ABBREVIATIONS

I, II, III, *IV, V, VI*	R. B. Beckett (ed), *John Constable's Correspondence*, Suffolk Records Society and the Boydell Press, Ipswich (6 vols.), 1962-68
JCD	R. B. Beckett (ed), *John Constable's Discourses*, Suffolk Records Society, 1970
FDC	Leslie Parris, Conal Shields, and Ian Fleming-Williams (eds), John Constable: *Further Documents and Correspondence*, Tate Gallery and Suffolk Records Society, 1975
H, Hoozee	Robert Hoozee, *L'Opera Completa di Constable*, Rizzoli, Milan, 1979
IFW	Ian Fleming-Williams, *Constable Landscape Watercolours and Drawings*, Tate Gallery, 1976
Leslie	C. R. Leslie, *Memoirs of the Life of John Constable* (1843, 2nd revised ed., 1845), London 1951
Parris	Leslie Parris, *The Tate Gallery Constable Collection*, 1981
R	Graham Reynolds, *The Later Paintings of John Constable*, Yale University Press, London and New Haven (2 vols.), 1984
R(V&A)	Graham Reynolds, *Catalogue of the Constable Collection in the Victoria and Albert Museum*, 1960
Rosenthal	Michael Rosenthal, *Constable, the Painter and his Landscape*, 1983
S., Shirley 1930	Hon. Andrew Shirley, *The Published Mezzotints of David Lucas after John Constable*, Oxford 1930
Smart & Brooks	Alastair Smart and Attfield Brooks, *Constable and his Country*, 1976
Tate 1976	Leslie Parris and Ian Fleming-Williams, *Constable*, catalogue of the Bicentenary exhibition held at the Tate Gallery, 1976
W, Wedmore	Frederick Wedmore, *Constable: Lucas: With a descriptive catalogue of the prints they did between them*, 1914
2nd Series	*English Landscape, or Mr David Lucas's New Series of Engravings*, 1846

JOHN CONSTABLE

p.8, col II, l.1	For a detailed discussion of Constable's dealings with patrons and dealers, see IV 1 ff. and 132 ff.
p.8, III, l.8 ff.	House advertisement, I 136
p.9, I, l.16	'trained up for the clergy', see *Leslie* p. 3, and Dr Grimwood's observations, ibid. Finding a successor was an important matter in the Constable family, cf. I 4.
l.37	'Handsome miller' story cf. *Leslie* p. 4.
II, l.2	Wood carving exh. Tate 1976 (2).
III, l.19	Ann Taylor's story quoted II 17-18.
ll.24	On George Frost see M. Rosenthal, *George Frost 1745-1821*, catalogue of the exhibition held at Gainsborough's House, Sudbury, Suffolk, 1974; for Constable & Froist see II 36 ff.
ll.25-34	For Constable's early interest in Gainsborough, cf. II 11 ff.
p.10, I, l.22	Letter from Ann Constable, I 25.
II, l.6	His father's health, etc., I 28.
l.18	Father's visits to Mills etc., I 29.
l.22	'Respectable friends', I 59.
l.25	West's picture, I 63.
l.27	'*earn money*', I 99.
III, l.9	Birthday greetings, I 96.
l.24	Dunthorne's patron, I 103.
p.11, I, *l.10-II, l.16*	Discussion of Constable's figures and the idea of work, see John Barrell, *The Dark Side of the Landscape*, Cambridge, 1980, and *Rosenthal*, 1983.
I, l.18	'road to happiness', VI 219.
l.33	'to remind not to deceive', *Leslie* p. 106.
II, l.28	'last day of Octr', VI 81.
p.12, I, l.1	'clever pictures', VI 65.
ll.5-27	'slimy posts', VI 77-8.
l.11	'poor Tom' i.e. Edgar in *King Lear*.
I, l.30	For Constable's relationship with the Fishers see JCC VI.
II, l.23	quote VI 226.
III, l.12	'unconscionable letter', IV 99-100.
l.25	'*real patrons*', VI 80.
p.13, I, l.29	The story of Abram's crutch told in *JCC* I 4, citing Hon. Andrew Shirley, *The Rainbow*, 1949, p. 34
II, l.2 and 6	Weather at Bergholt, I 137 and II 196.
p.14, I, l.3	Six-foot canvas, VI 76.
l.6	Cure for all ills, VI 204.
l.11	Getting afloat, III 18.
l.22	For a discussion of the topography of *The Leaping*

	Horse, see *Smart & Brooks*, 102 ff., and 138, plus *Rosenthal* p. 166.
p.15, I, l.20	Timber props etc., VI 191.
II, l.31	Abram's discouragement, I 233.
III, l.4	Constable's reports, II 440.
l.26	ditto, II 441.
l.28	ditto, II 439.
l.32	Sketch of John and Minna, R 27.34.
l.36	Sketch of *Flatford Old Bridge and Cottage*, R 27.25.
p.16, II, l.1	1813 sketch of *Flatford Old Bridge*, R(V&A) 121 p. 29
III, l.9	'nice house in Well Walk', II 442-3.
p.17, I, l.5	Wedding at Dedham, II 443.
II, l.6	State of mind in sketching, VI 142.
III, l.9	'delightful weather', II 442.
p.18, III, l.32	1802 *Dedham from Langham*, R(V&A) 37, exh. Tate 1976 No. 33.
p.19, I, l.8	Letter of 29 May 1802, II 32.
p.20, I, l.10	Letter of 21 Jan. 1829, III 18-19.
l.23	'The art will go out', VI 101.
l.31	National Galley, VI 107.
II, l.8	'Notions of freshness', VI 258.
l.24	Resolution not to harass his mind, III 96.
III, l.4	Attacking another canal, III 119.
l.11	1814 version of Willy Lott's, I 101.
l.27	'Plumb pudding', III 124.
l.34	Reynolds quote, R 35.1.
p.21, I, l.3	'oiling out', IV 278.
l.13	Parris quote, *Tate* 1976 320, p. 182.
II, l.11	'This lovely art', III 94-5.
l.28	Hampstead lecture, *JCD* 74.

CONSTABLE'S 'ENGLISH LANDSCAPE'

p.23, col.I Thomson quoted from J. Logie Robertson (ed.), *James Thomson, Poetical Works*, Oxford Standard Authors, Oxford (1908), 1971, p.59.

II, l.24 Letter of 17 Dec., 1824 IV 184, 185-6.

III, l.37 Further details of David Lucas are given by *Beckett* IV 314 ff., who cites E. Leggatt, introduction to the catalogue of *The Complete Works of David Lucas*, Gooden & Fox, 1903.

p.24, I, l.28 Fisher's remarks on lithography, VI 95.

p.25, I, l.3 Fisher on mezzotint, VI 188.

l.8 Sketches made especially for 'English Landscape' include *Dedham Mill* (R.29.59 but see notes to Pl.17), *A Windmill near Brighton* (R 29.60), *Stoke-by-Nayland* (R 29.61-62), and *Old Sarum* (R 29.65), *Approaching Storm* and *Departing Storm* (R 29.56,57).

l.25 *Dedham Mill, Leslie* p.180.

l.31 Lucas's annotation, *FDC* 60.

II, l.5 Note of 28 Aug., 1829, IV 321.

l.16 Note of 15 Sept., 1829, IV 322.

l.31 Lawrence's letter, *FDC* 234.

III, l.1 Letter of 26 Dec., 1829, *IV* 322-3, note, end 1830, IV 450.

l.6 Letter of 26 Jan., 1830, IV 324.

p.26, I, l.28 Letter of 26 Feb., 1830, IV 325.

II, l.18 Letter to Carpenter, 7 Apr. 1830, IV 143.

l.26 Letter of 30 Apr. 1830, IV 327.

l.33 Book forthcoming, VI 258.

p.27, I, l.10 Full text of *Athenaeum* review given by Shirley pp.28-9.

l.15 Original printing order for part 1, 27 May 1830, IV 450.

l.18 Actual printing about Aug. 1830, IV 451.

l.18 Prospectus: *Shirley* 1930 p.232 (I).

l.28 For Beckett's estimate of Constable's expenses up to 23 July 1830 see *JCC* IV 329.

II, 1.6 Arrangements for third number, III 32.

l.9 Outline of project, Nov. 1830, IV 144.

l.15 Undated letter, about Nov. 1830, IV 334, 444-5.

l.21 *Hadleigh Castle* considered from start, IV 322.

l.30 For various permutations, see IV 444-8.

l.32 First copy sent out, III 34.

III, l.2 Carpenter, re. advertising, IV 145.

p.28, III, l.27 Letter of 12 March 1831, IV 344-5.

l.31 Chantrey's letter, IV 346.

p.29, I, l.8 Ruined 'Heath', IV 347.

l.13 'evil hour', ibid.

l.15 Pruning of 15 July 1831, IV 350.

l.19 Third part issued, III 46.

l.25 Fourth part, IV 360.

p.30, I, l.33 Letter of 4 Dec. 1830, IV 360-2.

II, l.27 Ruined 'Salisbury', IV 367-8.

l.15 'New Sarum': It is not clear what Constable could mean by this. A new plate of *Old Sarum* (Pl.14) had been begun by 27 Oct. 1831 to replace that issued in Part 2. To have issued another *Old Sarum* in Part 5 would have seemed odd to anyone subscribing to the parts as they were issued. On the other hand no other small plate of Salisbury – that is 'new' Sarum as opposed to 'old' is known. Perhaps all this indicates is that there were no subscribers to the parts.

l.33 'Wings of a dove', IV 372.

III, l.3 Hopeless *Hadleigh*, IV 373.

l.11 Decline of Lucas's work, IV 319.

l.21 Henry Phillips's introduction, IV 371.

l.26 Drafts of the introduction in the Fitzwilliam Museum, Cambridge. For texts of introduction as published see *Shirley* 1930, p.219 ff.

p.31, I, l.17 'Cheerful morn of life', IV 375.

l.24 Part 5 issued July 1832, IV 380-1.

l.29 Considering appendix, IV 399.

II, l.5 Adding a 'Ruin', IV 382.

l.9 Proof of his ruin, IV 388.

l.14 Price reduction, IV 162.

pp.31-32 Sales: The selling agents for 'English Landscape' were Colnaghi's. A letter to Dominic Colnaghi of 25 Oct. 1831 noted by Beckett (IV 159) indicates *some* sales, as Constable had been asked to supply four sets of the prints.

p.32, I, l.6 Constable on reading print, III 108.

l.13 Losses, IV 414.

l.15 Further reduction, IV 295.

l.19 1835 prices, IV 425. 1835 prospectuses give the prices as 2, 3 and 5 guineas respectively, see Shirley p.241 ff.

l.20 'stock and stone', ibid.

l.25 For Constable's dealings with Carpenter see *Beckett* IV 135 ff.

II, l.4 Lucas's advertisement, IV 439.

III, l.11 Constable's instructions re. 'Frontispiece', IV 366.

THE LANDSCAPES

p.34, I, l.5 1802 'A Landscape' ==? *Wooded Landscape* (Art Gallery of Ontario, Toronto) H.273 where dated c.1810-20, cf. D. Taylor, 'New Light on an early painting by John Constable' *Burlington Magazine* CXII (Aug. 1980), pp.566-8. The problems of identifying exhibited works are reflected in Graham Reynolds catalogue of the *Later Paintings*, 1984. No doubt Charles Rhyne's companion volumes on the work up to 1816, forthcoming, will offer solutions to many of the problems posed by the earlier work.

II, l.2 Daniel Defoe, *A Tour through the Whole Island of Great Britain*, (1724-6), J. M. Dent, London (1962), 1974, p.59.

p.36, I, l.15 Arthur Young, 'A Fortnight's Tour in East Suffolk', *Annals of Agriculture and other Useful Arts* (ed. A. Young), XXIII (1795), p.48.

II, l.18 Possible exhibited view of Dedham Vale 1803 is *Dedham Vale*, 1802 R(V&A) 37. *Rosenthal* (p.38) suggests that some of the 1802 studies from nature appeared at the Academy the following year.

p.39, II, l.5 II 24.

l.16 II 70.

l.20 Sir Thomas Lawrence's approbation of *A Summerland*, Farington *Diary*, 23 April 1811.

III, l.24 'Summerland' fields, I 101.

l.36 Golding's interest in millat Dedham, see *Rosenthal* p.13 and n.13 (p.239). Flatford Mill is the property of the National Trust, but it is leased to the Nature Conservancy Council for use as a Field Study Centre. Visitors may park in the car park in Flatford Lane and walk alone to the Mill and Willy Lott's Cottage, or cross the bridge to the locak and the towpath. Bridge Cottage is used by the Trust as a shop and tea-rooms. The Mill and Willy Lott's Cottage are not open to the public.

p.43, III, l.26 'we live very retir'd', I 190.

p.44, I, l.5 Letter to Maria, II 80.

III, ll.29-36 Pencil sketches of elms at Flatford, 1814, R(V&A) 132 p.61, 1817 R(V&A) 161.

p.47, III, l.5 Letter to Maria, II 238.

p.48, II, l.10 Letter re. removing window at Keppel Street, VI 65.

III, l.7 Letter to Fisher re. Keppel Street, VI 99.

p.49, I, l.6 Letter to Fisher re. Hampstead, VI 71.

l.19	Letter to Fisher re. 'Skying', VI 76 ff.
p.50, II, *l*.4	Letter re. Hampstead, VI 81.
III, *l*.1	Letter of 7 Oct., VI 98-9.
l.7	Letter of 4 Oct., VI 91.
p.51, II, *l*.2	Letter from Fisher re. trees at Gillingham, VI 144.
l.11	Constable's reply, VI 146. The reference to Shakespeare is to *As You Like It* – see mezzotint 23.
III, *l*.31	Letter re. Brighton, VI 171.
p.52, III, *l*.14	Letter re. Hampstead, VI 204.
l.21	7 July 1826, VI 223.
l.29	9 Sept., ibid.
p.54, I, *l*.9	28 Nov., VI 228.
II, *l*.22	Letter of 26 Aug. 1827, VI 230-1.
l.31	Letter of 11 June 1828, VI 237.
III, *l*.8	Mrs. Constable's health and visit, *Leslie*, p.167-8.
l.33	Letter of 19 Dec. 1828, *FDC* 81.

THE MEZZOTINTS

1. **Frontispiece.**
Engraved between 12 March 1831 (IV 344) and 13 Feb. 1832 (IV 365). Early impressions dated 1831.
Refs: W 1; S 27; *Tate 1976* 274; R 31.18.
Epigraph in Latin on plate, translated by John Fisher, see *Tate 1976*, 274.
Letterpress: Constable had the following footnote paying tribute to his friends, the Bishop of Salisbury and Sir George Beaumont:
> *The late Dr. John Fisher, Bishop of Exeter, and afterwards Bishop of Salisbury, and also the late Sir George Beaumont, Baronet, both well known as admirers and patrons of Painting, often passed their summers at Dedham, the adjoining village to Bergholt; to the latter of whom the Author was happily introduced through the anxious and parental attention of his Mother; and for his truly valuable acquaintance with Dr. Fisher, he was indebted to the kindness of his early friends, the Hurlocks – of which circumstance he has a lively and grateful remembrance. These events entirely influenced his future life, and were the foundation of a sincere and uninterrupted friendship, which terminated but with the lives of these estimable men.

2. **Spring.**
Engraved plate begun before 15 Sept. 1829 (IV 322) and last touched 18 May 1830 (see W 2). A smaller version engraved by Lucas for Leslie's *Life*, 2nd ed., 1845 (W 45).
Refs: W 2; S 7; R(V&A) 122; H 222; R 21.13.
Carved windmill exhibited *Tate 1976* (No. 2). Letterpress draft ex coll. R. Beckett. Proofs: *Shirley*, Appendix D 2a-f, another in the Fitzwilliam Museum, Cambridge. A corrected proof exhibited *Tate 1976*, reprod. cat. 275. Lucas quote, *FDC* 54. 1821 sketches, R 21.11, 12. A close stylistic companion is R (V&A) 174. Full text of letterpress given, *JCD* pp.14-16.

3. **Sunset.**
Engraving begun after 15 Sept. 1829 (IV 322) but delayed by problems and still being worked on 2 March 1833 (IV 393). Early impressions dated 1831.
Refs: W 3; S 14; R(V&A) 120; H 161.
Constable's 'wig tree' quoted from E. E. Leggatt, *Complete Works of David Lucas*, 1903, pp.33-4. Constable to Lucas, 2 June 1832, IV 376. Sketch dated 13 July 1813, R(V&A) 121, p.21.

4. **Noon.**
Engraving started before 22 Sept. 1830 (IV 331). Date of issue, IV 338.

Refs: W 4; S 16; H 442; R 30.20.
Lucas inscription on a proof at the Fitzwilliam Museum, Cambridge, see R. Cadney, *Catalogue of Drawings and Watercolours with a selection of Mezzotints by David Lucas . . . in the Fitzwilliam Museum, Cambridge*, 1976, (B), p.138. For Lucas and Leslie's route to Hampstead see IV 331.

5. **Yarmouth Pier.**
Engraved before Sept. 1830 (Shirley, S.18), and proposed for inclusion in Part 3, Oct.-Nov. 1830 (IV 334). Rejected by 19 Feb. 1831 (IV 446) until 3 March 1832 when considered for inclusion in Part 5 (IV 369).
Refs: W 10; S 18; *Tate 1976* 214; H 362; R 22.37.
For further discussion of versions of *Yarmouth Jetty* see Parris pp.106-9 and R 22.36-41. For date of engraving, a proof inscribed 'the first I received Sepr' is dated by Shirley (S.18) to 1830 but by Beckett in *JCC* (IV 353) to 1831. Constable letters, 18 April 1823, VI 128; 23 July 1831, V 89.

6. **Summer Morning.**
Engraving proposed for Part 5 about Oct./Nov. 1830 (IV 444), and for Part 3, 23 Dec. 1830 (IV 446). Touched proofs 1 Jan. 1831 (IV 338). Alternations made Feb.-Apr. 1833 (IV 393, 396, 454).
Refs: W 6; S 26; R(V&A) 332; H 86.
Painting of 13 July 1812 exhibited *Tate 1976* (No. 112). For consideration of 1813 exhibit see Tate entry above, plus *IFW* p.44. For discussion of ploughs and ploughing see *Rosenthal* p.12. Further proofs and fragments of letterpress are given by Shirley, S. Appendix D, 6a-d, and Beckett, *JCD* p.18. Oil sketch of 2 November 1814, R(V&A) 136. For different states of engraving see Shirley 26.

7. **Summer Evening.**
Engraving begun before 15 Sep. 1829 (IV 322). Considered for Part 3 or Part 5, Nov. 1830 (IV 445). Selected for Part 3, 9 Dec. 1830 (ibid.).
Refs: W 7; S 6; R(V&A) 98; *Tate 1976* 103; H 121.
Letters of 12 Nov. 1811, II 54; 12 August 1809, I 36.

8. **Dell in the woods of Helmingham Park.**
Engraving begun before 26 Dec. 1829 (IV 322), and finished by 18 May 1830 (IV 327). Alterations suggested (eg 'cow to be made a stag'), 22 Nov. 1832 (IV 456).
Refs: W 9; S 12; H 474; R 30.3.
Of the several versions of this subject only two were in existence at the time the engraving was begun before Dec. 1829, that is the present picture and another bought by James Pulham in 1826

(R 26.21). The present picture seems identifiable with that mentioned by Constable on 10 July 1823 (IV 125) as being liked by Sir George Beaumont. Constable said that the chiaroscuro of the engraving was based on Pulham's picture (IV 105) but this seems unlikely in view of the fact that it remained in Pulham's collection until 1833. Constable painted a version for exhibition in 1830 (R 30.1) after the engraving had been started (IV 321) but this resembles the engraving only in general terms. 1800 drawing exhibited *Tate 1976* (No. 21) and repr. *IFW* pl. 1. Letter of 25 July 1800, II 25.

9. Hampstead Heath.
Engraving first considered for Part 4 about Oct./Nov. 1830 (IV 444). First proofs recorded 4 Nov. 1830 (Shirley 23a) and 20 Dec. 1830 (IV 338). Considered for Part 3, early 1831 (IV 446) and selected by 17 May 1831 (*ibid.*). Alterations suggested 23 Sept. 1832 (IV 454).
Refs: W 8; S 23; R(V&A) 301; *Tate 1976*, 254; H 481; R 28.2. 1819 sketch, R 19.32. Reynolds quote, R 28.2.

10. A Sea Beach.
Engraving started before 22 Sept. 1830 (IV 331). Small improvements requested 22 Nov. 1832 (IV 456).
Refs: W 11; S 17; H 483; R 24.79.
Letters of 9 Dec. 1835, III 133. Full letterpress (including material evidently written by Henry Phillips) given, *JCD*, pp.19-21.

11. Stoke Church.
Engraving begun 26 Dec. 1829 (IV 323). Proofs dated 23 and 26 Sept. 1830 (IV 332).
Refs: W 16; S 9; R(V&A) 330; *Tate 1976* 278; H 138; R 29.61.
The first state of the engraving (*Shirley* 9a-b where repr.) is quite different to any of the surviving oil paintings, and shows the church, not from the south as in the finished engraving, but from the south west. The closest records are the studies in the Louvre (RF 11615) and a sketch in charcoal on blue paper at the Royal Albert Memorial Museum, Exeter. *Letterpress:* Some additional lines of poetry are given by *JCD*, pp. 21-4.

12. River Stour.
Engraving proposed for Part 6, 19 Feb. 1831 (IV 446), Part 3, 17 May 1831 (IV 447), begun before 5 July 1831 (IV 349), complete impression wanted 31 Aug. 1831 (IV 351).
Refs: W 12; S 25; *Tate 1976* 129; H 191.
The sketch is at the Tate Gallery (No. 1816), the date of which is suggested by its closeness to the sketches of Flatford Mill made in 1811 (eg. R(V&A) 103). The finished painting of *Flatford Mill*

(ill. 17) was exhibited in 1812 and the similarity of its trees with those in *The Mill Stream*, together with the similarity of the water in *Landscape: Boys Fishing* (Pl. 13), exhibited in 1812, suggests a date of 1812 for the present picture. The ferry cut was closed *c.* 1840 (*Smart & Brooks* p. 135). 1814 picture, H 192.

13. Head of a Lock on the Stour.
Painting sent to Lucas for engraving about Oct./Nov. 1830 (IV 334, 444). Proposed for inclusion in Part 3, 9 Dec. 1830 (IV 445), Part 5, 17 May 1831 (IV 447), Part 4, about June 1831 (ibid.), Part 5, 19 Aug. 1831 (ibid.), Part 4, 23 Aug. 1831 (IV 448). Minor alterations proposed 22 Nov. 1832 (IV 456).
Refs: W 13; S 20; *Tate 1976* 118; H 174.
Some scholars have doubted the authenticity of this picture, eg. Charles Rhyne, letter of 31.1.1981, and Graham Reynolds – cited by *Rosenthal*, p.234 n59. But cf. *Tate 1976* 118. Rosenthal argues (p.63) that the picture's weak appearance is a product of Constable being constrained by the 'finish' required of an exhibitable picture. This seems to be confirmed by David Pike Watt's comments (IV 37). Details of sale to Carpenter given by Farington, *Diary*, 13 April 1814. Constable's letter to Lucas, 31 August 1831, IV 351. Constable to David Pike-Watts, 12 April 1814, IV 38-9.

14. Mound of the City of Old Sarum.
Engraving finished by 27 Oct. 1829 (*FDC* 234). A new plate begun by 27 Oct. 1831 (IV 358), still being worked 28 Feb. 1833 (IV 393), but issued in the complete edition, May 1833.
Refs: W 14; S8, 32; R(V&A) 322; H 516; R 29.65.
The new plate was begun because Constable was dissatisfied with the terraces in the first (*Leslie* 196). 1829 sketches, R 29.17, 18. Lawrence's letter, *FDC* 234.

15. A Summerland.
Engraving begun before 26 Dec. 1829 (IV 323), considered for Part 3 about Oct./Nov. 1830, Part 6, 9 Dec. 1830 (IV 445), Part 4, 19 Feb. 1831. Issue date, IV 360.
Refs: W 15; S 10; *Tate 1976* 123; H 193.

16. Barges on the Stour.
Engraving Engraving begun about Oct./Nov. 1830 when painting sent to Lucas (IV 334). Proposed for Part 3 then, Part 5, 9 Dec. 1830 (IV 445), Part 4, 19 Feb. 1831 (IV 446), Part 5, about June 1831, Part 4, 15 July 1831 (IV 448). Date issued (IV 360).
Refs: W 5; S 19; *Tate 1976* 201; H 329; R 22.2.
View on the Stour, 1822, R 22.1. Constable on fishing at Flatford, II 439.

17. A Water Mill.
This was one of the first plates to be engraved, 1829 (*FDC* 60), still proofing 26 Feb. 1830 (IV 325).
Refs: W 17; S5; H 518; R 29.59.
Considering 'Dedham Lock', IV 445. Letterpress reconstructed by Beckett, *JCD*, pp. 26-7.

18. Weymouth Bay.
Engraving begun late 1829)0).
Refs: W 18; S 13; H 616; R 19.9.
There is no reference to the engraving in the letter of 26 Feb. 1830 (IV 325) or before that. Constable seems to have commissioned the plate after this date, realising that he needed a marine subject for part 1. For other versions see National Gallery 2652 and R(V&A) 155. W. Wordsworth, *Elegaic Stanas, suggested by a picture of Peele Castle in a Storm, painted by Sir George Beaumont.* Constable's letter to Mrs. Leslie, III 29.

19. Summer Afternoon.
Engraving proposed for Part 6, 19 Feb. 1831446), Part 4, 17 May 1831 (IV 447), Part 5, 15 July (ibid.), Part 4, 31 Aug. 1831 (IV 448). Date issued, IV 360.
Refs: W 19; S 28; H 499; *Parris* 47; R 28.27.
Red Hill story, *Leslie* p. 129. Lucas quote, *FDC* 58. On matter of authenticity see *Parris* 47, and H.499. Constable to Lucas, 29 Sept. 1831, IV 355.

20. The Glebe Farm.
This plate (see 20a below) begun about Aug. 1831 (IV 351), when proposed for Part 4 (IV 448), Part 5, 31 Aug. 1831 (ibid.), Part 4, 29 Sept. 1831 (ibid.). Spoiled 4 Dec. 1831 (IV 360 ff.), recovered by 28 Feb. 1832 (IV 368). Proposed for Part 5, 3 March 1832 (IV 369). Some small improvements suggested Oct./Nov. 1832.
Refs: W 20; S 20; *Tate 1976* 321; H 536; *Parris* 37; R 27.8. Leslie's visit, *Life* p.286.
Earlier sketch, R(V&A) III. 1826 version, R 27.7. Letter of 9 Sept. 1826, VI 223-4. Leslie's version considered, IV 351, R 27.9. Letter re. Sheepshanks enquiry, III 144.

20a. A Ruin.
Refs: W 33; S 22, 22a.
First *Glebe Farm* (repr. *Shirley* 22a p.180) *quite different* from R(V&A) 111.
Unknown 'Sketch in a Lane', IV 335. Letter to Lucas 23 Aug. 1831, IV 351. Proofs requested 23 Jan. 1832, IV 364-5. Letter of 2 October 1832, IV 382. 20 Nov. 1832, IV 388.

21. The Nore.
First proposed for engraving before 15 Sept. 1829, then dropped (IV 322), proposed for Part 6 about Oct./Nov. 1830 (IV 414) but dropped after 17 May 1831, proposed in place of the spoiled *The Glebe Farm*, 4 Dec. 1831 (IV 361 and altered list of 19 Aug. 1831, IV 447, 351). Begun by 26 Dec. 1831 (IV 363), unhappy with it 5 May 1832 (IV 373) and 2 June 1832 (IV 376). Further improvements, 22 Nov. 1832 (IV 388-9), 9 Dec. 1832 (IV 390). A large plate (W 52; S 11) made from the full-scale sketch (Tate Gallery 4810) was begun at Lucas's own expense, 26 Feb. 1830 (IV 325), and brought near to completeion by 1830 (IV 326), but not published until 1849.
Refs: W 21; S 34; *Tate 1976* 263; H 502; *Parris* pp. 128-33; R 29.1. Letter re. walking on beach at Southend, II 127. Letter of 21 Jan. 1829, III 18. 1814 sketch, R(V&A) 127.

22. Vignette, Hampstead Heath.
According to Lucas this was the first plate of the 'English Landscape' series (*FDC* 60) and it is possible that it was near completion by the end of 1829. On 3 Nov. 1831 Constable suggested various alterations (IV 359).
Refs: W 22; S 3; *Tate 1976* 281; R 29.58.
Shirley mentions a proof (S.3b) dated 6 Oct. The present sundial has the motto translated into English: 'Time passeth away like a shadow'. Lucas quote, *FDC* 60.

23. Jaques and the Wounded Stag.
Engraving begun about Oct./Nov. 1830, when the watercolour was sent to Lucas and proposed for Part 6 (IV 335, 444). Proposed for Part 5, 19 Feb. 1831 (IV 446) but dropped 17 May 1831 when project cut from 6 to 5 parts. Considered for appendix 6 Nov. 1832 (IV 448).
Refs: W 26; S 15; R 32.10.
There are a number of different versions of *Jaques* recorded. The first is a watercolour offered for sale by Colnaghi's in 1828 (IV 157), when Constable indicated his intention to make a kit-cat sized painting from it. An untraced oil painting was sold at Christie's in 1839 from the collection of James Stewart (IV 124). A watercolour was exhibited at the RA in 1832 (492) but this seems unlikely to have been the present picture, which has been extended all round, presumably when Constable worked out the composition of his oil painting in 1828. Unless this extension was maked in 1832, this would surely have been unacceptable to the public. Shakespeare, *As You Like It*, II i 29-45. Sir George Beaumont painted a version of the subject which forms the basis of Constable's in reverse (*Tate 1976* 119). It is interesting in view of the possible memorial to Beaumont that this subject was sent

off to Lucas along with the *Glebe Farm*, a possible memorial to Bishop John Fisher (IV 335). 'cope him' *AYLI* II i 67-8. Letter describing life at Coleorton, 27 Oct. 1823, II 292. Letter to Leslie, 2 March 1832, III 95.

24. Porch of the Church at East Bergholt.
Engraving Constable may have considered this for inclusion Oct. 1830 (IV 332, III 31-32), but it was not included in any of the plans, and not engraved until *c.*1843 (*Shirley* 42).
Refs: W 23; S 42; *Tate 1976* 99; H 99; *Parris* 7. *Leslie* quote p. 21.

25. A Cottage in the Corn Field.
Engraving proposed for Part 5, 19 Feb. 1831 as 'Woodman's Cottage' (IV 446) but dropped when plan cut from 6 to 5 parts, 17 May 1831 (*Ibid.*), and not mentioned again. Engraved by Lucas *c.*1843.
Refs: W 30; S 45; R(V&A) 352; *Tate 1976* 297; H 550; R 33.3.
For 1815 date see *Rosenthal*, p. 91 ff. Another version, exhibited in 1817 is R 17.2. For sketches of cottage see R(V&A) 121 pp. 25, 44, 59, and R(V&A) 145, 157, Leslie quote p. 72. Constable to Leslie, 2 March 1833, III 44.

26. Willy Lott's House.
This engraving is hard to disentangle from *The Mill Stream* (no. 12) which seems to have been begun shortly before 5 July 1831 (IV 349). References to 'Old Lott's' and 'Billy Lott's' of 9 Dec. 1830, when proposed for Part 4 (IV 445), and 23 Dec. 1830, when proposed for Part 3 (IV 446), could refer to either. It seems to have been engraved by 3 March 1832, however (IV 370).
Refs: W 29; S 33; R(V&A) 329a; H 143.
Brooks' observations on water level, *Smart & Brooks*, p. 136. Constable's mother's report, I 52.

27. Flatford Mill.
Constable considered a 'Flatford Mill' for inclusion in Parts 4 or 6 in Oct. and Nov. 1830 (IV 444, 445) and mentions the loan of the picture to Lucas at that time (IV 336, 343). The subject was dropped 9 Dec. 1830 onwards, but considered for inclusion in an appendix, 6 Nov. 1832 (IV 448) — suggesting that perhaps it had already been engraved.
Refs: W 32; S 46; *Tate 1976* 151; H 233; *Parris* 14; R 17.1. Constable to Maria Bicknell, 12 Sept. 1816, II 203.

28. Hampstead Heath.
This subject was considered for Part 6 in Oct./Nov. 1830 as 'Hampstead with Cows' (IV 444), but not mentioned in any subsequent plans.

Refs: W 31; S 47; H 438; R 25.8.
For Constable's dealings with Schroth see II 314. R 25.7 reads *Schroth* in letter of 17 Dec. (IV 187). Darby letter, IV 97.

29. Sir Richard Steel's Cottage.
Engraving not mentioned in Constable's correspondence. Probably Lucas's own initiative, engraved *c.*1844-5.
Refs: W 25; S 48; H 663; R 32.6.

30. Gillingham Mill.
Lucas was considering engraving an upright watermill, perhaps Gillingham, 20 Dec. 1834 (IV 418), but this seems to have been a large plate undertaken on his own initiative. The present plate does not seem to have been engraved until *c.*1843, when dated.
Refs: W 24; S 43; R(V&A) 288; *Tate 1976* 246; H 479; R 27.5.
1823 oil sketch, R 23.22; painting, R 23.20. 'Slimy posts' letter, VI 77; 'brick monster' letter, VI 206. Fisher to Constable, 5 July 1823, VI 122-3.

31. Arundel Mill.
Engraved by Lucas. Late proofs dated 1846.
Refs: W 36; S 49; *Tate 1976* 336; H 565; R 37.1.
Constable to G. Constable, 17 Feb. 1837, V 37. *Leslie* quote p. 267. 1834 & 1835 sketches. R 34 21-26, 54, 69; R 35.10-12, 18, 19. Constable to Leslie, 16 July 1834, III 111.

32. View on the Orwell.
Engraving proposed for Part 4 about Oct./Nov. 1830 (IV 444), Part 3, 9 Dec. 1830 (IV 445). Probably begun by Dec. 1830 (*Shirley* 24). Proposed for Part 5, 17 May 1831 (IV 447), but dropped by 23 Aug. 1831 (IV 448). Reconsidered for Part 4, 26 Sept. 1831, but finally rejected 27 Sept. 1831 (IV 354). Considered for use in the appendix, 3 March 1832 (IV 370).
Refs: W 34; S 24; R(V&A) 96; H 96.
For Arrowsmith's interest in engraving see p. 23. Brighton boat studies, R 24.8, 10, 11, 14, 26-41, 45-54 &c.

33. Upright Mill.
One of the first engravings to be begun. Early proofs dated 1829, and pronounced 'quite perfect' by 26 Feb. 1830 (IV 325). 'Windmill' proposed for Part 4 or 5 about Oct./Nov. 1830 (IV 444). Dropped by 9 Dec. 1830 (IV 445).
Refs: W 37; S4; R(V&A) 310; H 493; R 29.60.
Sketch at Tate, R 24.15.

INDEX